Communication Theory and Millennial Popular Culture

This book is part of the Peter Lang Media and Communication list.
Every volume is peer reviewed and meets
the highest quality standards for content and production.

PETER LANG
New York • Bern • Frankfurt • Berlin
Brussels • Vienna • Oxford • Warsaw

Communication Theory and Millennial Popular Culture

ESSAYS AND APPLICATIONS

Kathleen Glenister Roberts, EDITOR

PETER LANG
New York • Bern • Frankfurt • Berlin
Brussels • Vienna • Oxford • Warsaw

Library of Congress Cataloging-in-Publication Data

Communication theory and millennial popular culture: essays and applications /
edited by Kathleen Glenister Roberts.
pages cm
Includes bibliographical references.
1. Popular culture. 2. Communication and technology. 3. Information theory.
4. Interpersonal communication. I. Glenister Roberts, Kathleen, editor.
HM621.C6436 302.2—dc23 2015024542
ISBN 978-1-4331-2643-7 (hardcover)
ISBN 978-1-4331-2642-0 (paperback)
ISBN 978-1-4539-1705-3 (e-book)

Bibliographic information published by **Die Deutsche Nationalbibliothek.**
Die Deutsche Nationalbibliothek lists this publication in the "Deutsche
Nationalbibliografie"; detailed bibliographic data are available
on the Internet at http://dnb.d-nb.de/.

The paper in this book meets the guidelines for permanence and durability
of the Committee on Production Guidelines for Book Longevity
of the Council of Library Resources.

For my parents and my brothers,

who made sure I grew up to love Merleau Ponty and Mel Brooks in equal measure.

Table of Contents

INTRODUCTION
Editor's Note
Kathleen Glenister Roberts
Theories, Artifacts, and Texts

Why do we study theory? There are many reasons. If you remember the "scientific method" from high school, you know that traditional theories start out with a hypothesis, and are tested through repeated experiments. If consistent results appear and prove the hypothesis, then you have a theory.

Theories exist in all academic disciplines, not just the sciences. In all fields, theories help solve puzzles—including in the discipline of communication. Theories help to troubleshoot gaps in our understanding, and to make sense of a world that seems to be changing very rapidly.

One of the authors in this book, Garret Castleberry, offers a very helpful perspective. Dr. Castleberry uses an analogy relating theorists to "showrunners":

> The term showrunner is unique in television. The **showrunner** functions similarly to a filmmaker or a composer with unique vision who steers the program in terms of the language spoken but often the look, sound, and scope of the series as well. In shaping a TV product, showrunners wield dynamic persuasive appeal. Academic theorists have a very similar job. Like showrunners, they shape how we view the world. Theorists offer informed insights based upon long-term research and analysis. For this reason, "theory" is often associated with heavy lifting, due to the burden placed on extending language and knowledge. Like the showrunner, a theorist harnesses potential for longstanding persuasive appeal. Yet whether persuasive appeal occurs through a theory or from a television show, these artifacts matter because they change our perceptions (Castleberry, this vol.).

This last point is especially important: theories change our perceptions. Recent social theory has even changed our perception about the majority of you reading this book: most of you are the generation broadly called "millennials."

By now you're probably familiar with this generation's supposed characteristics. If you were born after 1982, you're described as "technologically sophisticated multitaskers, capable of significant contributions to tomorrow's organizations, yet deficient in communication skills" (Hartman & McCambridge, 2011, p. 22). It has even been argued that, due to increased exposure to technology, members of the cohort most likely have actual neurological differences compared to their parents—and professors (Prensky, 2011).

When it comes to communication, millennials sometimes get a bad rap. There is widespread concern that, despite their electronic savvy, today's college students who are "digital natives" have less-developed interpersonal skills (Milliron, 2008). It is unclear whether millennials' communication truly is deficient, or if the nature of communication simply has to change. For instance, if millennials uniformly believe that ending a romantic relationship via text message is acceptable, then is that action really deplorable? Will it still be considered a breach of etiquette in 20 years, or will it be the norm? These are questions we are just starting to ask, bearing in mind that there is great diversity among the group we call "millennials" (there's some "troubleshooting" for you).

Characteristics of a generation have to be neutral to some extent: people are shaped by historical events and by their environments, among many other things. So it is helpful to meet a generation of students with *appreciation* for the differences they may have from their professors. Millennials show, for instance, a preference for an "informal style" of communication (Krader, 2010, p. 9), something that creates a bit of a generation gap today on college campuses, where many professors hail from the more formal Boom Generation and Generation X (Elam, Stratton, & Gibson, 2007).

What this book tries to do, in part, is blur the lines between generations. In the following chapters, we try to build upon what both parties already know. Writing relatively informally (like a college lecture), we discuss communication theories by applying them to "artifacts" of popular culture. Andrew Cole and Bob DuBois, for instance, explore the concept of "noise" through episodes of *The Walking Dead*. As they write to explain their project:

> We often learn more effectively, and remember information longer, when abstract concepts ... are made more real and personally relevant (Brown, Roediger, & McDaniel, 2014). For that reason, examples from popular media can be useful in helping us understand new concepts (Cole & DuBois, personal communication, 2015).

These labels—"artifact" and "text"—are useful for TV shows like *The Walking Dead* or *Breaking Bad*. In this book, the terms apply to films, technological forms, and literature, as well. Dr. Castleberry's thoughts on his essay are helpful here, again, explaining exactly what we mean in the field of communication by "artifact" or "text":

These words are both strategic and interchangeable. Barry Brummett (2010) sees a *text* as specific kind of *message* that performs a specific kind of work. Thus when referring to materials like TV shows as texts, we are recognizing the persuasive and thus rhetorical values that they carry. In the communication field ..., learning to *read*—or "close read" as Brummett might say—a text for its rhetorical values helps elevate our ability to move from passive consumers to active audiences (Castleberry, personal communication 2015).

The authors in this book have selected texts and artifacts they know appeal to members of the millennial generation. Some of the authors—graduate students Gerald Hickly, Joe Hatfield, and Jake Dionne—are themselves millennials. Others are "Generation Xers" who clearly share affinities for the media favorites of the younger generation. For instance, Kelli Smith and Pixy Ferris analyze one of the most prominent phenomena of the millennial period: Harry Potter. Likewise, Claudia Bucciferro shows expert knowledge of *The Hunger Games* trilogy—"young adult" novels that truly deserve their broad, intergenerational audience. In that sense, this book is not just for millennials. If you were born before 1982, you'll find useful discussions of theory merged with familiar texts from hip-hop, *X-Men*, and *The Lord of the Rings*, along with *Parks & Recreation* and *Scandal.*

Fields of Communication Theory

This book is arranged in four parts, based on the settings and forms communication takes.

It begins with the roots of the communication discipline. The ideas you are learning about communication today began in ancient Greece, with the philosophers who discussed **Rhetoric** (Part I). Of course, communication itself existed long before that, all over the world and in many forms. But the origins of contemporary media theory, for example, can be found in the very first form of "mass communication": public speaking.

Greek city-states between 500 and 300 B.C. were marvelous experiments in forms of government and public interaction. In Athens, the city-state often termed the birthplace of democracy, there was one way of reaching "the masses," and that was to be a commanding speaker. Those who wished to be heard stood in the Athenaeum and used their voice to persuade the crowd. Imagine what it was like to share ideas with no printing press, no radio, no television, and no Twitter.

We may think that the modern forms of mass media that I just listed—from the printing press to Twitter—have made public speaking irrelevant. But they haven't. Instead, these marvels of technology simply allow the spoken word to travel much farther and faster. A public speaker in the Athenaeum in 323 B.C. had little choice but to project his voice and keep the crowd interested, if he wanted to share an idea. He hoped they might then continue the discussion. Today, speeches are broadcast across the entire planet instantly. And if the Twitterverse disagrees with any part of the speech, well, that seems to travel even faster. So rhetoric is still crucial to the way global politics are conducted (see the examples of ethos in Elena Strauman's chapter), and to the way we shape identities in smaller communities (see the chapter on epideictic rhetoric).

Particularly in the United States, public speaking is highly valued. Nancy Bressler's chapter offers some tips from your favorite TV shows, on how to use nonverbal communication in your public speaking. But rhetorical theory extends beyond public speaking, as chapters on Kenneth Burke's theories (by Gerald Hickly, Jake Dionne, and Joe Hatfield) will show in this first section.

The broadening of persuasion beyond public speaking and into other cultural forms has impacted critical and cultural studies in communication. Part II, **Culture**, thinks about this term in its broadest sense, not diversity or exoticism. Everyone is part of a culture. For communication, culture can be thought of as the symbolic systems, framed by institutions (like education, law, religion, and healthcare), that arise from and enhance a group of people's identity, history, beliefs, and worldviews. Krystal Fogle and Claudia Bucciferro, in their chapters, show how groups assign meaning to human experience through symbols and themes.

Cultural studies, as a field of theories, assumes that culture is *not fixed*: culture is created by people in interaction. For instance, I said above that culture's symbolic structures arise in part from history. But history is more than just a sequence of events: it's the way a group of people remembers and discusses those events. Some happenings are important to a group and add to their sense of identity. Others do not, and they are forgotten—no one speaks of them. Or they argue about and critique those events. Most critical approaches are marked by "deconstruction," as readers will see in chapters on the postmodern nature of hip-hop (by Hunter Fine), hegemony and counter-hegemony in *Frozen* (by Janelle Applequist), and Muted Group theory through several Pixar films (by Bruce Finklea and Sally Hardig).

Part III, on **Media and Technology**, is an extension, in many ways, of the arguments about "culture" in the previous section. The artifacts these authors chose may have more immediacy, because of rapidly shifting technology. Overall, they are marked by an interpretive approach in communication known as *media ecology*. "Media" are simply the forms intentional messages take, while "ecology" relates to its familiar sense in ecological systems: media ecology treats media as an environment.

From this perspective, media and technology can be seen as the ways we organize not just information, but *knowledge*. Chrys Egan and Andrew Sharma offer a chapter analyzing the way advertising has changed, through hashtags, in the new millennial media environment that includes Twitter. Brian Gilchrist and Brent Sleasman offer similar insights in their respective chapters on the smartphone, and zombie metaphors. Interaction with this media environment takes forms that impact other forms of communication, too, including the parasocial. These ideas are explored in chapters by Paul Lucas and Linnea Sudduth Ward.

Finally, Part IV of the book, **Interpersonal Communication**, concerns the interaction between two people—a dyad. Perhaps it's a sign of the times that this section is a bit smaller: most professors offering chapters in this book wanted to write about media and technology when thinking of the millennial generation. But that may make interpersonal communication theory all the more important for millennials: there is growing concern that the interpersonal etiquette and skills that older people expect of millennials are not being met by today's college students. Returning to the basic theories of interpersonal communication will be useful, as seen in Alysa Ann Lucas's chapter on *Pretty Little Liars*. Whether millennials will change the face of communication or not, there are still multiple generations who need to communicate with one another. I believe you will find that these interpersonal theories are still applicable to how we interact with people, even if that's online or mediated. Sara Trask and Holly Holladay's chapter about *Catfish* is especially interesting, since it shows how the internet has made interpersonal deception easy and widespread (even to the point that it has its own noun: "Catfishing").

Some Final Pointers

It has been said that communication is one of the few truly "hybrid" fields of study, since its theories arise from both quantitative and qualitative perspec-

tives. Many scholars use the methods of social science: surveys, experiments, and statistics—and are thus quantitative. The writers in this book work from the other perspective: we are interpretive and critical scholars, looking at the qualities of a text or artifact, rather than at the numerical outcomes of a survey. In that sense, this book is not exhaustive. The 20 chapters cover a range of humanities theories in multiple communication fields, although there are other interesting approaches not explored in this volume.

There is a certain value to interpretive and critical work that you can't find in quantitative studies. While social scientists want to *predict* human behavior, humanities scholars like the ones in this book are striving to *understand*. We value free will and variance among humans in the ways they behave. Nonetheless, we encourage you to embrace both perspectives as much as you can. If you want to work in marketing as a communication professional, for instance, it's important to get the qualitative data—to understand who your customers really are as individuals. On the other hand, in a moment of crisis, you'll be glad you know the value of surveys for quick snapshots of your public. So, go beyond this book in looking for theories.

Perhaps because we value free will and variance, we don't all use the exact same wording for definitions, or approach our theory "troubleshooting" in the same way. You'll see multiple definitions for "rhetoric," for instance, after reading a few chapters. We believe that there are many ways to view such a broad human phenomenon, and that our differential definitions complement rather than contradict one another. You'll also see "dialogue boxes," written by millennial students, responding to chapter authors' ideas. These may be helpful for sparking your own thoughts and discussions.

Finally, the authors of these essays don't assume that all our readers are as obsessed with our favorite artifacts as we are. We have written our pieces to give you enough understanding of a TV show, movie, book, or musical artist that you can follow along with theoretical explorations. That means, yes, there are some spoilers! Thank goodness you can stream season one of *Game of Thrones* if you really need to. Happy reading!

References

Brown, P. C., Roediger, H., & McDaniel, M. (2014). *Make it stick: The science of successful learning*. Cambridge, MA: Harvard University Press.

Brummett, B. (2010). *Techniques of close reading*. Thousand Oaks, CA: Sage.

Castleberry, G. (2015). Understanding Stuart Hall's Encoding/Decoding Model through TV's *Breaking Bad*. In K. G. Roberts (Ed.), *Communication theory and millennial popular culture: Essays and applications* (pp. 100–116). New York, NY: Peter Lang.

Cole, A., & DuBois, B. (2015) "Don't Open, Dead Inside"—External and Internal Noise in *The Walking Dead*. In K. G. Roberts (Ed.), *Communication theory and millennial popular culture: Essays and applications* (pp. 232–43). New York, NY: Peter Lang.

Elam, C., Stratton, T., & Gibson, D. D. (2007) Welcoming a new generation to college: The millennial students. *Journal of College Admission*, Spring 2007, 20–25.

Hartman, J. L., & McCambridge, J. (2011). Optimizing millennials' communication styles. *Business Communication Quarterly*, 74(1), 22–44.

Krader, C. (2010). Mentoring the millennial mind. (Cover story). *Ophthalmology Times*, 35(22), 1–9.

Milliron, V. C. (2008). Exploring millennial student values and societal trends: Accounting course selection preferences. *Issues in Accounting Education*, 23, 405–19.

Prensky, M. (2011). Do they really *think* differently? In M. Bauerlein (Ed.), *The digital divide* (pp. 12–25). New York, NY: Penguin.

Part I

Rhetoric

CHAPTER 1

Improving Your Speech Delivery with *Modern Family* and *Friends*

Nancy Bressler

This chapter examines some principles of public speaking, especially how nonverbal cues can be used to enhance or diminish credibility while speaking. Using some basic public speaking texts and analyses of speeches from two popular sitcoms—*Modern Family* and *Friends*—I will illustrate in detail several ways in which good nonverbal communication can affect your credibility while giving a speech. First, I will introduce the TV shows and a specific episode from each. Then the chapter will discuss how credibility is perceived in public speaking. Finally, I will demonstrate how each nonverbal speaking principle influences the credibility of the speaker, and offer examples from the TV sitcoms. Let's get started with *Modern Family*.

Modern Family

The ABC domestic sitcom *Modern Family* (2009–present) has proven to be a major ratings draw, with 12.6 million viewers and a 4.2 rating with adults 18–49 for its pilot episode (Hibberd, 2010). *Modern Family* is an unconventional family sitcom that uses a "mockumentary" format. A mockumentary is a genre of media that looks and sounds like a documentary, but within the context of a fictional program (Hight, 2001). A single camera follows the action, focuses in on characters' expressions, and frequently cuts away from the show to provide the audience with more details about the characters' true thoughts and feelings (Wilson, 2010). In a mockumentary, characters can break the fourth wall by making eye contact and even looking directly at the camera (Detweiler, 2012). As *Modern Family*'s executive producer, Christopher Lloyd, remarked in an interview: "There are little discovered moments we can point to, where in a standard comedy you'd have to indicate that to the audience more" (Wilson, 2010, para. 8). Consequently, the mockumentary is an excellent way to examine how the characters' elements of speech delivery are effective, or hinder their overall message.

Modern Family focuses on three very diverse families that are all related to one another. Jay Pritchett, an upper-middle-class business owner, is the patriarch of this extended family. Six months before we meet these characters, Jay remarries a younger Colombian woman named Gloria, who has a

10-year-old son, Manny. Jay's daughter, Claire, embodies the traditional nuclear family. Claire, a stay-at-home mother when the series begins, is married to Phil Dunphy, a realtor, and they have three biological children: Haley, Alex, and Luke. Claire's brother is Mitchell Pritchett, a lawyer, who is in a long-term relationship with his partner, Cameron Tucker. In the pilot episode, the two adopt a baby girl, Lily.

One of the plots within the third season focuses on Claire's desire to run for town council. When she perceives her neighborhood to be unsafe, because of drivers speeding through the streets, Claire decides to petition for a stop sign; but her request is not taken seriously by local government. So she runs for town council. In order to compete with her opponent, Claire prepares for the election debate with the help of her family, in episode 13: "Little Bo Bleep" (Chupack & Koch, 2012). This two-minute scene from the episode demonstrates the importance of nonverbal behaviors, in aiding a speaker's credibility.

Friends

From 1994 to 2004, *Friends* aired on Thursday nights on NBC. Immediately following its premiere, the show rarely dropped below 19 million viewers a week. Thus, *Friends'* popularity and cultural impact were significant from the beginning. The show lasted for ten seasons, winning more than 60 Primetime Emmy Awards, including Outstanding Comedy Series in 2002. When the series aired its finale in May 2004, it was the most-watched series episode of the decade ("Friends finale," 2009).

Friends featured a group of six friends who live in New York City. The sitcom aired at a time in television history when comedies were considered "shows-about-nothing." *Seinfeld* (1989–1998) started this sitcom trend, of idealistic representations of the American family being replaced by young, white friends, who lived in the city and embodied "the comical consequences of life in a world void of any ultimate significance or fundamental meaning" (Hibbs, 1999, p. 22). The main characters in *Friends* are Monica Geller, a chef, and her brother Ross, a paleontologist. In the first episode of the series, their childhood friend, Rachel Green, returns to their lives. Monica and Rachel were close in high school, while Ross had a crush on Rachel. In the pilot episode, Rachel calls off her wedding on the day of the ceremony, runs away, and moves in with Monica. Chandler Bing and Joey Tribbiani live across the hall from them, and towards the end of the series, Chandler and

Monica develop a romantic relationship. Monica's former roommate, Phoebe, is also part of the group.

Each episode of the series starts with the same phrase "The One ...," a clever play on the vernacular way in which television fans discuss episodes of their favorite shows ("Did you see the one where Jesse starts taking pills to help her stay awake and get into Stanford?"). During season 8 of *Friends*, episode 18 is titled "The One in Massapequa." In this episode, the group gathers together for Ross and Monica's parents' 35th wedding anniversary party. Even though Ross has traditionally given the toast, Monica insists that she can deliver an equally memorable speech. In her attempt to give an emotional and sentimental toast that will leave her audience in tears, Monica desperately uses every verbal and nonverbal ploy to persuade her audience that she is a great speaker. Because of her exhaustive and exaggerated use of nonverbal behavior, Monica's toast from *Friends* is an excellent case study in speech delivery techniques.

Now that you are familiar with the specific episodes I will discuss, let's define "credibility," and its role in the elements of an effective speech.

Credibility Factors

A key component of delivering an effective speech is that the speaker be perceived as credible by the audience. **Credibility** is the audience's assessment of whether or not they can believe the speaker's message. Since an address delivered in person includes a visual component, it is up to the speaker to incorporate nonverbal cues that aid in his or her credibility with the audience, and do not detract from it.

Credibility is usually determined by four main factors: competence, trustworthiness, dynamism, and composure (Gass & Seiter, 2007; Pornpitakpan, 2004). First, **competence** is the information that the speaker provides during his or her speech. If the speaker can demonstrate to the audience that she is familiar and fluent with the information being presented, she is often perceived as more credible. Second, **trustworthiness** relates to how open and honest the audience perceives the speaker to be. If the audience does not believe the speaker is being truthful, most elements of the message will be lost. Third, **dynamism** is the eagerness and passion about the topic displayed while speaking. If the speaker is energetic, the audience will perceive him as more engaging, and, by association, the topic as more compelling. Finally, **composure** registers as the extent to which the speaker remains steady and

consistent while delivering the speech. Even though aspects of the speech may challenge the speaker's plan, such as a disruptive audience member, technological issues, or nerves, the ability of the speaker to overcome these obstacles reflects on his or her composure (Rothwell, 2013).

Nonverbal Behaviors During a Speech

Given these four dimensions of credibility (Rothwell, 2013), we will now discover how credibility is earned and diminished through a speaker's nonverbal behaviors during an address. The rest of this chapter will focus on nonverbal behavioral categories of speech delivery, including: eye contact, facial expressions, gestures, movement, posture, vocal delivery, and personal appearance (Beebe, Beebe, & Ivy, 2012). Using the examples from *Modern Family* and *Friends,* we will now examine how each nonverbal behavior contributed to, or hindered, the speaker's message. These examples also provide insight at two stages of the speech process: development (Claire, from *Modern Family,* is still preparing and practicing her speech), and execution (Monica, from *Friends*, is delivering her speech in front of an actual audience).

Eye Contact

Maintaining **eye contact** during a speech is crucial, because it determines whether the speaker is able to make a connection with his or her audience members. Even if the speaker tries to avoid the audience members, they can still see her. Therefore, engaging with as many audience members as possible makes them feel included in the communication process. Eye contact is also crucial for establishing credibility, because it aids in the speaker's competence. For example, throughout the scene, Claire maintains eye contact with her children, who are acting as her audience. Since Claire believes in her message (that a stop sign in the neighborhood would create a safer environment), she utilizes eye contact to demonstrate that she is confident and knowledgeable about this issue. While Claire maintains great eye contact with her audience when providing answers, she exercises poor eye contact when her opponent (impersonated, in this practice round, by her husband) answers his questions. She frequently rolls her eyes at his responses, demonstrating a lack of composure. Her audience (i.e., her children) notice and call attention to her nonverbal communication. This example demonstrates how

Claire was not aware that her nonverbal eye-rolling was diminishing her credibility because of her lack of composure.

In contrast, Monica does not maintain good eye contact throughout her speech. Rather than engage the rest of the audience in her message, Monica glances around the room, but primarily focuses on her two parents. Because her parents are the main focus of the speech, it might seem reasonable for Monica to focus on them. However, she is lacking dynamism when she avoids the other audience members in the room. While the topic of her speech is her parents, Monica's audience is the entire room. By avoiding eye contact with most of her listeners, Monica seems uninterested in their presence.

Facial Expression

Because of the intricacy of the human facial muscles, a speaker's face conveys more information than any other nonverbal channel (Beebe et al., 2012). Drawing on all of these muscles at once, a speaker's **facial expressions** are crucial to his believability. Therefore, an effective speaker should strive to match her facial expressions with the overall tone of the speech. In addition, the speaker's facial movements should vary throughout the speech, as different ideas and topics are presented.

Just a few seconds into her practice speech, Claire disrupts her message by frowning and pursing her lips. Her daughter Haley comments, "Don't purse your lips like that. It makes you look annoyed." While Claire is appearing to act serious and concerned with the issues that she will discuss during the speech, her audience members have already observed that Claire's facial expression does not match the topics at hand. Claire demonstrates aversion to her family's critiques, rather than attention to the issues.

Monica also displays ineffective facial expressions while delivering her speech. About a minute into her toast, Monica says "When I look around this room, I'm saddened by the thought of those who could not be with us." When Monica delivers this heartbreaking line, she smiles at the end of the sentence. Her smile contradicts the implied, touching sentiment of her words. Someone who is truly depressed at the thought of lost loved ones would not be smiling in this moment. Thus, Monica's trustworthiness and sincerity is questioned. Because her facial expression (smiling) does not complement the poignant moment in her speech, Monica implies dishonesty.

Gestures

When a speaker uses movements of his or her head, arms, or hands to articulate meaning, the speaker has engaged in **gestures** (Beebe et al., 2012). Gestures can be used by the speaker to highlight and accentuate key ideas in the speech. As Motley (1995) advocated, gestures should appear spontaneous and effortless: "In natural conversation, we use gestures every day without thinking about them. And when we do consciously think about gestures, they become uncomfortable and inhibited" (p. 99). Thus, gestures while delivering a speech should look natural and unplanned, even though the speaker should strategically associate his gestures with important ideas.

During the *Modern Family* scene, Claire's efficacy depends on the specific gestures in her speech delivery. When her daughter asks how Claire would serve effectively on the town council, Claire prepares the following answer: "If elected, I would consider all opinions and not ignore those of the opposition as Councilman Bailey has done for six terms." After she concludes her statement, Claire emphatically nods her head. This gesture of nodding her head emphasizes the confidence that Claire has in her answer. She is clearly knowledgeable about how the town council works, and her gesture of nodding her head highlights her competence in this area.

However, Claire also demonstrates, once again, a lack of composure in her gestures. As her children and husband continue to critique her nonverbal speech delivery, Claire becomes increasingly frustrated by their remarks. As her aggravation at their comments increases, so do Claire's gestures. She frequently shakes her head or waves her arms around, with no relationship to any aspect of her speech. Instead of highlighting a key feature of her message, these gestures underscore her frustration and lack of composure. Each wild gesture further decreases Claire's credibility, because self-control has eluded her.

Monica, from *Friends,* also begins her speech with excellent gestures, but reduces them as her speech continues and her frustration grows. As she concludes the introduction to her toast, Monica states, "I know I probably don't say it enough, but ... I love you." Immediately following the statement, Monica puts her hand to her check as if to simulate catching a tear. Monica includes this gesture here to highlight the sentimental meaning of that particular part of her speech. Through this gesture, Monica embodies dynamism, by exhibiting the emotional connection she has with her parents.

Similarly to Claire's speech, Monica's gestures also decrease in meaning as she becomes frustrated with her audience. While Monica begins by displaying the emotional significance of her speech, her audience's lack of response to her sentiment begins to frustrate her. This leads to an increase in arm and hand movements that have no connection to any messages in her toast. Just like Claire, these awkward movements diminish Monica's credibility, because they demonstrate her lack of composure.

Movement

Similar to gestures, movement within a speech should also have a connection to a key idea within the message of the speech. Movement, or changing location, should have a purpose connecting to the main ideas or organization of your speech. For example, if there is a key idea you wish to highlight, some movement indicates to your audience that this is a crucial aspect. You could also use movement to organize your speech by underscoring a transition to the next main idea. While many communication researchers would argue that no movement is better than random movement, Claire's lack of movement through the scene also weakens her dynamism. While she incorporates gestures into the speech, Claire rarely moves from behind her pretend podium. The only time that she demonstrates movement in her delivery is when she angrily walks off because of her audience's criticisms. This lack of dynamism ultimately diminishes her credibility, as well. Claire appears to lack any energetic movements that would indicate her passion and commitment to her topic.

By contrast, Monica does demonstrate movement as a way of transitioning to the next main idea in her speech. After discussing the loved ones that had passed away and could not make it to her parents' anniversary party, Monica asks an audience member to pass around a picture of these family members. She moves to the edge of the stage and hands the person the picture. As she moves back to the microphone, she switches to the next main idea of her speech. Consequently, Monica's use of movement serves as a transition between the last idea she spoke of (missing loved ones) and her next subject (movie scenes that depict love). This organization ultimately portrays Monica as a more competent speaker.

Posture

A confident and credible speaker should also demonstrate an upright posture. While your posture should not be rigid and inflexible, it should be confident. A credible speaker is able to avoid slumping over a podium or chair. In her scene, Claire struggles with poised posture, which betrays her lack of self-assurance. She frequently leans down to the makeshift podium, with a hair-brush tied to it, to simulate a microphone. Her husband, Phil, encourages her to stand up straight and not speak into the "microphone." Yet, later in the scene, Claire finds herself bending toward the hairbrush again. Ultimately, this gives the audience the impression of fear. Claire's composure—and thus credibility—is weakened.

In comparison, even as Monica becomes more frustrated with her audience, she never loses her posture. Monica is using a real microphone to project her voice during her speech, yet she never slouches down to it. Unlike Claire, even though Monica becomes increasingly agitated by her audience's response to her speech, she does not allow it to affect her posture or her composure. Thus, in contrast to Claire, Monica's credibility is not hindered by her posture.

Vocal Delivery

A speaker's **vocal delivery** is judged on how well he or she is understood, and to what extent the speaker talks with variety in his or her delivery. For example, if a speaker keeps his pitch the same throughout the speech, he is considered monotone. A monotone speaker gives the impression of indifference about the topic of the speech, and lacks the dynamism needed to discuss it. A speaker who presents at an incredibly fast rate gives the impression of self-consciousness under scrutiny, and thus seems less confident in the message and less competent about the topic. A speaker who interrupts the speech with "ums" and "ahs" lacks the smoothness needed to convey competence. Volume, pitch, rate, and fluency all contribute to the impact of a speaker's vocal delivery.

Claire maintains a sarcastic tone throughout most of the speech preparation. At moments of annoyance, the pitch of her voice climbs as she makes a sarcastic comment towards her audience who are trying to prepare her for the debate. However, Claire's most noteworthy moment of ineffective vocal delivery comes when her daughter, Alex (who is pretending to be the moderator of the debate) asks her, "So, Mrs. Dunphy, why are you running for local

office?" Claire responds, "Ok, um, that's good. I, um …" Alex responds, "Mom, you really shouldn't stutter over a basic question like that. You should at least know why you are running." Claire has clearly demonstrated her lack of knowledge on the subject, in that instance. Alex immediately points it out to her, because Claire's credibility has been significantly reduced in that moment. Her deficiency of awareness on the fundamental question of why she is running for political office deeply affects her audience's perceptions about her competence.

Monica's vocal delivery remains mainly effective throughout the scene. Even though her audience fails to respond in the way she hoped, Monica maintains a consistent volume and rate throughout her speech. She also speaks slowly enough for her audience to hear every word she says. At the very end of her speech, however, Monica becomes so irritated that the pitch of her voice rises. She raises her champagne glass and shrieks "Here's to Mom and Dad. Whatever!" In this final moment, Monica's credibility decreases, because she is unable to maintain her composure.

Finding Humor in Nonverbal Delivery Techniques

During the scene from *Modern Family*, as her family is pointing out her errors, Claire remarks, "Some of this is subjective!" While she has a point, that it is the personal interpretations of her audience that determine whether her nonverbal behavior is effective or not, the credibility of the speaker still lies in the audience members' interpretations. The audience ultimately determines if a speaker is credible. And as these scenes demonstrate, credibility is directly influenced by nonverbal delivery techniques.

Throughout this chapter, we have found humor in the effective or deficient nonverbal cues of Claire Dunphy's and Monica Geller's speeches. The sitcom actors deliver embellished, comedic performances that enhanced their nonverbal delivery more than the serious and subtle efforts of professional speakers. Yet, these humorous examples do highlight how nonverbal delivery aspects can accentuate or obstruct a speaker's credibility with his or her audience. By constructively evaluating speech deliveries on popular sitcoms, these scenes display the importance of nonverbal delivery techniques in enhancing a speaker's competence, trustworthiness, dynamism, and composure during an address.

Keywords from This Chapter

Competence
Composure
Credibility
Dynamism
Eye contact
Facial expressions
Gestures
Trustworthiness
Vocal delivery

References

Beebe, S. A., Beebe, S. J., & Ivy, D. K. (2012). *Communication: Principles for a lifetime.* Boston, MA: Pearson.

Chupack, C. (Writer), & Koch, C. (Director) (2012). Little bo bleep. [Television series episode]. In P. Corrigan, S. Levitan, C. Lloyd, D. O'Shannon, B. Walsh, B. Wrubel, & D. Zuker (Producers), *Modern Family.* Los Angeles, CA: Lloyd-Levitan Productions & 20th Century Fox Television.

Detweiler, E. (2012). "I was just doing a little joke there": Irony and the paradoxes of the sitcom in *The Office. Journal of Popular Culture, 45*(4), 727–748.

"Friends" finale is decade's most-watched TV show. (2009, December 4). *Chicago Tribune.* Retrieved from: http://www.chicagotribune.com/

Gass, R., & Seiter, J. (2007). *Persuasion, social influence, and compliance gaining.* Boston, MA: Allyn & Bacon.

Hibberd, J. (2010, November 30). Massive premieres for "Cougar Town," "Modern Family." *The Hollywood Reporter.* Retrieved from: http://www.hollywoodreporter.com/

Hibbs, T. S. (1999). *Shows about nothing: Nihilism in popular culture from the* Exorcist *to* Seinfeld. Dallas, TX: Spence Publishing Company.

Hight, C. (2001). Television mockumentary: Reflexivity, satire, and a call to play. Retrieved from: http://www.waikato.ac.nz/fass/mock-doc/teaching.shtml

Motley, M. T. (1995). *Overcoming your fear of public speaking: A proven method.* New York, NY: McGraw-Hill.

Pornpitakpan, C. (2004). The persuasiveness of source, credibility: A critical review of five decades. *Journal of Applied Social Psychology,* 34, 243–81.

Rothwell, J. D. (2013). *In the company of others: An introduction to communication* (4th ed.). New York, NY: Oxford University Press.

Tibbals, P. (Writer), & Halvorson, G. (Director) (2012). The one in Massapequa. [Television series episode]. In K. S. Bright, T. Cohen, D. Crane, S. Goldberg-Meehan, M. Kauffman, A. Reich, & S. Silveri (Producers), *Friends.* Los Angeles, CA: Bright/Kauffman/Crane Productions & Warner Bros. Television.

Wilson, B. (2010, September 19). We are family. *The Sunday Times.* Retrieved from: http://www.thesundaytimes.co.uk

Reading this chapter brought back memories of learning how to give presentations back in high school. The teachers taught us how to create a presentation that will not only inform, but also entertain the audience on the point that we were trying to make. The author of this chapter does point out valid components of delivering a speech: competence, trustworthiness, dynamism, and composure, along with nonverbal behaviors, all of which are essential in giving a well-thought-out speech. I agree with these components, because it was everything that was covered in my English classes and in public speaking courses.

When reading the main ideas of this chapter, I saw a connection, similar to the author's points about episodes of *Modern Family* and *Friends*, to an episode of *The Office*. In episode seventeen of season two of this "mockumentary," Dwight Schrute is being honored with an award and has to give a speech. Naturally, Dwight's boss, Michael Scott, decides to give him some pointers on how to give his speech. However, when one watches this episode, it does not take long to realize that his pointers are what not to do when giving a speech. Once Dwight discards these suggestions and gives his own speech, the points that the author has made in this chapter are apparent in the way Dwight delivers his speech to his audience.

Overall, this chapter gives an insight on components of speech delivery shown in past and present television shows. I feel that this is a sufficient way of delivering the message of what to do and what not to do when giving a speech, because the targeted audience will be able to relate to the characters and take away what points are being made. In today's society, the more that a topic can relate to popular interests and ideals, the more interested the audience becomes, which results in retaining the information given.

—Emily Grecco

Life as Performance—Dramatism and the Music of Lady Gaga

Jake Dionne & Joe Hatfield

"I want your drama," sang Lady Gaga in her hit song "Bad Romance." Gaga's need for "drama" marks a particular communication phenomenon. Rather than running from drama, which some might see as draining or destructive, Gaga embraces it as a necessary component of her life. Accordingly, *life as drama* becomes a metaphor, a vehicle through which we can explore Gaga not only as a pop star, but also a communication goddess.

Many years prior to Lady Gaga's fame, Kenneth Burke, a literary critic, argued in favor of a new model for life: *life as drama*. He did not consider life itself dramatic, but rather thought that exchanges between communicators and audiences were similar to plots unfolding on stage. Every great drama needs a script, and Burke knew that. Consequently, Burke (1973) famously observed that literature was "equipment for living" (p. 61). In the context of this discussion, literatures, or **artifacts**, are not just books; they are also other creations, like movies, music, and speeches. What is most important is the fact that the artifacts we interact with *reflect* communication and society, *train* us how to communicate, and *provide tools* needed to adapt to different situations.

Burke was not satisfied with observing communication, as it unfolded between communicators and audiences. He also sought to reveal, within the drama of life, the motive behind human actions on the world's stage. Burke (1969b) contended that any given number of motives drive communicators to use certain words, talk in particular ways, and, ultimately, persuade audiences to act. For Burke, this was how **rhetoric** occurred—an endless process of communicators *motivating* audiences into action. Since he developed these essential theories, competent communicators have applied Burke's observations to their own dramas, in order to better interact with audiences.

Henceforth, we will focus on Burke's theory of dramatism—*life as drama*. **Dramatism** is not only an orientation that communicators can adopt, to help them better assess their effectiveness in exchanging messages with audiences, but also a metaphor which will help locate the motive behind other communicator's words. Central to dramatism is its relationship to the following concepts: identification, guilt-redemption, and the pentad.

Unlike Burke, we live in the *Age of Gaga*. In an effort to demonstrate the relevance of dramatism and its associated terms, we turn to Gaga and examine her music, as artifacts by which we might determine motives in her dramas. Set apart by fame, Gaga communicates with her fans through her records, social media accounts, and interviews. Given the scope of her career, keep in mind that the artifacts we have chosen are not the only pieces from Gaga that can be analyzed. Without further delay, we invite you to watch a concert as we, through the lens of Burke's theories, highlight the concepts of identification, guilt-redemption, and the pentad, in "Born This Way," "Applause," and "Paparazzi," respectively.

Identification and "Born This Way"

Although Gaga's success is largely due to her unmatched creativity, her relationship with her fans helps bolster her fame. During *artRAVE: The ARTPOP Ball*, her concert tour for ARTPOP, Gaga candidly said, "When I'm long gone, they'll say she was special, but her fans were really something" (@LadyGagaNowNet, 2014). The loyalty of her fans, affectionately known as "Little Monsters," offers a glimpse into the relationship between communication and identification.

To better understand why the Little Monsters worship Gaga, we must recognize the divide between celebrity and audience. Burke (1969b) observed that humans, regardless of their perceived similarities, are divided and separate from one another. Consequently, we spend much of our lives trying to reconnect and become one with our everyday audiences. At its most basic level, **identification** is a process of persuasion, by which humans achieve this shared connection and thus become whole through one another. Regarding identification, Burke (1969b) wrote, "You persuade a man only insofar as you can talk his language by speech, gesture, tonality, order, image, attitude, idea, identifying your ways with his" (p. 55). In other words, for Gaga to persuade her audience, identification—a shared connection—must exist between the sender and receiver of messages.

But identification is much more complex than simply connecting with audiences. Gaga certainly knows that it is not enough simply to sing the tunes her fans adore. Rather, Gaga must dance to these tunes, in ways that do not adversely affect the sound. As Burke noted, even though communicators seek to identify themselves with certain audiences, they might also be identified with larger collectivities, ideologies, or systems of power. For example,

Gaga, as a musician, identifies with the record industry, which is a money-driven enterprise. Consequently, Gaga is identified with capitalism. Although she praises her music as art, she is still connected to an industry focused on producing capital. This is not to say that Gaga is only interested in accumulating wealth, but instead to point out how her desire to be an artist is complicated, in terms of identification. As both an artist and an employed musician under contract, Gaga has a dual relationship with her fans. Her Little Monsters support Gaga through not only love and affection, but also through money.

Likewise, Lady Gaga has long been an outspoken advocate for LGBT equality. Accordingly, LGBT members comprise a large demographic of her Little Monsters. In 2011, Gaga released "Born This Way," a chart-topping anthem celebrating difference and individuality. Inherent in the song title is a play on the "born this way" narrative often told by members of the LGBT community. Gaga sings, *"No matter gay, straight, or bi / lesbian, transgendered life / I'm on the right track baby / I was born to survive."* The cathartic theme of overcoming adversity struck a cord with audiences, and through this song, Gaga identified with her Little Monsters.

Identification in "Born This Way" can be taken a step further. Not only does Gaga identify with her LGBT-identifying Little Monsters, she also identifies with larger ideological structures concerning LGBT rights. Gaga sings, *"I'm beautiful in my way / 'cause God makes no mistakes / I'm on the right track, baby / I was born this way."* Here we see Gaga's language connect to religion, science, and the whole LGBT equality movement. Identifying with all three forms of power through her material song, Gaga becomes **consubstantial**—of the same substance—with those who believe in the same way she does. Burke (1969b) maintained that only through identification could persuasion occur. Extending Burke's assertions, Day (1960) explained, "[Burke] considers things to be 'consubstantial' if they are united or identified in common interest ..." (p. 271). The unifying interest or "substance," as Burke (1969b) called it, that binds together Gaga and her fans, is the song "Born This Way" (p. 21). In all, Gaga's language is action in the world; as she shares common beliefs with her fans, she connects person-to-person, through identification.

Guilt-Redemption and "Applause"

In her pursuit to identify with her fans, **guilt-redemption** forms the over-arching purpose for communication (Burke, 1984). Of what might Gaga be guilty? Here we turn away from "Born This Way," and listen to a more recent track. "Applause," a song from Gaga's third album, further showcases her fervent relationship with dramatism. Through "Applause" and its accompanying music video, Gaga offers commentary on her status as a celebrity, her connection to her Little Monsters, and, most importantly, the status of *perfect* fame that she desires: *"Give me that thing that I love / put your hands up make 'em touch."*

We intentionally use the word "perfect." Burke (1966) considered communicators to be "goaded by the spirit of hierarchy" and "rotten with **perfection**" (p. 16). Communicators, separated from one another in terms of various structures, like class, gender, race, sexuality, and species, are interested in climbing social ladders. For instance, as we write this chapter, we are more interested in being global pop stars, than in discussing one. In other words, from our vantage point, Gaga is perfect. In our everyday lives, we all set goals and present ourselves in terms of what it means to be perfect in particular settings. Whether or not we reach perfection is irrelevant. Regardless, we continuously strive for this perfection (hence, we are "rotten" with it), and when we do not attain it, we are left with a sense of guilt.

Burke (1984) argued that the ultimate motive of human communication was the purging of guilt. **Guilt** is the ever-present anxiety, brought about by social standards that motivate communicators to behave in certain ways. Burke asserted that communicators create drama by disrupting, resisting, or altogether rejecting **hierarchies**. By this, he meant that communication divides the world into right/wrong, good/bad, this/that, or even, famous/average. As a result, when one does not align with a dominant social hierarchy, she or he experiences guilt. To overcome such a negative feeling, one purges himself of the guilt by placing blame elsewhere. In discussing guilt-redemption, Burke asserted that humans sacrifice others to climb the social ladder and achieve identification with the hierarchal structure under question. Unfortunately, these hierarchies are multiple in number, unstable, and constantly breaking and forming—this is drama.

With guilt looming, communicators are trapped in the unending quest, to reach the perfection located at the top of a hierarchy. "Applause" best demonstrates the relationship between communicators and hierarchies. For

Gaga, perfection is the clapping of hands. To make her Little Monsters clap, and thus purge her guilt by coming closer to the heights of fame, she performs. Through the applause of her fans, it is clear that her Little Monsters identify with Gaga. Furthermore, the substance (the applause) sparks additional identification between the fans and the singer, because everyone understands how it feels to crave and receive that affirmation. However, despite identification, Gaga and her fans also exist on a hierarchy. By way of applause, Gaga does indeed stand on top of the hierarchy, as perhaps an embodiment of perfection that fans also wish to reach. So Gaga and her fans are motivated by relinquishing guilt, in an attempt to reach the top of the hierarchy.

In another lyric, Gaga belts, "*I stand here waiting for you to bang the gong, to crash the critics saying is it right or is it wrong?*" In an attempt to further climb the famous/average ladder, achieve the desired applause, and reach perfection, Gaga blames the critics. She transfers her guilt onto them and their critique. In terms of dramatism, life literally becomes a stage for Gaga, with the critics as the enemy. The artist displaces them within the social hierarchy, and thus dramatizes her life. This occurs much in the same way as everyday communicators place blame on one another.

Unfortunately, this cycle of guilt-redemption is endless. Regardless of success, Gaga will always need to purge her guilt through new performances. Hierarchies will crumble, new pop stars will challenge Gaga, her fans will grow up; but she will not lose sight of perfection. Accordingly, she must be prepared for new hierarchies. No amount of applause will help Gaga reach perfection in the hierarchy that separates her from her fans, and from the critics. Gaga will always be part of numerous hierarchies restricting perfection. In other words, Gaga will always identify with an infinite number of systems of power seeking to contain her. As one hierarchy crumbles, another will form. Gaga can only critique hierarchies while standing within one. Gaga will never be able to reverse division or step outside of it, and, in turn, cycles of guilt-redemption will continue to be present in her life and artistry.

The Pentad and "Paparazzi"

In 2009, Gaga released the music video for "Paparazzi." The video depicts Gaga's ultimate demise, as a celebutante who killed her boyfriend for betraying her, only to find redemption through the lens of the camera and the adoration of the public. Gaga sings, "*I'm your biggest fan / I'll follow you until*

you love me / Papa-papa-razzi." Throughout the video, Gaga self-aggrandizes her own status as a new pop star, by dressing eccentrically and defying musical norms. Viewers of the performance were certainly left with a "gaga" sensibility, one that imagines the world as constructed through extravagant outfits and exaggerated narratives.

This Gaga sensibility might be deconstructed to reveal motives beyond guilt-redemption. In crafting a method for revealing motive in communication, Burke (1969a) identified the "dramatistic pentad," and its five key components: act, scene, agent, agency, and purpose (p. 67). By identifying each element, communicators are better enabled to identify another's motive. As Burke (1969a) explained:

> In a rounded statement about motives, you must have some word that names the *act* (names what took place, in thought or deed), and another that names the *scene* (the background of the act, the situation in which it occurred); also, you must indicate what person or kind of person (*agent*) performed the act, what means or instruments he used (*agency*), and the *purpose* (p. xv).

Given the dense narrative in "Paparazzi," it is an ideal artifact in which to explore Burke's pentad, with the intent of unveiling the motive and thus better understanding life as drama. For the purpose of keeping the pentad's elements separate, we will now discuss "Paparazzi" in sections.

Act

While there are a number of acts to choose from in this particular video, we will want to focus on a broader interpretation, in order to better understand "Paparazzi" as representative of Gaga's relationship to dramatism. For example, one could certainly consider the scene in which Gaga kills her boyfriend the "act" of the video, but as we begin identifying more elements of the pentad, we will better understand that picking this particular act would limit our final interpretation of motive. So, with this broader scope in mind, we will turn our attention to the "act" as not only the action itself but also the presentation of an action. Therefore, we can assign *the rise and fall of a pop star* as the act of "Paparazzi."

Scene

The scene can be a challenging aspect of the pentad to identify. If a scene is unclear, we must determine it to the best of our ability, while also keeping in

mind that the scene will play an important role in the determination of the motive. The "scene" can be thought of as the stage, landscape, situation, or even socio-cultural context in which a particular rhetoric is presented (Burke, 1970). The scene in "Paparazzi," however, may or may not be obvious. For the purpose of this analysis, we will call the scene *the culture of celebrity and fans and paparazzi*. To this end, we stress that the scene, like the act, is up for interpretation, and will ultimately determine how the motive reveals itself.

Agent

The "agent" is the person or persons within a particular scene that ultimately perform the act, or enable an act to occur. In "Paparazzi," the agent is quite clearly *Gaga* herself. After the first scene of the video, in which her boyfriend pushes her off the mansion balcony, Gaga begins her trek, as the agent who is able to dramatize the rise and fall of her own stardom.

Agency

"Agency" can be thought of as *how* the agent accomplishes an act. This will include the material objects that an agent uses to accomplish the act, or even the cultural or social influences that endow the agent with a particular set of skills. In "Paparazzi," Gaga's agency is *her ability to embody superstardom, and her awareness of how pop stars thrive in a particular context or scene*. Because Gaga understands dramatism as a critical aspect of everyday life, she is equipped with the ability to live and demonstrate the popular narrative regarding the "comeback of the celebrity."

Purpose

In determining the various components of the pentad, we save the purpose for last. "Purpose" can be used interchangeably with motive, or the intention of the agent to accomplish a particular act. In other words, as critics, we will want to ask ourselves, "Why is the agent performing this action?" Keeping in mind the other four elements of the pentad found so far, we are ready to identify the motive that drives Gaga to accomplish the rise and fall of the pop star, for all to see. Fitting with the theme of this analysis so far, we will call Gaga's purpose *to exemplify the ways in which dramatism is a vital part of our everyday lives and the ways in which we view celebrity*.

Again, we stress that all five elements of the pentad are open for interpreta-
tion, and can be used as a method or heuristic for rhetorical criticism. Once a
critic begins using the pentad as a form of critique, she will find that her in-
terpretation of a person's motive is up for debate. As with any subjective
mode of analysis, the pentad should not be thought of as identifying any ob-
jective reality. Instead, dramatism relies on these pentadic parts in order to
play out within the lives of everyday people, who, unlike Gaga, do not real-
ize that life is a stage. In this section, we have identified the ways in which a
pentadic analysis can help in understanding how Gaga lives her life dramatis-
tically, and how her art in a video like "Paparazzi" reflects a motive to dis-
play dramatism apparently and outlandishly.

Conclusion

Throughout this chapter, we have covered three Burkean concepts relating to
theories of dramatism, in accordance with the musical work and life of Lady
Gaga. Though oppositional on the surface, both Gaga and Burke, relate in
their dramatistic approaches. It is no wonder, then, that we have placed both
the critic and artist in the same chapter, to demonstrate their similarities.

As explained in all three sections, dramatism can be used as an applied
theory of analysis. According to Burke, social actors create drama in their
everyday lives, and behave as though life is a stage by using language rhetor-
ically. Gaga, too, mirrors this recognition that language is but a tool, for act-
ing and motivating others to act. In order to motivate this action, one must
instill identification between himself and his audience. Additionally, the pro-
cess of guilt-redemption illustrates the ways in which dramatistic action is
directed, via attempts to resist hierarchies and reach a state of perfection. In
order to decipher these components of dramatism, Burke enlists pentadic
criticism as a method for separating rhetorical action into identifiable parts.
Using Gaga as an example, this chapter joins preexisting and abundant
scholarship pertaining to Burke and dramatism, and encourages you to con-
tinue examining rhetoric and communication with dramatistic concepts in
mind.

Keywords from This Chapter

Agency
Artifacts
Consubstantial

Dramatism
Guilt
Guilt-redemption
Hierarchies
Identification
Perfection
Rhetoric

References

Burke, K. (1966). *Language as symbolic action: Essays on life, literature, and method.* Berkeley, CA: University of California Press.

Burke, K. (1969a). *A grammar of motives.* Berkeley, CA: University of California Press.

Burke, K. (1969b). *A rhetoric of motives.* Berkeley, CA: University of California Press.

Burke, K. (1970). *The rhetoric of religion: Studies in logology.* Berkeley, CA: University of California Press.

Burke, K. (1973). *The philosophy of the literary form: Studies in symbolic action* (3rd ed.). Berkeley, CA: University of California Press.

Burke, K. (1984). *Permanence and change: An anatomy of purpose* (3rd ed.). Berkeley, CA: University of California Press.

Day, D. G. (1960). Persuasion and the concept of identification. *Quarterly Journal of Speech, 46*(3), 270–73.

@LadyGagaNowNet [Twitter Username]. (2014, Nov. 10). "When I'm long gone they'll say she was special but her fans were really something." –Lady Gaga. [Tweet]. Retrieved from: https://twitter.com/ladygaganownet/status/531978183214895104

As a self-proclaimed Lady Gaga fan, I found Dionne and Hatfield's chapter relating dramatism to Gaga's music fascinating. Gaga could justifiably be said to be one of the most controversial celebrities that society has seen. However, through controversy we can find enlightenment. By observing the behavior that Gaga projects upon society, in addition to the blatant relationship she has with her fans, the concept of dramatism can be exemplified and better understood.

There are several pop songs that have gained immense popularity through uplifting lyrics concerning self-love and acceptance of others. As a recent example, Meghan Trainor's "All About That Bass" celebrates women who have a little more junk in their trunk. While doing so, Trainor caused a stir, when critics claimed her song was body-shaming thinner women. In Gaga's "Born This Way," a stronger sense of identification can be built among the audience, because the lyrics do not put one identity or appearance above another, but rather state that all of these attributes are something to be proud of. One must still be skeptical of Gaga's intentions concerning "Born This Way," considering she is involved, as previously stated by Dionne and Hatfield, in the capitalistic hierarchy.

In regards to the discussion of guilt-redemption and Gaga's song "Applause," I can definitely see some validity to Dionne and Hatfield's points. I believe it is safe to say that everybody has a picture of who he or she would like to be. This picture can be considered one's own "perfection." As Gaga has stated in interviews and in lyrics, her sense of perfection is living out the fame. Everyone must fight off hierarchies that stand between her and her perfection. For a woman such as myself, that hierarchy might be the struggle to gain a position most commonly held by a man. For Gaga, her main obstacles are the critics and the media. In another popular Gaga song featuring R. Kelly, "Do What U Want," Gaga candidly sends a message to the critics by singing, *"You can't have my heart and // you won't use my mind but // do what you want with my body."* This is another example of guilt-redemption as seen in Gaga's music. I think one last thing should be considered in relation to guilt-redemption: the opposing viewpoint. Although Gaga sees the critics as nuisances, keeping her from her own perfection, perhaps she, and all of us, could consider the opinions of those who "stand in our way," as a window into a different insight about ourselves.

Overall, I think Gaga's music does a great job of providing a modern vehicle in which to understand the concept of dramatism. Celebrities and the products they produce, as well as their relations with the public, set an example of a real-life drama.
—Ashley Mahler

CHAPTER 3

"Clear eyes, full hearts, can't lose"— Finding the God-Terms in *Friday Night Lights*

Gerald J. Hickly III

Imagine a small Texas town largely left behind by the post-industrial age. A town where the primary centers of commerce are the local auto dealership, Garrity Motors, and the strip club, The Landing Strip, refurbished from a closed airport. A town where everything screeches to a complete halt and all troubles can be forgotten once a week for a season. A town that is singularly and totally consumed by one thing, one name: Dillon Panthers. This is the world of Dillon, Texas, as painted by NBC's *Friday Night Lights*, a critically acclaimed television drama. This series was inspired by H. G. Bissinger's thought-provoking book of the same name.

Because of its complexity and its realistic depiction of contemporary issues, *Friday Night Lights* is a reflection of human communication. It is a helpful text to explore communication theories you may not have studied before. Relying on the work of Kenneth Burke, this chapter hopes to illuminate the concepts of god-terms and Cluster Analysis, by looking at how those ideas make themselves apparent in *Friday Night Lights*.

Kenneth Burke—The Outsider on the Inside

Kenneth Burke is one of the discipline's great enigmas. He lacks the credentials that would permit his work to have any serious sway by today's standards. Despite being revered as one of the greatest rhetorical scholars of all time (Foss, 2009), Burke never received a college diploma. He attended The Ohio State University, then Columbia University, but dropped out of both (Dickstein, 2004). He was not a communication scholar *per se*, but he was very interested in symbols. One definition of **rhetoric** is "the human use of symbols to communicate" (Foss, 2009, p. 3). Since Burke studied **symbols**, *which we use to communicate,* his ideas are important for communication theory—especially rhetoric.

Cluster Analysis and the Presence of God-Terms

Burke had many intriguing lines of thought. The one this chapter will hope to illuminate comes from the scholar's fascination with identification. For Burke, **identification** is a process by which humans are able to affiliate with various "properties or substances," and, from there, create a sense of identity (Foss, 2009, p. 63). It is through this emergence of identity, Burke supposes, that rhetoric comes about. Identification leads to a notion known as consubstantiality. **Consubstantiality** deals with the power of identification to allow association and dissociation with other individuals, based on what they identify with. The words we use are of utmost importance. How we identify directly affects how we use words, and what it is that those words *symbolically represent*. From here, we can begin to speak of Cluster Analysis.

The goal of **Cluster Analysis** is to seek and identify key words used by a speaker, or a **rhetor**, in Burke's more traditional term. In Cluster Analysis, once key phrases have been identified, we can explore what repeatedly gathers, or *clusters*, around the key term. Regarding key terms, Burke identifies "god-terms" and "devil-terms." While I will be presenting a very basic explanation for your ease of learning, there will be enough of the core argument present, to do justice to Burke's ideas.

In its most essential form, a **god-term** is a word, phrase, or other symbolic identifier that signifies the role of God within the argument. A **devil-term**, by contrast, is a symbolic signification of the devil in the argument. Again, this is a radically condensed understanding of these concepts. However, this elementary definition allows for an easy application to Cluster Analysis. Performing a Cluster Analysis can very readily help determine god-terms and devil-terms within an argument. Identifying the types of terms that cluster around a key idea can paint a clear and compelling picture of how that key term is functioning in an argument. Now we have laid a sufficient groundwork to examine *Friday Night Lights*, as an artifact that abundantly lends itself to clarification through Cluster Analysis.

A Visitor's Guide to Dillon, Texas

Before going too deeply into the rhetorical analysis, it is important to introduce some basic components of *Friday Night Lights*. While this chapter focuses on the NBC television series that ran from 2006–2011, the full story precedes the launch of the pilot episode. In 1990 H. G. Bissinger published *Friday Night Lights: A Town, A Team, and a Dream*. The volume took a

thorough and textured look at the town of Odessa, Texas, and their seeming-
ly single-minded devotion to the local high school's football team: the Per-
mian Panthers. Bissinger's chilling exposé became an instant classic, as it
shed light on the sheer intensity of Odessa's obsession with high school
football. Bissinger spent four months closely shadowing every element that
went into the football program during their 1988 season, and recorded it all
fastidiously in his volume. According to the author, the publication of *Friday
Night Lights* had significant and unintended consequences for the Permian
Panthers that turned the town quite hostilely against him (Bissinger, 2000, p.
362). Bissinger had to cancel a scheduled visit to Odessa after the release of
the book, because of legitimate threats made against him; and the Permian
Panthers were banned from participation in the playoffs, following the reve-
lation of University Interscholastic League code violations, brought to light
by the book (Bissinger, 2000, p. 362).

Bissinger's novel inspired a 2004 film adaptation, starring Billy Bob
Thornton, which directly paralleled the expository content that Bissinger un-
covered while shadowing the lives of coaches and players in Odessa. But it is
the later NBC television show that this chapter will examine. Although a
Cluster Analysis could be effectively used on the book or movie, the televi-
sion show provides fertile ground for a particularly deep analysis that will
hopefully aid in creating a better understanding of the theories under discus-
sion. The version of *Friday Night Lights* that we will look at in this chapter is
heavily *inspired* by Bissinger's novel, but avoids making overt connections.
Instead of being set in Odessa, NBC's *Friday Night Lights* welcomes the
viewer into the fictionalized town of Dillon. This change protects the names
and roles of all the people implicated in Bissinger's novel, and replaces them
with archetypes. The show tells the story of Eric Taylor, newly appointed
Head Coach of the Dillon Panthers. Walking into a team projected to be the
best in the nation that year, Taylor must bear the weight of a town that has
put its hopes and dreams on the 2006 Texas State Football Championship.

Dillon Panthers—The God-Term

The concept of a god-term can be observed from the very first moments of
Friday Night Lights. Sweeping shots of the Dillon landscape underlie excited
radio chatter pointed towards one singular object: the Dillon Panthers. A
week before the Panthers even take the field for the first game of the season,
we, the audience, are brought into the world of the team, and the town that

showers them with utter devotion. TV crews swarm the football stadium, to catch footage from practice and interview the stars of the team. Through this expository scene, the expectation of nothing short of a State Championship appearance is put upon the shoulders of the Panthers, and first-year Head Coach Eric Taylor. In the town of Dillon, which has seemingly little going for it, one thing has become symbolic for the people to rally around: the Panthers. And so, at its most basic level, we have identified a god-term.

It is one thing to say, at the most cursory level, that the symbol of the Dillon Panthers becomes a god-term for *Friday Night Lights*. However, Cluster Analysis makes this claim more interesting and complex. If Cluster Analysis determines what words or symbols surround a key term, then, in this case, we must take a look at what "clusters" around the symbol of the Dillon Panthers.

As previously suggested, one thing that clearly seems to cluster around the Panthers is the idea of the Texas State Championship. The TV interview depicted at the show's onset informs the audience of the hype and hope being thrust onto this team. In addition, the pilot reveals that the Dillon Panthers as god-term, and the State Championship as expectation, is not specific to the 2006 team. Indeed, these symbols have long stood as the salvation of the town. Buddy Garrity, a former Panther State Champion player, and chair of the current Booster Association, hosts a pep rally. The event clearly reveals a culture of devotion to the point of obsession, and hope in the Panthers to the point of religiosity. When Coach Taylor concludes his address to the gathered team supporters, the room erupts into a special kind of applause, with dozens of middle-aged men thrusting fists into the air, each one ornamented by a golden ring with a sapphire stone set at its center: a Texas State Championship Ring.

Key Clusters—Coach, Street, Smash, and Saracen

In keeping with the team as god-term, certain key individuals become tightly clustered around the symbolic center of the Dillon Panthers. First, there is Eric Taylor: the Panthers' new Head Coach. While Coach Taylor had spent several years as part of the Dillon football program (including as the quarterback coach of hometown hero Jason Street), his appointment as Head Coach is viewed as controversial. In Coach Taylor, at least initially, we can see that not all the ideas that cluster around the god-term are necessarily positive. Rather, the cluster ideas reveal the nature of the god-term, through consub-

stantiality. Such is the reverent love for the Dillon Panthers, that Coach Taylor is actually viewed as a threat to the potential for a state title.

In the pilot episode, Coach Taylor expresses his understanding of this sort of social isolation in a conversation he has with his wife, Tami. Tami has just identified her dream house, which happens to be within the family's price range. So, Tami attempts to convince Eric to move. Though Eric certainly agrees that the house would be nice, he qualifies any high hopes, by saying that they will have to see what happens on Friday night. The statement cannot be more clear. Our scholar Kenneth Burke would explain it this way: even though Eric does enjoy the luxury of being clustered with the symbol of the Dillon Panthers, Eric knows that there is a significant difference between being clustered around the god-term, and being the god-term itself.

Starting quarterback Jason Street is a character who finds himself nearly synonymous with what the Dillon Panthers represent at the start of the show. Unlike Coach Taylor—whose relationship to the god-term is based on tentative optimism—Jason Street is the quintessential Dillon Panther. As far as the community is concerned, Jason is the sure-fire key to the State Championship. Generally considered a prodigy, and heralded as the nation's number one high school quarterback, Street is so closely clustered with the god-term, as it is displayed in the team, that they could almost be said to be one and the same. What makes the character so fascinating, however, is what happens when his ideal circumstances change. Having enjoyed the symbolic equivalence of the son-of-god in the Dillon context, Jason's world is spun on its head in almost every conceivable sense: he sustains a spinal injury in the first game of the season, leaving him permanently paralyzed from the waist down.

The team's loss of Jason Street significantly shakes the faith the town once had in a sure-fire trip to the State Championship. Backup quarterback Matthew Saracen did not take a single snap during any of the practices leading up to the game. Why should he? In the eyes of the Panthers' faithful fans, having a backup for Jason Street was one of the most laughable ideas in the world. Yet with Street's injury, the burden of success falls on the shoulders of the young, untested Saracen. The town of Dillon begins to grow anxious. They wonder if Street's departure from the field will result in deterioration of the town, the team, and the dream. These worries persist, even when the Panthers are able to bank a win on a long, passing touchdown from Saracen, in the closing seconds of his first game as starting quarterback.

While Street's injury certainly affects the way the town views him and the larger god-term, the effect on Street's psyche is perhaps still more interesting. Through the course of the show's first season, Jason Street goes through a whole gamut of emotions. This is understandable for someone who sustains a life-altering injury, but more intriguing when Street's association with the god-term is brought into clear focus. Considering that everything about his life has changed overnight, Jason's initial reaction is not to fly into a wild fury, or even try desperately to retain his grandeur. Rather, Jason is plagued with a haunting guilt that he failed his team. Having been so closely aligned with the god-term, he feels the immediate weight of defaulting on his perceived obligation, to the community that burdened him with such prominent symbolic significance. When Coach Taylor visits him in the hospital, Jason attempts to apologize for failing him. Coach Taylor is nearly overwhelmed by the concept, and calmly tells Jason that if anyone failed, it was him as a coach, for not adequately teaching Jason to make a tackle.

After the initial shock of his reality settles, Jason begins to swing into violent anger. He pushes away his long-time girlfriend, Lyla Garrity, and gives up on any long-term hope for his life. The severity of his depression is a direct result of the void he feels from losing his role as a key cluster for the god-term.

As time passes, Jason eventually is able to rejoin the Panthers as a member of the coaching staff. Though initially excited about the return to the organization, Jason begins to feel that he was nothing more than a mascot: the brave young boy whose symbolic life was sacrificed in the name of the Dillon Panthers. For the town and the team, this is a social convenience: they can keep Jason Street as an icon, still tied inseparably to the god-term. Yet for Jason himself, the reality of going from a hero to a mascot is a sort of social death that keeps him shackled in association to the god-term, never experiencing any freedom of his own.

A third individual who becomes closely clustered around the god-term, is the hot-headed running back Brian "Smash" Williams. In the pilot episode, a newspaper headline identifies the on-field synergy between Jason Street and Smash Williams as one of the key ingredients in the Panthers' dominance. Unlike Coach Taylor (whose association to the god-term is obligatory and uncertain), or Jason Street (who views the association as an inherent responsibility), Smash Williams views his association as a launch pad for greatness. An egotistical young man, Smash acts out, in order to retain the limelight. Throughout his run on the show, he often attempts to leverage his

star status as a Panther with the community at large, in order to make self-gratifying social plays. For example, in the first season, Assistant Coach Mac McGill went on record about Smash's play style, in a way that was misconstrued as a racist remark. Smash rallied all the African American players on the team, and orchestrated a walkout that threatened to jeopardize their chance of making the playoffs. While Smash eventually conceded to a compromise, he labored for a long time under the misapprehension that his close association with the god-term symbol of the Dillon Panthers, was the same as being the god-term itself. Smash is eventually humbled in this particular scenario; but throughout the character's run on the show, he consistently experiences conditions in which his voracious desire for fame is twisted and intensified, due to his clustered association with the god-term of the Dillon Panthers.

A final character who slowly begins to cluster around the god-term is sophomore Matthew Saracen, the backup quarterback. Saracen is portrayed as a boy of humble means. He lives with his ailing grandmother, whom he cares for. His mother left when he was young, and his father is serving in Iraq. On top of this, he is the backup quarterback, lost behind the tremendous shadow of Jason Street. Street's tragic injury certainly has lifelong implications for the hometown hero, but also for young Matt Saracen, whose life is dramatically altered. He goes from being a total unknown, to the new "QB 1" of the Dillon Panthers. Over the course of the first season, Saracen begins to cluster strongly around the Dillon Panthers god-term. He experiences ups and downs in his relationship with this symbol. Besides having to fight the long battle of comparison against his similarly clustered predecessor, the new quarterback must also assume the pressures and obligations that Jason Street formerly carried, in relationship to the god-term of the Dillon Panthers. However, by the end of the season, Saracen has stabilized his connection with the god-term, at least as much as possible.

Clear Eyes and Full Hearts

The Burkean concept of Cluster Analysis provides a window through which to critically examine the symbolic significance of social interaction. By identifying key themes and paying attention to what clusters around them, and what those relationships look like, we can paint a vibrant picture of a rhetorical situation. Furthermore, Cluster Analysis can help reveal certain god-terms, which bear the symbolic weight of all goodness within the context.

Using *Friday Night Lights* as an artifact on which to try Cluster Analysis, we can clearly see the presence of a strong god-term that emerges throughout the first season: the Dillon Panthers. The town of Dillon is shown to place all the symbolic weight of hope and virtue on the term, and the people closely associated with it.

While length prohibits further discussion here, the Cluster Analysis continues to be interesting as show goes on. A key shift that occurs between the third and fourth seasons creates fascinating ground to examine how the clustering of terms has evolved, and how that affects the meaning of the god-term. Cluster Analysis provides a gateway for examining the deeply symbolic nature of social interaction, often left untapped in everyday life.

Keywords from This Chapter

Cluster Analysis
Consubstantiality
Devil-terms
God-term
Identification
Rhetor
Rhetoric
Symbols

References

Bissinger, H. G. (2000). *Friday night lights: A town, a team, and a dream*. Boston, MA: Da Capo Press.

Dickstein, B. S. (Ed.) (2004). Burke, Kenneth Duva. Retrieved from: http://pabook.libraries.psu.edu/palitmap/bios/Burke__Kenneth.html

Foss, S. (2009). *Rhetorical criticism: Exploration and practice*. Long Grove, IL: Waveland Press, Inc.

I agree with Hickly's explanations and conclusion, regarding Cluster Analysis and *Friday Night Lights*. Hickly does an excellent job explaining Kenneth Burke's definition of identification, and how rhetoric comes about from identification. Hickly's explanations of Cluster Analysis and terms like god-term and devil-terms are clear and concise, and it is remarkable how well he relates these terms to the Dillon Panthers and *Friday Night Lights*. *Friday Night Lights* was a popular show that many students of our generation watched and related to, because the social situation depicted in the TV show matched the types of situations many students my age and older were experiencing in their own lives at that time.

One of the many things that sticks out to me in this chapter, is how well Hickly connects Jason Street, Coach Taylor, Smash Williams, and Matt Saracen, as all clustered around the god-term of the Dillon Panthers, as he calls it. Hickly uses these associations, and their impact on the town of Dillon in the show, to explain the concept of Cluster Analysis, and how it can be used to identify symbols and their importance. This is especially impressive because viewers who related to the show can easily follow these explanations, and come to the same conclusion Hickly did. This allows readers to realize the importance and significance of the god-term, which all the characters cluster around, and to take these associations into their own lives as a result.

—Dan Fadden

CHAPTER 4

Understanding Ceremonial Speech through Fantasy Literature

Kathleen Glenister Roberts

If you enroll in a public speaking course you will often learn to distinguish among types of speeches. These distinctions are based on an ancient description from Aristotle. Recall from the introduction to this book, that public speaking was essentially the only "mass medium" available in ancient Greece, and so philosophers certainly took notice and taught their observations to their followers. Aristotle wrote a book on rhetoric, in which he separated the public speeches of his day into three categories:

1. **Forensic** speech, which concerns a *past* event, and who is at fault. These kinds of speeches typically are heard in courts of law.
2. **Epideictic** speech, related to the *present*, which assigns praise (or sometimes blame) to a person or group. These kinds of speeches are heard at ceremonies, and function especially to awaken the senses (**aesthetic** value).
3. **Deliberative** speech, focused on the *future*, which attempt to move people to action. These kinds of speeches were political during Aristotle's time; and today, persuasion is all around us: in politics, advertising, and interpersonal encounters.

Each of these three categories seems to remain separate. It is inappropriate, for instance, to try to sell something (deliberative) to a jury in a courtroom (forensic). It would be equally wrong to add your own political opinions (deliberative) to a eulogy at a funeral (epideictic).

We can easily see examples of forensic and deliberative speech in today's society; but epideictic speech is sometimes harder to identify. In this chapter, I want to look at epideictic or ceremonial speech through fantasy literature. This is helpful for two reasons. First, most fantasy literature in the Western tradition—like J. R. R. Tolkien's *Lord of the Rings,* C. S. Lewis's *Chronicles of Narnia,* and J. K. Rowling's *Harry Potter*—follows plotlines that make clear distinctions between good and evil. (A popular exception is *Game of Thrones*; see Elena Strauman's chapter in this book.) There is a general ethos in most fantasy books, which underscores that if the good people just fight as hard as they can and never give up, they can defeat evil. This happens in all three series mentioned above. Certainly there is pain, grief,

and loss along the way. But in the end, evil is defeated, and the protagonists live happily ever after.

This triumph of good over evil says something very specific about values. **Values** represent judgments about what is good and worthwhile. In these fantasy novels (and subsequent movies), certain character traits like bravery, freedom, love, friendship, and sacrifice are rewarded with security and happiness. These values resonate with readers because they are communal. In that sense, they are like **ethics**: public principles and standards for decision-making that are for the good of the whole, not just oneself.

Values and ethics are encoded in many epideictic speeches. **Epideictic** is from the Greek *epideixis*, which means "to display," and, among other things, it can be said that epideictic or **ceremonial** speeches seek to shed light on—to display—values that the group hold dear. The addresses attempt to teach these values to the young, and remind the old of their importance.

There is a second reason that fantasy literature can be useful in understanding epideictic rhetoric. Fantasy literature contains "magic" and mystery, two qualities that also appear in ritual. Some scholars of epideictic rhetoric understand that this category of speeches is important for its relation to ritual, either occurring during rituals, or performing rituals in language. Let's look first at what ritual means: transformation.

What Are Rituals?

Look again at Aristotle's three types of speech above. Aristotle is trying to get us to think of ceremonial speech as rooted in "the present." Epideictic occurs in the present, at an important occasion for the audience or group. If we understand epideictic speech as related to ritual action, then we can start to understand why it might also play an important role in forensic or deliberative rhetoric (Carter, 1991).

What would it mean to see the ritual in epideictic speech? **Rituals** are repeated, cyclical, communal events that are thought to transform individuals or the community itself. **Rites of passage** move individuals—in front of their communities, in a formal event—from one status in life to another. For instance, rites of passage move children (at least symbolically) into adulthood in their cultural group. Examples include the puberty ritual in Papua New Guinea, and also the Jewish bar mitzvah in New York.

In Tolkien's *The Fellowship of the Ring*, the elven queen Galadriel goes through an unusual rite of passage. Frodo is carrying a ring—the One Ring—

of great power, and leaders of the free beings (humans, elves, and dwarves) agree it must be destroyed. Frodo undertakes this burden, and is helped in his journey by a fellowship of representatives from the other societies. Nine companions in all, they encounter many dangers. Their one safety net, the wizard Gandalf, is killed on the way. The remaining eight escape and find refuge at Lothlòrien, the golden wood of the elves.

Galadriel is the queen of this place. For those unfamiliar with Tolkien's work, the elves in this story are nothing like Keebler's cookie-makers or Santa's toy-makers. They are far more like angels. They are tall, beautiful, wise, and immortal. Galadriel is described in Tolkien's work as a beautiful and perpetually young girl. She is fully aware of the evil that Frodo is trying to destroy. The problem with the ring is that it is so tempting: even very good people want to possess it, sometimes with the idea that they can help others with its power. But the ring deceives people; it answers only to its Satanic creator, Sauron.

A ritual of sorts happens between Frodo and Galadriel. Alone with her, Frodo has a vision of the terrible things that will happen to all those he loves, if he fails to take the ring back to its origins and destroy it. He asks Galadriel please to take the ring from him. The request is sudden, but it is something Galadriel has thought about: how would she react, if given the opportunity to possess the One Ring? She imagines:

> And now at last it comes, you will give me the ring freely! And in place of a Dark Lord you will set up a queen. And I shall not be dark, but beautiful and terrible as the Morning and the Night! Fair as the Sea and the Sun and the Snow upon the Mountain! Dreadful as the Storm and the Lightning! Stronger than the foundations of the earth. All shall love me and despair! (Tolkien, 1954, p. 356)

As she speaks, Galadriel lifts her hand up, and the ring she wears illuminates her, making everything around grow dark. To Frodo, she seems even taller, taller beyond measure, and "beautiful beyond enduring, terrible and worshipful." The film version of this scene emphasizes the transformation well: even her voice becomes harsh and horrible, in its power. But quickly Galadriel drops her hand; all returns to normal, and she laughs. Her voice is soft and sad:

> "I pass the test," she said. "I will diminish, and go into the West and remain Galadriel." (Tolkien, 1954, p. 357).

Tolkien writes this scene with Galadriel in an interesting way: the objects of nature—the storm, the lightning, morning, night, sea, snow, and so forth—are all capitalized, becoming characters in their own right. They are forces to be reckoned with. We gain a sense of why everyone would love Galadriel *and despair*—because the ring would wield such terrible power through her. More important, though, is her own acknowledgment that this was a "test" she needed to pass. She feels uncertain before Frodo offers the ring: would she be tempted to take it? She is, but she refuses. "I will remain Galadriel"—her rite of passage *makes permanent* her identity. She has faced the evil of the ring, and won.

Now, let's ask: in human rituals, what phases take place, and why is speech important?

The Phases of Rituals and the Role of Speech

Scholars in the past 100 years have observed rituals around the world, and pointed out three general phases that seem to take place: separation, liminality, and reincorporation (Turner, 1964; van Gennep, 1960). I explain these phases below. By far the most important phase is *liminality*, and I will offer the majority of examples from fantasy literature in that section, so that you may understand communication during that phase as fully as possible.

Separation

The individual person(s) to be transformed must first be temporarily removed from the community. This is **separation**. The action itself may be highly symbolic. In some cultures, boys who are about to undergo a puberty ritual might be taken out of the village, to a special hut in the forest for a day. This prepares the boys, and sends a powerful signal to their village that something serious is about to happen.

In other cultures, separation may be more symbolic than physical. For instance, many women in the United States and other cultures wear an engagement ring on their left hand. In old-fashioned terms, these women are "spoken for": by the conventions of their culture, they are no longer available to other men for courtship. Of course, this separation phase is generally much longer for engaged women than it is for the boys in the village, but the same idea is being communicated to the community: something serious is going to happen, and these individuals are planning to undergo a change in status that is sanctioned by their cultural group.

Liminality

The individuals are brought back to their community, where the other members have gathered. There, many actions are performed, and words spoken (speech). At this stage, the individuals are "in between" their old status (child, for instance), and the new status yet to come (adult). Because they are "in between," or at the threshold (limen), this part of the ritual is called the **liminal phase**. Remember, the liminal phase is thought of as the most important in a ritual. It is the heart of ritual action, and far more complicated than the other two.

Danger and vulnerability add to the "in-between" feeling of the liminal phase. In many cultures, because the individuals undergoing the ritual are "between" categories—neither this (child) nor yet that (adult)—the people undergoing the ritual are considered dangerous (Douglas, 2002). It is a powerful and mysterious time in community life. But certain types of liminal stages may also place the individuals in danger. Take, for instance, a further example from *Lord of the Rings*.

The film version of *Return of the King* depicts a stirring speech by Aragorn, at the Black Gate of Mordor. He has overcome his reluctance to step into his true self, the rightful king of Gondor, over the course of the trilogy. Men (and women) have followed him, into this final battle to defeat Sauron. They face a terrifying army. Though, in the books, the battle occurs so swiftly that there is no time for a rousing speech, even diehard fans of the novels cannot help but be stirred by Viggo Mortensen's portrayal of Aragorn in the movie, as he says to his men:

Hold your ground! Hold your ground!

Sons of Gondor, of Rohan, my brothers. I see in your eyes the same fear that would take the heart of me.

A day may come when the courage of men fails, when we forsake our friends and break all bonds of fellowship.

But it is not this day.

An hour of wolves and shattered shields, when the age of men comes crashing down.

But it is not this day!

This day we fight!

By all that you hold dear on this good Earth, I bid you stand, Men of the West!

Aragorn's speech in the film highlights two aspects of epideictic rhetoric. The first applies to all kinds of ceremonial speeches: they typically draw on the past to stir feelings of unity in the audience. In this case, there is a double history. Within the fictional world of Middle Earth, Aragorn appeals to the age-old alliance between Gondor and Rohan. He calls everyone in his company "my brothers," aiming to give them courage. He appeals also to "all that you hold dear on this good Earth," and means to remind them of why they are fighting. They hold the good Earth in common, and have always protected it. That history is very much present on "this day."

At the same time, there is a cultural history outside of fiction that makes the speech even more compelling. The cadence of Aragorn's words remind many listeners of Winston Churchill. Churchill was the Prime Minister of Great Britain during World War II, and is renowned for the stirring speeches he made during the war. Much of his work in the early years required appeals to alliances with the United States. Epideictic speeches—and great literature—are conscious of history.

Aragorn's speech also lends an interesting twist to the link between epideictic and war. When we discuss liminality and the sense of being "in-between," it strikes me that there is a strange feeling before going into battle that must be unlike anything else in human life. One is filled with questions, with the desperate uncertainty of whether or not life will continue (both individually and collectively). No one can live "in the present" more than one who is fighting for his or her very life. This was the situation in Great Britain under Churchill, and in the fictional scene of Aragorn at the Black Gate.

Another aspect of the liminal phase is attentiveness to **values**. **Gnosis**, or sacred knowledge, is passed on in a ritual. The knowledge is often considered sacred because it is essential for the community to thrive. For instance, Harry Potter's headmaster, Albus Dumbledore, takes many ceremonial occasions to try to teach his students about the values that are important to Hogwarts, to the wizarding world, and to humankind in general.

This **teaching function** in epideictic rhetoric is important (Hauser, 1999), and Dumbledore is masterfully subtle when he does it. For instance, he takes the ceremonial occasion of the awarding of the House Cup, in *Harry Potter and the Philosopher's Stone*, to explain courage. Although the

Slytherins—the most cunning group of students in the school—technically win the House Cup, Dumbledore decides to award some additional points, while his awards presentation unfolds. He gives Gryffindor House more points for the actions of Harry (who showed courage in facing Voldemort), Hermione (for keeping a cool head in the face of danger), and Ron (for self-sacrifice). But the character who ends up winning the cup for Gryffindor is Neville Longbottom, a shy and bumbling boy. Neville, unaware of Harry's plans to thwart Voldemort, tried to stop the three from breaking the rules. Dumbledore says: "It takes a great deal of courage to stand up to our enemies, but a great deal more to stand up to our friends" (Rowling, 1997, p. 306). Naming Neville, he awards the points that tip the cup to Gryffindor. He makes a powerful statement to the students about what is valued at Hogwarts.

Also during the liminal phase of ritual, **narratives** or **scripture** are shared with the group. At funerals, for instance, stories are told about the person who passed away. This gives comfort to the family, but it also emphasizes values.

Albus Dumbledore's speech to the students after Cedric Diggory's death, in *Harry Potter and the Goblet of Fire*, is much like the funeral orations of Aristotle's time: Dumbledore uses **exemplars**, heroic individuals who embody important values in the speech. Harry is praised for his bravery in facing Voldemort and bringing back Cedric's body. Cedric is also an exemplar: "He was a good and loyal friend, a hard worker, he valued fair play" (Rowling, 2000, pp. 721–22). Cedric died through no fault of his own. He was an innocent, and he was school champion—a title given to the one person who embodied the best virtues of Hogwarts. Dumbledore emphasizes his exemplary quality: "His death has affected you all, whether you knew him well or not" (Rowling, 2000, p. 722).

Especially with this last statement, Dumbledore indicates that Cedric's death is sad and meaningful. Exemplars were used in Aristotle's time, and are still used today, to rejuvenate the values of a community, and to call forth strength for the future. This is important in *The Goblet of Fire*, because Dumbledore wants students to know the truth: Voldemort has returned to power and is Cedric's murderer. Dumbledore calls the students to join together in the fight against evil. He ends his speech with these words:

Remember Cedric.

Remember, if the time should come when you have to make a choice between what is right, and what is easy,

remember what happened to a boy who was good, and kind, and brave, because he strayed across the path of Lord Voldemort.

Remember Cedric Diggory (Rowling, 2000, p. 724).

Dumbledore makes this speech especially artful by using what scholars call **parallelism**: beginning each line with the same sound or word. In this case, he emphasizes the word *"remember"* through parallel placement, because although Cedric's death is unspeakably sad, he can be held up as an exemplar. The story of his life and death must not be forgotten.

Another occurrence in the liminal phase is **symbolic inversion**: the way in which enactors of a ritual reverse the meaning of everyday life. Symbolic inversion "turns the everyday world on its head." Everything has a strange new meaning, and normal social structures are flipped upside down.

At the very beginning of *The Fellowship of the Ring* (the first book in the trilogy), the narrator takes us to Bilbo Baggins' huge 111th birthday celebration. The birthday reminds us of two important features of epideictic rhetoric. First, epideictic speeches are not just reserved for exotic rituals: a birthday is a rite of passage, too. A birthday celebration is contained in what we call **ritual genres**: categories of public life that encapsulate transformations. For instance, celebrations, festivals, holidays, and public displays call for epideictic speech to make them whole. Certain occasions seem to require speech. In many cultures, it would be strange to celebrate a birthday without any speeches.

The second thing to be aware of is that *audiences have expectations* about speechmaking. Bilbo's birthday speech is actually rather strange. For one thing, the character gives the speech himself. Since epideictic speeches are usually speeches of praise, it tends to be left up to someone who knows the honored individual well to speak. It seems a little odd to heap praise on oneself, in most cultures.

But this is why Bilbo's birthday isn't normal: his speech is one that praises the people at his birthday party, rather than himself, since he plans to leave them forever. He changes the speech into a different epideictic occasion: one of farewell, rather than typical birthday greetings:

"Today is my one hundred and eleventh birthday: I am eleventy-one today! ... I have called you all together for ... Three Purposes! First of all, to tell you that I am immensely fond of you all ... I don't know half of you half as well as I should like; and I like less than half of you half as well as you deserve ... Secondly to celebrate my birthday ... Thirdly and finally I wish to make an ANNOUNCEMENT ... I am going. I am leaving NOW. GOOD-BYE!" (Tolkien, 1954, p. 29–30).

Ritual drama is the actual physical action that "transforms" the person(s) undergoing the ritual. It moves them, officially, from one stage of life to another. While this action is usually also highly symbolic, it announces to the group, beyond doubt, that the change has formally and irrevocably occurred. An officiant (for example, a priest) may make some movement over the person, or the person may be marked differently—with paint, or with new clothing, for instance.

There is a profound example of ritual drama in *The Magician's Nephew,* the first book of C. S. Lewis's *Chronicles of Narnia.* Throughout that series, human beings on earth find passageways to other "parallel" kinds of worlds. In this origin story, Digory Kirke is a young boy, who, along with his friend and a few other characters, accidentally finds himself present at the very moment that Narnia is being created. Lewis allows the ritual drama of creation to unfold beautifully, as the great Lion, Aslan, runs in circles, and sings: "Narnia, Narnia, Narnia. Awake" (Lewis, 1955, p. 119). His graceful run, beautiful music, and most of all words, call every blade of grass, every rock, and every tree into existence.

The threefold call, "Narnia, Narnia, Narnia," seems to not only create the world, but also to saturate that world with a kind of verbal instinct. Readers see in later Narnia stories, for instance, that the characters seem to know to call on things, by repeating their names three times. This is what I call a "ritual sensibility." It is a tradition that Aslan starts, not unlike the traditions that start our own ceremonial speeches. We know to say "Good evening, ladies and gentlemen," or to use other kinds of formulae during a formal speech meant to celebrate. Skipping these familiar markers is usually frowned upon in formal contexts.

In most cultures, all these components of the liminal phase require speech. Sacred knowledge must be explained, and narratives must be told. Symbolic inversion definitely includes speech: often words used during rituals are unusual and very different from everyday diction. Even ritual drama tends to be accompanied by special incantations or powerful words—"I now

pronounce you husband and wife," for example—that allow us to realize the ritual power of epideictic speech.

Reincorporation

After the proper things have been said and done in front of the community during the liminal phase, the individuals are reintroduced back into the group—but with a new status. This relatively short phase is **reincorporation,** and signals the end of the ritual itself (though it may be followed by a community celebration, or continued gathering of some sort). During reincorporation, the initiates are presented to the community with a new status, and there is time for applause, perhaps, and then celebration. The move from a house of worship where a wedding takes place, on to the wedding reception, is a good example of reincorporation in American culture.

Conclusion

As you can see from the three steps above, there is a great deal of communication involved in a ritual. This is thus a useful model for understanding epideictic rhetoric. Of the three types of rhetoric, epideictic is most focused on praise, "the present," and ritual occasions. Fantasy literature provides an interesting test case for epideictic speech in Western culture, because it contains magic and transformations (like ritual), and typically exalts what is good and heroic over what is evil or selfish (values). Epideictic rhetoric is often thought to have teaching functions (Hauser, 1999), as well as ritual functions (Carter, 1991). Examples of these communication dynamics abound in *The Lord of the Rings, The Chronicles of Narnia,* and *Harry Potter.*

Keywords from This Chapter

Aesthetic
Ceremonial
Danger and vulnerability
Deliberative
Epideictic
Ethics
Exemplars
Forensic
Gnosis

Liminal phase

Narratives and/or scripture

Parallelism

Reincorporation

Rites of passage

Rituals

Ritual drama

Ritual genres

Separation

Symbolic inversion

Teaching function

Values

References

Carter, M. F. (1991). The ritual functions of epideictic: The case of Socrates' funeral oration. *Rhetorica: A Journal of the History of Rhetoric, 9*(3), 209–32.

Douglas, M. (2002). *Purity and danger*. London, England: Routledge.

Hauser, G. (1999). Aristotle on epideictic: The formation of public morality. *Rhetoric Society Quarterly, 29*(1): 5–23.

Jackson, P. (Producer, Director). (2003). *The lord of the rings: The return of the king* (Motion Picture). United States: New Line Cinema.

Lewis, C. S. (1955). *The magician's nephew*. New York, NY: HarperCollins.

Rowling, J. K. (1997). *Harry Potter and the sorcerer's stone*. New York, NY: Scholastic.

Rowling, J. K. (2000). *Harry Potter and the goblet of fire*. New York, NY: Scholastic.

Tolkien, J. R. R. (1954). *The fellowship of the ring*. Boston, MA: Houghton Mifflin Company.

Turner, V. (1964). Betwixt and between: The liminal period in Rites de Passage. In J. Helm (Ed.), *Symposium in new approaches to the study of religion* (pp. 4–20). Seattle, WA: University of Washington Press.

Van Gennep, A. (1960). *The rites of passage*. Chicago, IL: University of Chicago Press.

Every kid daydreams, while sitting in math class, that she could actually be levitating feathers, transfiguring animals, riding hippogriffs, or passing a quaffle. Every 11-year-old waits by the mailbox, hoping for a letter that will send him through a brick wall to platform 9 ¾, to catch the scarlet *Hogwarts Express*. Every kid fantasizes about walking through the back of her closet, to feel pine needles prick her hands and hear snow crunch under her feet, having passed into the land of Narnia. As young children, we were captivated by the mystery and majesty of these novels, and our infatuation increased as the stories won our trust and confidence in the ultimate triumph of good over evil. As we matured, we realized that, all along, it was the humanness of the characters enveloped by these fantasy worlds that truly magnetized and attracted us: the wavering confidence of Frodo, unsure if he can complete the mission set before him; the vulnerable, empathetic nature of Lucy Pevensie who sought to rescue her friend Mr. Tumnus. It was not physical strength, but steadfast faith, that gave her courage to stand firm by Aslan's side as the entire opposing army threatened to stampede across the bridge. The human characteristics of these fantasy figures allow us to relate to them on a personal level. They have neither super-human nor extraordinary qualities, which gives us hope that we, too, can employ integrity in the challenges we face in our own lives.

My generation grew up with Harry Potter. Harry began at Hogwarts as we started middle school. Harry was taking O.W.L.S. as we were taking state exams. We experienced Harry's rites of passage and we witnessed stages of ritual separation, liminality, and reincorporation, right along with him. We didn't know it at the time, but the teaching function of epideictic speech, represented in fantasy literature, taught us integrity. As youths, it gave us a rudimentary basis for choosing right over wrong. As we grew into young adults, this precedence became a total unfurling of virtuous decisions and altruism, until evil was overcome, reassuring us that triumph will ultimately avail those who act out of selflessness, without seeking personal gain. The author beautifully outlines the importance of epideictic speech, exemplified by scenes from Rowling, Lewis, and Tolkien. Roberts distinctly uses examples pertaining to western culture. High context cultures (typically Eastern) that place less focus on praise and individuality might view epideictic rhetoric differently. One aspect that the author did not mention is the significance of the community of the person being praised through this type of speech.

Parallel to our world today, the characters in these series had strong connections with their communities. Especially alongside the corruption of society, the community's role in establishing and nurturing essential virtues is paramount for the success of its younger members. Such input provides tools and imparts wisdom. Nevertheless, there comes a point in these characters' journeys (and in our own paths, as well) when each one finds himself facing decisions he must make entirely independently. These decisions, between what is easy or popular, and what is right and just, are the liminal climaxes that invite panegyric, epideictic rhetoric, which seeks to highlight and detail these very moments and events in one's life that are worthy to be recognized and celebrated.

—Julia Marn

CHAPTER 5

Winning Isn't Everything—Credibility, Leadership, and Virtue in HBO's *Game of Thrones*

Elena C. Strauman

HBO's popular drama *Game of Thrones* takes place in the fantasy world of Westeros. As the title suggests, the show focuses on the struggle of various players to win the Iron Throne and rule the seven kingdoms of the realm. As the show has progressed, we have learned more and more about these characters, chosen favorites, and made our own theories and predictions. Of course, we have had all of our expectations upended, by George. R. R. Martin's often startling and disconcerting storytelling. At its core, *Game of Thrones* is a character-driven drama. The show is richly populated with suitors to the throne, as well as their supporters and detractors, all of whom strategically position themselves to take or maintain power.

One theory of communication maintains that **narratives** represent good reasons for audiences to understand and embrace social and moral lessons (Fisher, 1984). If that is the case, then what can audiences learn or understand from *Game of Thrones*? A central question of the show, beyond who *will* win the Iron Throne, is who *should* win it. As a text, *Game of Thrones* does not provide easy answers. Often, traditionally good or heroic characters meet with disaster, while characters with questionable character, characteristics, morals, or motives (or downright bad guys) seemingly succeed. As such, *Game of Thrones* addresses a central concept in communication theory: credibility. This chapter explains and illustrates this concept, by focusing on the first season of the show—specifically on the character of Ned Stark, his status as an "honorable" man, and the (ultimately fatal) consequences of doing the right thing.

The Narrative

The Starks of Winterfell, headed by patriarch Ned Stark, rule the north. Stark is known as an honorable man, in part because of his history as a war hero. He is also the best friend and ally of King Robert Baratheon, who has ruled the Seven Kingdoms for seventeen years. Robert came to power when he overthrew Aerys Targaryen (also known as, "The Mad King").

As the show opens, disturbing news arrives from King's Landing. The Hand of the King (the King's highest political advisor) has died, under suspicious circumstances. Additionally, the King is riding for Winterfell. Ned correctly deduces that the King means to name him the new Hand.

The audience is introduced to Ned as a man of honor and duty. He is shown to be a good family man, strong, respected, and principled. These valued traits make him an ideal Hand, while simultaneously rendering him vulnerable to those who do not have such honorable intentions and ideals. Drawing on classical communication theory, the following section details the centrality of credibility in the field of communication. This foundation provides a lens through which we can better understand the character of Ned Stark, and the perils and pitfalls that beset an honorable man playing the game of thrones.

Conceptual Foundations

The study of communication has been concerned with the importance of credibility for thousands of years. Aristotle maintained that "we trust good men more and sooner, as a rule, about everything; while, about things which do not admit of precision, but only guess work, we trust them absolutely" (Aristotle, n.d., Book 1.2). At their core, Aristotle's writings provide a working definition of rhetoric that is still in use in communication classrooms today. He defines **rhetoric** as "the faculty of observing in any given case the available means of persuasion" (Aristotle, n.d., Book 1.2). A primary "available means," and one of three central forms of proof in a rhetorical act, is the concept of *ethos*, which we translate today roughly as "credibility."

Much has been written to refine and understand what Aristotle truly meant by the term *ethos*. The general consensus is that *ethos* is reflective of an individual's moral character, and the habits and behaviors that reflect his or her inner excellence or goodness (Miller, 1974). This relationship between habits and character is a significant one, because of Aristotle's concern for the work of building a moral life. Aristotle believed in the pursuit of excellence in all things. He believed that there needed to be consistency between a person's actions and chosen persona. In Aristotle's estimation, it was not enough for a speaker to say that she was a good person. She had to consistently show this identity, through a combination of words and deeds. In this way, a person lived a "complete life." So, virtue is as virtue does, or, put another way, a virtuous person makes a habit of making virtuous choices.

Aristotle believed that *ethos* was comprised of three dimensions: intelligence or wisdom (**phronesis**); virtue, goodness, or character (**arête**); and goodwill (**eunoia**). He was primarily concerned with the ways in which a speaker crafts *ethos* within a rhetorical act. However, other classical thinkers, such as Isocrates, maintained that an individual's *ethos* is further supported or compromised by audience perception of character, based on history and prior reputation. Despite slight definitional and practical differences, other classical and contemporary scholars have defined *ethos* in ways comparable to Aristotle's. Words such as source credibility, prestige, and personal proof are contemporary constructs similar to a traditional notion of ethos (McCroskey & Young, 1981).

Understanding the importance of *ethos* is central to an education in communication, for a variety of reasons. First, as communicators, we must constantly think of the ways in which we present ourselves as credible actors. Second, as members of the polis, we all make judgments about individuals' character on a daily basis.

These judgments influence our willingness to accept or reject a speaker's message, based in part on our appraisals of the quality of their characters. Estimations of *ethos* by an audience are largely intuitive and **enthymematic** (reflective of what we already know and accept as true about the world). For example, a politician may highlight his or her military service, as a means of establishing credibility. This will only work if the audience accepts that military service contributes to, or heightens, one's credibility. Alternatively, an audience might reject a message from a source because the speaker lacks the expertise to speak on a topic, or is deemed unreliable based on past history. So, the audience performs a simple and intuitive calculation, considering what they already know about the speaker (**prior ethos**), as well as what the speaker does or says (**demonstrated ethos**), to make a determination of the overall credibility of a speaker and his character.

With this conceptual foundation in mind, we can now return to the case of *Game of Thrones'* Ned Stark. We will focus on two interrelated subplots, to explore Ned's character, motives, and pursuit of "the good" (with its problematic results).

Plot 1: Upholding Honor

As noted in the introduction, Robert's reign is based on the overthrow of "The Mad King" Aerys Targaryen. When Aerys falls from power and is

killed by one of his own guards, his eldest son Rhaegar, along with Rhaegar's wife and two children, are killed by Robert and his allies. Aerys' other two children (Viserys and Daenerys) escape from King's Landing and go into hiding, leaving Robert free to claim the Iron Throne. While Robert's rebellion had its roots in the King's cruelty and unsuitability for rule, he had a personal motive as well. Robert was engaged to Ned's sister, Lyanna, who was abducted by Rhaegar in the later stages of the uprising. After Rhaegar's death, Ned finds Lyanna on her deathbed. Although the cause of her death is unclear, Robert blames the Targaryens for the death of his bride-to-be, and vows to kill any remaining Targaryens that he can find.

This situation is the first point of contention between Ned and Robert, when Ned (reluctantly) accepts his appointment as Hand of the King. The King learns the whereabouts of Viserys and Daenarys Targaryen, and that Daenarys has been wed to a powerful, if savage, warlord. Robert is concerned that if Daenarys has a child with this powerful man, she will have the military power to attempt to overthrow Robert's rule, and return the Targaryens to the throne.

Upon hearing of the wedding, Robert wants to have Daenerys killed to prevent the possibility of an uprising. Ned objects, maintaining that Daenerys is "little more than a child," and thus no threat to the realm. Ned's logic falls on deaf ears, however, and the situation gains urgency when it is confirmed (by means of a spy) that Daenerys is pregnant. Robert calls his council together to plan the assassination of Daenerys.

The council deliberation scene, in season 1, episode 5, offers a chance to assess Ned's *ethos*, over and against the credibility of the King and other members of the council. All of them have differing perspectives, on the decision to kill Daenerys. When Robert demands that Daenerys be killed, Ned responds that Robert will "dishonor [him]self forever," if he does. Robert, in a Machiavellian show of power, exclaims, "Honor? One king, seven kingdoms! Do you think honor keeps them in line? Do you think it's honor that's keeping the peace? It's fear. Fear and blood."

Robert's approach is a pragmatic one. He wants to leave no room for someone to challenge the legitimacy of his rule, and fear is the strongest insurance. Robert is a man of action, and believes something must be done immediately to quash the threat. Ned again urges caution in the decision to "murder a child," as he believes distance and logistics will prevent any serious challenge to the realm.

The other members of the council weigh in, siding with Robert, constructing arguments that will support the King's decision. Varys, Westeros's version of the director of intelligence, states, "I understand your misgivings, my lord. It is a terrible thing we must consider, a vile thing. Yet, we who presume to rule must do vile things for the good of the realm. Should the gods grant Daenarys a son, the realm will bleed." Pycelle (a "master" or learned man trained in medicine and advising) continues, "I bear this girl no ill will, but should the Dothraki invade, how many innocents will die? How many towns will burn? Is it not wiser, kinder even, that she should die now, so that tens of thousands might live?" Both Varys and Pycelle are promoting a **utilitarian perspective** in this scene. They are willing to sacrifice a single mother and child, for the greater good of the realm. No matter how "distasteful" the act will be, they see the benefit of killing a minority to protect the majority.

Ned's sense of honor prevents him from supporting such an act. He appeals to Robert again, in the following exchange:

NED: I followed you into war twice. Without doubts. Without second thoughts. But I will not follow you now. The Robert I grew up with didn't tremble at the shadow of an unborn child. ... I will have no part in it.

ROBERT: You're the King's Hand, Lord Stark. You'll do as I command, or I will find a new Hand who will!

NED [*throwing his badge on Robert's desk*]: Good luck to him. I thought you were a better man.

Ned walks out, with Robert screaming curses and threats at his back. He shows that he is a man of principle, unwilling to bend what is right to what will make his King happy.

This scene offers an insight into the construction of Ned's ethos. Despite Robert's labeling him "an honorable fool," Ned demonstrates his intelligence and logical ability, by showing how the Dorthraki truly pose no threat. His good character and virtue reject the killing of an innocent woman and child to maintain power. Lastly, he shows goodwill towards others, in that he is concerned for his friend Robert, whose reputation would be tarnished if he proceeds with the act.

Ned's ethos also stands in sharp contrast to Robert's. Although as king he possesses an unmistakable authority, the storyline reinforces that Robert's position is maintained by force, political expedience, and fear rather than love. Robert's personal habits fall far short of Aristotle's standard of excel-

lence. Interestingly, Ned is able to overlook some of the personal habits that compromise the king—Robert sleeps with prostitutes, and drinks excessively. Robert is also cruel to his wife, children, and others he finds inferior. All of this compromises the character element of his ethos, not to mention goodwill. Robert's quick temper and rash decision-making (even if he sees a kind of rationality in a situation) undercuts his wisdom or intelligence. However, it is his willingness to kill an innocent that truly dooms Robert's moral status, in the eyes of his old friend.

What we are left with is a clear presentation of Ned as the show's central hero, against which the other leaders in King's Landing are judged. Ned is feared by those in power, because it is understood that his ethics will lead him to do what is *right*. His willingness to renounce his title, power, and friendship with Robert for the sake of his honor (even in the face of Robert's death threats) reminds the audience that this is a man of principle. Unfortunately, the next plotline will illustrate that adhering too strictly to a moral code can cost someone dearly.

Plot 2: The Perils of Honor

Robert ultimately decides to forgive Ned for his objection, in the plan to kill Daenerys. However, a new crisis has been brewing. Since his arrival in the capital, Ned has been investigating Queen Cersei and her family. He suspects that the Lannisters have something to do with the death of the previous Hand, as well as the attempted murder of his son. Ned's inquiries lead him to uncover a shocking truth—the Queen's three children, and future heirs to the Iron Throne, are not Robert's. Rather, they are the product of incest between the Queen and her brother.

Ned puts these pieces together, while Robert is away hunting. Driven by a sense of mercy, Ned decides to confront the Queen about the truth. She does not deny his claims. Ned offers her a chance to save herself and her children, stating, "When Robert returns from his hunt, I'll tell him the truth. You must be gone by then. You and your children. I'll not have their blood on my hands. Go as far away as you can, with as many men as you can. Because wherever you go, Robert's wrath will follow." Instead of being grateful for the chance, Cersei chides Ned for his lack of political ambition, and issues a chilling warning, "When you play the game of thrones, you win or you die. There is no middle ground."

Shortly thereafter, news of a hunting accident reaches the castle. The king has been mortally wounded during a drunken, foolhardy charge against a wild boar. Although there is no proof, the story suggests that Cersei had a hand in Robert's death. Robert names Ned "Protector of the Realm," until his "rightful heir" is able to take the throne. Robert assumes that his heir is his eldest son, Joffrey. However, Ned uses this vague language to attempt to remove the Lannisters from power. When Joffrey attempts to take the throne, Ned mounts a challenge, and is subsequently betrayed and arrested for treason.

While Ned is imprisoned, he is visited by Varys, the "Master of Whispers," who urges him to forget his honor, in order to serve the realm and save himself and his family from disaster. The interactions between the two illustrate an interesting interplay between an idealized ethos, and a pragmatic one.

Ned has always been suspicious of Varys, openly questioning if he might be a spy. However, Ned soon learns that there is more to Varys than meets the eye. For Ned, the world is governed by a simple sense of morality: a man does the honorable or virtuous thing. It is his trust in this principle that lands him in prison. Ned cannot understand why someone would not do the same. Consider the following exchange, from season 1, episode 8:

NED: You watched my men being slaughtered and did nothing.

VARYS: And would again, my lord. I was unarmed, unarmored, and surrounded by Lannister swords. When you look at me, do you see a hero? What madness led you to tell Cersei you learned the truth of Joffrey's birth?

NED: The madness of mercy. That she might save her children.

VARYS: Ah, the children. It's always the innocent that suffer. It wasn't the wine that killed Robert. Or the boar. The wine slowed him down and the boar ripped him open. But it was your mercy that killed the king.

Varys illustrates an important lesson for survival, in the politically treacherous world of Westeros. While being honorable is certainly a worthy goal, one must also have a sense of self-preservation. Varys recognizes that one cannot serve the realm honorably, if one is dead. So, Ned dismisses Varys as a coward. Varys doesn't view this negatively: unlike Ned, he is free from prison and able to enact change.

In this way, Ned illustrates another aspect of Aristotle's thoughts on virtue. In his *Nicomachean Ethics,* Aristotle argued that true virtues were situated as a "golden mean" (Aristotle, n.d., Book 2) between two extremes. So, while bravery is a virtue, it is situated between the oppositional terms of cowardliness and foolhardiness. In Ned's case, his bravery edges too far into the realm of foolishness. Thus, while we admire Ned's bravery (and good will, and character), we also question the wisdom of his choices.

Varys visits Ned again, to try to convince him to save himself "for the good of the realm." But to do so, Ned must violate his honor. His struggle is illustrated in the following exchange:

> VARYS: When I was still a boy. ... I travelled through the free cities with a troop of actors. They taught me that every man has a role to play. The same is true at court. I am the master of whispers. My role is to be sly, obsequious, and without scruples. I am a good actor, my lord.
>
> NED: Can you free me from this pen?
>
> VARYS: I could. But will I? No. As I've said, I'm no hero.

Varys explains that war is coming between Ned's son and the Lannisters and that Robert's brother (and true heir) is making plans to take the throne. War is coming to Westeros. Varys pleads with Ned:

> VARYS: Cersei's no fool. She knows a tame wolf is more valuable than a dead one.
>
> NED: You want me to serve the woman who killed my king? Who butchered my men?
>
> VARYS: I want you to serve the realm! Tell the queen you will confess your vile treason. Tell your son to lay down his sword and proclaim Joffrey the true heir. Cersei knows you as a man of honor. If you give her the peace she needs and promise to carry your secret to your grave, I believe she will allow you to take the black and live out your life at the Wall with your brother and your bastard son.
>
> NED: You think my life is some precious thing to me? That I would trade my honor for a few more years of what? Of war? You grew up with actors. You learned their craft. You learned it well. I grew up with soldiers. I learned how to die a long time ago.
>
> VARYS: Pity. Such a pity. What of your daughter's life? Is that a precious thing to you?

Varys clearly sees the value in Ned. He knows that Ned has the ability to bring about peace. However, to do so, Ned must compromise his honor and principles. To Varys, this is a reasonable price to pay (and serves the greatest good), but Ned is unsure. It is only when Varys reminds him that he forsakes not just his own life, that Ned reconsiders. He also risks the lives of his entire family. So Ned takes the advice, to try to broker peace by confessing treason. Unfortunately, Ned makes his play too late, and in a cruel and shocking twist, Joffrey ignores his mother's plan to pardon Ned, and has him beheaded as a traitor.

Conclusions: What Do We Learn?

Credibility is a tricky but central concept to the study of communication. To possess true *ethos,* a person's words and actions must be consistently focused in the direction of good. But what happens when living the best possible life—focused on developing habits of excellence and demonstrating good will, good character, and intelligence—meets with the cold reality of political maneuvering?

Game of Thrones reflects many contemporary texts that seem to revel in a sense of moral ambiguity, where what is right and good conflicts with what is pragmatic, in often devastating ways. What can we make of a text that makes a hero into a foolish pawn? Ned's prior ethos as an "honorable man" sets the audience expectation that his honor will save him. Ultimately, his honor is his downfall. Ned stands in sharp contrast to characters like Varys (who have learned to construct a compromised honor that allows them to attempt to do good, while remaining alive), or Robert (whose success comes not from virtue, but from the ability to apply force), or even the villainous Joffrey (who rises to the throne through treachery and manipulation).

Game of Thrones reminds us that the good guys don't always win. While we can appreciate Ned for his heroism, we also can recognize that he is the maker of his own end. His death is the catalyst for a series of awful consequences, which could have been avoided if he had been a bit less principled. Perhaps this trend of moral ambiguity and narrative reversal is reflective of a social reality that questions the efficacy, or even the possibility, of heroes (Meyrowitz, 1985; Postman, 1985). Perhaps in this game, it is virtue that wins or dies. Nevertheless, the contemporary communication student can learn much about classical theory, by applying it to texts such as *Game of Thrones.* Such programs allow us to question the assumptions of the tradi-

tional storytelling morality of good versus evil, and encourage us to embrace a more nuanced understanding of our heroes.

Keywords from This Chapter

Demonstrated ethos
Enthymematic
Narratives
Prior ethos
Rhetoric
Utilitarian perspective

References

Aristotle (n.d.). *Nicomachean ethics.* (W. D. Ross, Trans.). Retrieved from: http://classics.mit.edu/Aristotle/nicomachaen.html

Aristotle (n.d.). *Rhetoric.* (W. R. Roberts, Trans.). Retrieved from: http://classics.mit.edu/Aristotle/rhetoric.1.i.html

Fisher, W. R. (1984). Narration as human communication paradigm: The case of public moral argument. *Communication Monographs, 51,* 1–22.

McCroskey, J. C., & Young, T. J. (1981). Ethos and credibility: The construct and its measurement after three decades. *Central States Speech Journal, 32,* 24–34.

Meyrowitz, J. (1985). *No sense of place.* London, England: Oxford University Press.

Miller, A. B. (1974). Aristotle on habit and character: Implications for the Rhetoric. *Speech Monographs, 41,* 309–16.

Postman, N. (1985). *Amusing ourselves to death.* New York, NY: Penguin Books.

Oftentimes, the best way of learning is from a book or story. Fairytales and oral tradition are primarily what form moral lessons. The author from this chapter uses the theory of a narrative as a medium to teach a social and ethical ideal. I strongly agree with this theory. Some may find it outdated, but I find it to be used as much or more so than any other technique. For me, narratives appeal to the reader on an individual level, allowing for my own opinions on the characters to form. Considering the theory mentioned previously, the author applies it to *Game of Thrones*.

First, she finds Robert's approach to be pragmatic. I consider the King's rule to be reasonable and practical, as well. Taking the setting of *Game of Thrones* into account, Robert's leading in fear is necessary. While I do not agree with the killing of innocents, Robert is simply being proactive as a ruler of a kingdom. His credibility becomes stronger, because he is thinking of the well-being of the whole kingdom. His utilitarian perspective, much like Varys and Pycelle, shows he only has the best in mind, for the majority involved. For Robert's credibility to increase even more, he needs to appeal to the emotional side, in order to gain the approval of Ned and others. Interestingly, Robert's credibility is the one most viewers, including the author, find questionable. For me, it is truly Ned whose credibility becomes questionable, as the narrative progresses. As the author points out, Varys appeals to Ned's sense of duty to his family. However, Ned still chooses to indulge in his own personal honor, and condemn his family to the wrath of Queen Cersei. Ned is said to have no self-preservation. Yet, he is no good to his family dead. This seems to me that Ned is selfish and puts his public image first. A truly honorable man would do what is best for those around him, especially his family, despite what others may think of his honor. This is what the author refers to as enthymematics. We all have opinions on what adds to a character's credibility. The author makes a good point of Ned's mercy, and missing self-preservation, contributing to his downfall. I agree with this; but the traits also took away from his credibility. Despite these differences in weighing up Ned's and Robert's credibility, I do agree with the over-arching theory of narratives as teaching tools for moral lessons.

—Erin Hayden

Part II

Culture

CHAPTER 6

"Let it go, let it go"—Hegemony and Counter-Hegemony in Disney's *Frozen*

Janelle Applequist

Fairytales have become staples for countless cultures, serving as frames of reference for morality, providing children with avenues for imaginative escape, and even shaping bedtime rituals for families around the world. One of the most popular forms of the fairytale involves a prince and princess, often centered on romance and royalty. If you were to rank these characters in terms of sheer popularity, you would be hard-pressed to find any with more cultural reach than the Walt Disney princesses. Not only has Disney created princesses who are known on a first-name basis by children (and adults) everywhere, but the international corporation has also formed a brand: the *Disney Princess*, which extends beyond animated films into theme parks, Broadway stages, and merchandising (Do Rozario, 2004). Thus, Disney's long line of animated films has become a fairytale staple. Each film provides a romanticized portrayal of royalty and adventure for young audiences, while serving as a significant source of nostalgia for older viewers.

Given that Disney Princesses like Ariel, Cinderella, Jasmine, and Belle have amassed such cultural authority, it can be argued that these films are part of larger hegemonic processes that have been perpetuated by the Walt Disney Company. **Hegemony** explains how a powerful group of people can impose dominant beliefs, explanations, perceptions, values, and morals on others. Hegemony is seen in, and supported by, society and its cultural artifacts (Gramsci, 1970, p. 160).

It is necessary to understand hegemony in relation to the concept of ideology. Very basically, **ideology** is a way of thinking involving meaning production and interpretation, with the media serving as one of the main sites for this process (Fiske, 1997). Hegemony, or hegemonic processes, help to allow ideologies to stay in place, because these processes are made to look like they are "common sense"—therefore, society rarely questions or criticizes their outcomes (Lull, 2000). In order for hegemony to operate, ideological viewpoints (ways of thinking) must become normalized aspects of culture. **Normalized** means that individuals consent to the process without truly realizing it.

Unless we think about these processes, hegemonies can easily go undetected, simply because they seem "normal" for society. However, Gramsci

theorized that hegemony has the ability to change, or become resistant—which introduces his concept of counter-hegemony. **Counter-hegemony** involves the purposeful change in certain cultural representations, in an effort to shed light on new conceptions of what it means to be "normal" in society. Counter-hegemony acts as a form of resistance against already-apparent forms of power (Bloommaert & Bulcean, 2000).

The media, including the Walt Disney Company, plays a large role in the perpetuation of particular hegemonies. Disney is a major conglomerate, serving as an information-diffusing, socializing institution for society, meaning that the lessons it creates and repeats become crystallized and sustained in society (Lull, 2000). Disney's animated fairytales have created and supported messages that perpetuate socially accepted, hegemonic norms of beauty, gender roles, age, and status, to name a few (Brule, 2008). These norms subscribe to more traditional notions of **patriarchy**: the belief that men are strong, and women should be submissive. While Disney's blockbuster hit *Frozen* (del Vecho, Buck, & Lee, 2013) continued the use of some traditional hegemonic norms seen in other Disney animated films, the movie also left audiences surprised and excited, through its attempt to "flip the script": *Frozen* challenged certain traditional themes seen in fairytales. The film presented the Disney Princess as someone new—more independent and adventurous, and less reliant on the love of a man. A discussion of the themes seen in *Frozen* provides an important and interesting analysis of hegemony and counter-hegemony (see Table 1).

Table 1: Examples of Hegemony and Counter-Hegemony in Disney's *Frozen*

HEGEMONY	COUNTER-HEGEMONY (RESISTANCE)
Beauty	Gendered roles
Age (Youthfulness)	How love is defined
Ethnicity	Princess as representing authority (not continuing patriarchy); female as the order (royalty)
Status in current social system (royalty)	
Princess seeking autonomy	

The cultural reach of *Frozen* is difficult to ignore. Since its release, the film has earned more than \$1.2 billion, making it the fifth-highest-grossing film of all time (Konnikova, 2014). Chances are, you have seen *Frozen*, and can probably recite the lyrics to its seminal number, "Let it Go" (Anderson-Lopez, & Lopez, 2013). If you haven't, here is a summary:

> Fearless optimist Anna (voice of Kristen Bell) teams up with rugged mountain man Kristoff (voice of Jonathan Groff II) and his loyal reindeer Sven in an epic journey … to find Anna's sister Elsa (voice of Idina Menzel), whose icy powers have trapped the kingdom of Arendelle in eternal winter. Encountering Everest-like conditions, mystical trolls and a hilarious snowman named Olaf, Anna and Kristoff battle the elements in a race to save the kingdom (Walt Disney Studios, 2013).

With that story outline to orient us, we can now take a look at how *Frozen* is a helpful cultural artifact, for understanding hegemony as a concept in communication.

Hegemony

Elements of traditional hegemony, previously seen in Disney animated classics, carried over into this film. First of all, the ideal standards of feminine beauty are clearly perpetuated in *Frozen*, as both main characters (Anna and Elsa) conform to previously established Disney standards of what it means to be physically attractive. The appearance of a Disney Princess is anything but unique—she can be recognized by her thinness (particularly represented by a tiny waist), perfectly coiffed hair, symmetrical facial features, and large, innocent eyes. In this sense, Anna and Elsa are examples of how Disney has continued the hegemonic norms of beauty in this new film. Age is also an important consideration for hegemonic continuity used in the film. Disney consistently creates princesses who imply that youth determines value and beauty. Anna and Elsa are no exception (Brule, 2008).

The ethnicity of Disney Princesses provides another area for explorations of hegemony. Ethnic origin of a Princess can be recognized rather quickly in Disney films, with visual cues such as skin tone, speech pattern, clothing, and references to heritage, serving as forms of explanation for audience members (Smith, Pieper, Granados, & Choueiti, 2010; Wilson, Kunkel, Linz, Potter, Donnerstein, Smith et al., 1997). The majority of Disney Princesses from classic animated films are white, signified primarily through their extremely pale skin tones (e.g., Cinderella, Ariel, Belle, Aurora, etc.). Anna and Elsa are not only white, but once again, have skin tones that are as fair as

porcelain. This reaffirms a hegemonic idea of who should be in power, since both pale characters possess royal standing. Status in one's social system is also a consideration, when looking at hegemonic norms presented in Disney animated films. Depictions of royalty in *Frozen* affirm the exceptional value of high status. The heroines Anna and Elsa are both princesses. A significant portion of the film features the celebration of Elsa's crowning as Queen of Arendelle, after the girls' parents die in a shipwreck. These characters are highly privileged. They live in a luxurious castle, have servants, and don't have to work. Ignoring the fact that in most cases it is necessary for individuals to work their way to economic stability, *Frozen* reiterates the idea that royalty should be valued and promoted.

A final hegemonic norm in *Frozen* is shown in the way females must struggle for a sense of autonomy. Again, *Frozen* is consistent with previous storylines in Disney's animated repertoire. In *The Little Mermaid*, Ariel longs for legs that would enable her to interact with humans on land. *Cinderella* features a main character imprisoned in her own house, with an evil step-family who enslave her. In *Beauty and the Beast*, Belle dreams of a life where she "fits in," since her love of reading makes her an outcast in her town. Princess Jasmine disguises herself as a street person in *Aladdin*, risking her life just to get a taste of what it feels like to be "normal."

In *Frozen*, Elsa clearly struggles with her autonomy from the start. Gifted with magical powers that enable her to freeze anything she touches, she is taught from a young age to "conceal, don't feel," in an effort to protect herself and others from danger. Most notably, on her coronation day, Elsa forgets her mantra, and feels frustration as a result of her sister Anna's impulsive engagement to Prince Hans. This causes Elsa to accidentally freeze the entire community of Arendelle. Panicked and scared, she flees toward the North Mountain, to hide from the townspeople, who all accuse her of witchcraft. Once she arrives and realizes she is finally alone with her powers, Elsa proceeds to exercise her autonomy in a way she had never been able to before. She builds her own frozen kingdom, while singing the lyrics to the now-popular anthem "Let it Go" (Anderson-Lopez, & Lopez, 2013), which express her quest for, and new attainment of, autonomy and independence.

Elsa's actions represent the search for and ultimate arrival into self-hood. Her experience of growing up is cast off, physically and emotionally, through her increasing reliance on her own abilities and judgments—a common theme for Disney films. This is often seen in the form of Disney Prin-

cesses defying their fathers; but here, Elsa defies her responsibilities as Queen (Do Rozario, 2004; Richards, 1995). Ultimately, Elsa's quest for independence pays off, as she learns to manage her powers in a way that ends up benefiting Arendelle. Although she caused the problem by freezing Arendelle, putting it into a perpetual blizzard, she and Anna are able to break the spell, by learning that love can thaw the ice. It is then that Elsa learns how to control her powers, thawing Arendelle. She does, however, freeze one portion of the town, at the end of the film, for people to ice skate and enjoy themselves.

Although it is clear that the Walt Disney Company continued its use of certain themes in *Frozen*, thereby perpetuating particular hegemonic norms, the film also gained praise from audience members and film critics for its attempts to dismantle more traditional themes seen in fairytales. In the next section of this chapter I will show how counter-hegemony in *Frozen* offers new ways of conceptualizing princesses and the fairytale genre.

Counter-Hegemony

Perhaps for one of the first times throughout Disney's history of animated success, the company shifted its traditional script of a prince rescuing a princess, and offered examples of counter-hegemony. Some portrayals in the film went against normalized definitions. Remember our definition of **counter-hegemony**: the way everyday people resist traditional avenues for meaning-making (Van Bauwel, 2006). Traditionally oppressed groups (such as female characters, in Disney's animated films) are given an opportunity to "fight against" power and cultural norms (Downing, Ford, Gil, & Stein, 2001). These resistant representations help to dismantle the legitimacy of the status quo. Various examples of these counter-hegemonies can be seen in *Frozen*.

The most notable example occurs in the film's conclusion, which itself acts as a form of resistance, against traditional versions of fairytales from the Disney studio. Earlier Disney movies rest on the notion that to have a "happy ending," a princess must be saved by a prince, who then guarantees her a lifetime of happiness (Smith et al., 2010). In *Frozen*, the story plays out differently. When Anna finds Elsa in her isolated ice-kingdom, Anna is accidentally hit by an misfired spell, and is slowly freezing to death. The only way for the spell to be broken is by "an act of true love." It is assumed, from earlier events in the film, that this "act of true love" can only be performed

by Prince Hans, the man Anna had known for one day and become engaged to at the beginning of the movie. We soon learn, however, that Prince Hans was using Anna as a pawn in his own power-grabbing schemes, and that he did not truly love her.

Then, in keeping with hegemonic representations, audience members quickly assume that "true love" was right in front of Anna all along, in the form of her closeness with Kristoff, the man who helped her navigate the mountains. As Kristoff runs toward Anna, she begins to freeze. He is unable to make it to her in time, and Kristoff and Elsa suddenly realize the spell has taken hold, and Anna is frozen forever. The audience is left feeling stunned and sad that Kristoff is unable to save her. Suddenly, Elsa begins to cry as she realizes her sister has turned into solid ice, throwing her arms around her. Slowly, Anna begins to melt, showing that, in fact, it was not necessary for Anna to be saved by a prince, or by a man at all, for that matter. The real "true love" is in her sisterly bond with Elsa.

Traditional representations of love in Disney films are most always presented as "romantic love," with marriage or romantic union serving as the "happy ending" of the fairytale. In previous portrayals (save the very recent *The Princess and the Frog*), Disney has used this form of love as the resolution to every conflict (Altman, 1989; Do Rozario, 2004). In the case of *Frozen,* however, romantic love is replaced with familial love, presenting a strong example of counter-hegemony. It is important to note that Anna still ends up with her ultimate love interest, Kristoff, as evidenced by their kiss at the end of the film; but this relationship is not what remedied the conflicts present in the storyline—this was done only by Anna and Elsa's sisterly love.

A second example of counter-hegemony seen in the film, is the presentation of women serving as royalty. While this is common in other Disney films (which each contains a princess), *Frozen* is unique in requiring females (Queen Elsa and Princess Anna) to continue the lineage through autonomous rule. They are not reliant upon the princes or kings seen in other Disney classics. In fact, Elsa does not have a love interest, and Anna ultimately falls for Kristoff, a man who has no ties to royalty and sells ice for a living. In more traditional representations, Disney creates animated societies that are dominated by men, depicting forms of patriarchy and female subordination (Wasko, 2001; Zipes, 1995). Here, Elsa and Anna present counter-hegemonic examples of female authority and leadership.

Finally, counter-hegemony can be seen in *Frozen* through the film's portrayal of gender roles. Traditional representations of gender in fairytales lim-

its female characters to roles that are traditionally "feminine" (e.g., helpful, nurturing, and kind). Anna does exemplify these conventional female characteristics, but also embodies traditionally masculine qualities, as well. She is athletic, brave, and adventurous (England, Descartes, & Collier-Meek, 2011). She has the ability to "keep up" with Kristoff during their expedition, often to his surprise (evidenced by his facial expressions), even helping him physically to fight off a pack of hungry wolves, and often asserting her ability to "take care of herself." Her actions throughout the film break traditional notions of what it means to be "feminine," featuring her in situations where she proves her independence, strength, and bravery. In this portrayal, Disney engaged in counter-hegemony, whereby a lead female character—a Disney princess, at that—is able to transcend traditional boundaries, to offer an example of a female providing leadership, strength, and a strong intellectual capacity.

Conclusion

Traditional Disney films have long relied upon culturally accepted and normalized adaptations of the fairytale. These include specific representations of beauty, age, ethnicity, gender messages, and the role of love, to name a few. With Disney's 2013 release of *Frozen*, some traditions remain, while a number of others are challenged and reversed throughout the film. With elements that defy gender roles, how love is signified, and how authority is represented, *Frozen* sets itself apart, as an example of resistant media.

By exploring issues of hegemony, and particularly counter-hegemony, in this chapter, I hope you feel you can now better recognize culturally established norms. When we do this, we also consider the ways popular culture can adapt and better reflect a diverse, integrated society (Brule, 2008). Should Disney continue to challenge more traditional themes present in fairytales, the company has an opportunity to break through common social norms, in a way that could prove positive, useful, and encouraging, for young and adult viewers alike.

Keywords from This Chapter

Counter-hegemony
Hegemony
Ideology
Normalized
Patriarchy

References

Altman, R. (1989). *The American film musical.* Bloomington, IN: Indiana University Press.
Anderson-Lopez, K., & Lopez, R. (2013). Let it go [Recorded by Idina Menzel]. On *Frozen: Original Motion Picture Soundtrack.* Burbank, CA: Walt Disney Records.
Bloommaert, J., & Bulcean, C. (2000). Critical discourse analysis. *Annual Review of Anthropology, 29*(1), 449.
Brule, N. J. (2008). "Sleeping Beauty gets a makeover": Using the retelling of fairytales to create an awareness of hegemonic norms and the social construction of value. *CommunicationTeacher, 22*(3), 71–5.
Del Vecho, P. (Producer), & Buck, C., & Lee, J. (Directors). (2013). *Frozen.* [Motion Picture] United States: Walt Disney Studios.
Do Rozario, R. C. (2004). The princess and the magic kingdom: Beyond nostalgia, the function of the Disney princess. *Women's Studies in Communication, 27*(1), 34–59.
Downing, J., Ford, T., Gil, G., & Stein, L. (2001). *Radical media: Rebellious communication and social movements.* Thousand Oaks, CA: Sage.
England, D. E., Descartes, L., & Collier-Meek, M. A. (2011). Gender role portrayal and the Disney princesses. *Sex Roles, 64*(1), 555–67.
Fiske, J. (1997). *Introduction to communication studies.* New York, NY: Routledge.
Gramsci, A. (1970). *Selections from prison notebooks.* New York, NY: International Publishers.
Konnikova, M. (2014). How "Frozen" took over the world. Retrieved from: http://www.newyorker.com/science/maria-konnikova/how-frozen-took-over-the-world
Lull, J. (2000). Hegemony. In J. Lull (Ed.), *Media, communication, culture: A global approach* (2nd ed.) (pp. 48–59). New York, NY: Columbia University Press.
Richards, C. (1995). Room to dance: Girls' play and "The Little Mermaid." In C. Bazalgette &D. Buckingham (Eds.), *In front of the children: Screen entertainment and young audiences* (pp. 141–50). London, England: British Film Institute.
Smith, S. L., Pieper, K. M., Granados, A., & Choueiti, M. (2010). Assessing gender-related portrayals in top-grossing G-rated films. *Sex Roles, 62*, 774–86.
Van Bauwel, S. (2006, June). *Rearticulating resistance as concept in the field of media studies: A case study on the resistance against hegemonic gender identities in popular visual culture.* Paper presented at the annual meeting of the International Communication Association, Dresden International Conference Centre, Dresden, Germany.
Walt Disney Studios (2013). [*Frozen* plot summary]. Retrieved from: http://frozen.disney.com
Wasko, J. (2001). *Understanding Disney: The manufacture of fantasy.* Cambridge, England: Polity Press.
Wilson, B. J., Kunkel, D., Linz, D., Potter, D., Donnerstein, W. J., & Smith, S. L., et al. (1997).

Violence in television programming overall: University of California, Santa Barbara study. In *National television violence study* (p. 253). Thousand Oaks, CA: Sage.

Zipes, J. (1995). Breaking the Disney spell. In E. Bell, L. Haas, & L. Sells (Eds.), *From mouse to mermaid: The politics of film, gender, and culture* (pp. 21–42). Bloomington, IN: Indiana University Press.

I was immediately drawn to this article because of the *Frozen* reference. I initially thought the younger generation's fascination with a movie like *Frozen* was a great thing—after all, Anna and Elsa seem like strong capable, young women. They share a sisterly bond, something a lot of Disney movies seem to lack. Yet, there is something slightly unnerving about *Frozen*, and Applequist's chapter finally helped me put my finger on the problem with it (and other Disney movies, from which it isn't all that different, after all): gender roles and stereotypes are still present, and it would be unfortunate to not acknowledge these issues, and question them.

Disney movies play a large role in our thought processes. Almost everyone in my generation (as a nineteen-year-old college student) has a favorite Disney movie. Even full-grown adults have developed strong feelings for Disney—and for good reason. Disney is quite involved in our lives—whether we like it or not. They have invaded our sunny states, our dark movie theaters, and even our minds. Applequist was quick (not to mention correct) to point out that *Frozen* is chock full of ideologies. Anna and Elsa are beautiful, feminine, tiny-waisted, vocally blessed girls. Males and females have idolized this body shape for decades, and Disney cashes in on our idea of beauty, feeding us what we think is physically attractive. Have you ever seen a short, chunky, or even muscle-strong princess?

Yes, it is obvious that Disney does the long-haired, fair-skinned beauties quite well. However, it is also important to remember that they have also tried to become more "globally aware." Films like *Pocahontas* and *The Princess and the Frog* employ ethnic princesses to satisfy society's need to feel like we are culturally aware. You can say you watched a movie about old New Orleans and pre-colonial America, then watch a movie about strong, sassy sisters (like *Frozen)*. Parents are left feeling like they've made their child more aware of societal differences by exposing them to different eras and colors of skin. Yet, the problem still remains that Disney really doesn't stretch themselves. They shy away from truly controversial or serious issues.

Do they ever discuss poverty in a non-fairytale sense? Do they ever discuss human rights? No—though the question also needs to be asked, "Do they need to?" After all, for most kids (and parents) watching a movie is sort of an escape (for a sick child or a tired mom) from day-to-day life.

We don't want to raise ignorant children, or feed into hegemonies; but do we want to raise kids who don't ever have a chance to rest their mind, or quiet their thoughts, for an hour or two? I think an important question that we need to ask regarding movie characters and plots in relation to real life is, "How do we balance fictional fairy-tales with our own stories that aren't quite as charming?"

—Rachel Williams

CHAPTER 7

Mockingjays and Silent Salutes— Introducing Semiotics through *The Hunger Games*

Claudia Bucciferro

Close your eyes and consider these words: *The Hunger Games*. Let related images come to mind. Don't think of the story behind the title, just the images. What do you see?

Pictures related to *The Hunger Games* have filled media outlets in recent years. The books and movies have been enormously popular, attracting millions of followers and leading to some controversies (Bartlett, 2012). Even if you are not particularly interested in the series, you are probably familiar with it. Revisit the images you thought about. Do you see a gold circle enclosing a bird? Or a girl wielding a bow and arrow? Perhaps a young woman with an outline of wings against a fiery background? Think: what do these pictures mean? This chapter will introduce you to a theoretical framework, often used to study and analyze images such these. Its name is **semiotics**.

As a discipline and a theoretical body, semiotics concerns itself with the study of the symbolic construction of "meaning" (Berger, 2012). It focuses on how meaning is structured, passed-on, interpreted, and contested, advancing the idea that humans build conceptually complex worlds that intertwine with what we consider *real* (Barthes, 1988). Semiotics studies how things (such as bows and arrows, or certain hand gestures) come to stand in for larger meanings, representing something that goes beyond them (Barthes, 2012). The **signs** that are the focus of semiotic analysis are powerful, because they can move people to act, think, or feel in certain ways (Eco, 1976). Semiotics covers a wide range of phenomena, from social practices and rituals, to visual symbolism (Cobley, 2010). One reason the relationship between media images and processes of signification is prominent, is because of the visual richness that defines media content (Silverman, 1983). This chapter explains main principles of semiotics, through an analysis of *The Hunger Games* texts, considering both the film series (starring Jennifer Lawrence), and the original books written by Suzanne Collins (2008, 2009, 2010).

Studying Signs and Their Meanings

Scholarly analyses of *The Hunger Games* have focused on aspects such as representations of gender, relationships, politics, and violence (Bartlett, 2012; Pharr & Clark, 2012; Taber, Woloshyn, & Lane, 2013). Some authors have noted allegorical references to ancient Rome (Wilson, 2010). While writing, Collins drew from classical accounts, conceiving the Games as a kind of gladiator fight (Margolis, 2010), and assigning Latin names to characters from the Capitol (e.g., Caesar, Octavia). She called her fictional country "Panem," a reference to the Latin phrase *panem et circenses* ("bread and circuses"), the famous expression suggesting that as long as people are well-fed and well-entertained, they will not question their government (Wilson, 2010). From a semiotic perspective, we must consider *The Hunger Games* not as a self-contained text, but as part of a larger tapestry of meanings, full of layers and **inter-textual** references (Barthes, 1988). Some people may "catch" the references to Rome, while others will pay attention to alternative aspects of the story. A text is always **polyvalent**, so it can be read in more than one way (Eco, 1976).

In its origins, semiotics was influenced by linguistics, especially by ideas proposed by Ferdinand de Saussure and Charles Peirce—the two scholars who gave the discipline a name more than a century ago (Hénault, 2010; Houser, 2010). Saussure transformed linguistic inquiry, by saying that human language is composed of arbitrary signs (words) that bear no direct relationship to the things they designate, but acquire meaning through a conventional understanding within a community (Saussure, 2013). For example, the word "horse" has nothing in common with the actual animal—it is an abstract representation, so it only has meaning for those who know what it stands for. As Eco (1976) elaborates, meaning is "a cultural unit," not a static reference (p. 66).

Over the years, human language has been considered "the signifying system *par excellence*" (Silverman, 1983, p. 5). It is unique because of its high degree of conventionality, and its symbolic and arbitrary character, though it is not the only conceptual system we use (Hénault, 2010). Language presents us with a limited number of units (or letters) that combine according to particular rules (grammar), in order to produce words that can represent complex objects (e.g., "spaceship"), abstract concepts (e.g., "democracy"), or things that live only in our imagination (e.g., "unicorn"). When humans combine these words to form sentences, we can talk about anything that ex-

ists, and even create virtual worlds in our minds (Chandler, 2007). This is the basis for all fantasy and storytelling—which in turn relate to complex cultural processes of signification.

Therefore, when people read a story or engage with a visual text, they not only glean ideas, but become participants in a profound meaning-making practice that actualizes and validates other codes (Eco, 2014). Semiotics offers a pathway for analyzing the whole process, and uncovering the hidden logic connecting different conceptual systems (Silverman, 1983; Signo, 2015). Chandler (2007) explains:

> Semiotics involves the study not only of what we refer to as "signs" in everyday speech, but of anything which "stands for" something else. In a semiotic sense, signs take the form of words, images, sounds, gestures and objects. Contemporary semioticians study signs not in isolation but as part of semiotic "sign-systems" (such as a medium or a genre). They study how meanings are made and how reality is represented (p. 2).

As Roland Barthes (1988, 2012) points out, meaning can be attributed to a wide array of "things" that function as cultural artifacts, acquiring social and historical relevance. Analyses have been done regarding buildings, statues, ceremonies, gestures, dress codes, religious rituals, comics, advertisements, and more (Berger, 2012; Signo, 2015). In *A Theory of Semiotics*, Umberto Eco (1976) tackles the question of how are signs produced, and how their meanings become conventionalized. He states that signs are not freestanding, but interdependent: they form sign-systems. Signs develop within circumstances that enable dominant meanings, and they conceptually exist only in relationship to a community of interpreters (Eco, 1976; Silverman, 1983). A sign means something *to someone*, not inherently on its own.

These ideas may seem abstract, but if we read the *The Hunger Games* with this in mind, we see that the story illustrates this process behind the emergence and consolidation of a sign. Throughout the series, a whistled tune, a hand gesture, and a drawing become something more: a challenge to the status quo, and a code for the rebellion. By embracing and using these signs, people risk their lives. Furthermore, once a sign or symbol takes hold, it cannot be crushed, but becomes a powerful conceptual construct that can be a catalyst for social change.

More than a Gesture, More than a Bird

Semiotics studies how signs and sign-systems develop over time, and how their meaning changes along with social, political, and historical shifts (Cobley, 2010; Eco, 2014). For example, the image of an outstretched left arm with a fist is recognizable within the context of 20th-century social movements: it has represented the political Left, the revolution, the proletariat, Black power, and a general struggle for equality. The symbol has been put on posters and painted as graffiti; and people have been punished for using it. Such iconic gestures make lasting impressions, so there is a conceptual link between the raised fist, and the stylized three-fingers-up used in *The Hunger Games*. Although their meanings vary, they evoke related ideas. The same goes for the figure of the inspirational rebel—there have been many in the real world, even though none of them was quite like the fictional Mockingjay.

In this sense, a symbol may be particular to the world of Panem, but it can relate to similar historical usages that add depth to its meaning. Let's try a basic semiotic analysis on two main symbols from *The Hunger Games*: the three-fingers-up, and the mockingjay.

Three-Fingers-Up

A raised left hand, with three outstretched fingers, first appears as a symbolic gesture, when Katniss volunteers to take her sister's place at the reaping. She walks up to the stage, and Effie asks for a round of applause, but people silently offer a solemn greeting. As she explains in the book:

> At first one, then another, then almost every member of the crowd touches the three middle fingers of their left hand to their lips and holds it out to me. It is an old and rarely used gesture of our district, occasionally seen at funerals. It means thanks, it means admiration, it means good-bye to someone you love (Collins, 2008, p. 24).

The gesture is used during other pivotal moments of the story: when Rue dies, during the victory tour, and when Katniss officially joins the rebels. After Rue's death, Katniss is seen bidding her farewell; and the gesture's meaning broadens, to encompass empathy, strength, kinship, and honor. Later, during the victory tour, Katniss and Peeta visit Rue's district, and improvise a speech that moves the silent crowd. In response, an old man whistles a tune formerly used by Rue, and everyone raises the three fingers of the left hand. Katniss wonders: "What will [President Snow] think of this very pub-

lic salute to the girl who defied the Capitol?" (Collins, 2009, p. 61). The whistling man is immediately approached by Peacekeepers, dragged to the front steps, and killed with a gunshot. The scene suggests the sign's prominence, and the emblematic role that Katniss is called to play in the rebellion. Because the fictional three-fingers-up sign has conceptual ties to other politically charged hand gestures, it wasn't long before it crossed over into the real world. In 2014, *The New York Times* reported that students protesting the military government in Thailand identified with *The Hunger Games'* critique of authoritarianism, and began using the symbol in their protests (Mydans, 2014). As part of a crackdown on political dissenters, the sign was officially banned in the country, and the police were instructed to detain anyone using it, even in quiet places, such as movie theaters. Mydans (2014) explains that the gesture was construed as "a symbol of defiance," but that it had a more personal meaning for some people—one of the students interpreted it as "a sign to show that I am calling for my basic right to live my life" (n.p.). These incidents illustrate the power that a sign can have, and how it can travel beyond its original cultural and social context. As suggested in the film *Mockingjay: Part 1*, the relationship between a grassroots movement, a strong leader, and the idea of rebellion is mediated symbolically.

The Mockingjay

The figure of the mockingjay is first introduced when Katniss receives what will become her emblem: a golden pin featuring a small bird. The pin's source is different in the books and the movies (in the books, Katniss gets it from her friend Marge; in the movies, from a woman at the Hob), but its construed meaning is the same. The pin is a token that connects Katniss to the people in her district, and reminds her of her life before she was a tribute. She wears the pin when she goes into the arena, and for the audience, its image will eventually represent her persona.

Mockingjays have significance for Katniss, because her father was fond of them, and they were abundant in the woods near her house. She explains that the birds could be considered "something of a slap in the face to the Capitol" (Collins, 2008, p. 42), because they were the offspring of a genetically engineered species ("jabberjays"), that was left to die in the wild when deemed no longer useful, but that unexpectedly survived. Thus, the mockingjay represents an affirmation of life, and a connection to the unruly power of

nature. Suzanne Collins implies that both Katniss and the mockingjay defy the Capitol's design, so they are naturally subversive:

> Katniss is the mockingjay. She is the thing that should never have been created, that the Capitol never intended to happen. In the same way they just let the jabberjays go and thought, "We don't have to worry about them," they thought, "[We] don't have to worry about District 12." And this new creature evolved, which is the mockingjay, which is Katniss (Margolis, 2010, n.p.).

In the arena, the birds are complicit in Katniss and Rue's alliance, since the girls whistle a song to communicate, counting on the mockingjays to echo it through the forest. The mockingjay then becomes a symbol for hope and collaboration, in the midst of adverse circumstances. According to the novels, Rue almost seems to embody a bird—she is light, small, agile, can travel through the trees, and appears at her televised interview "dressed in a gossamer gown complete with wings" (Collins, 2008, p. 126). Upon her death, the symbolism of the mockingjay also deepens, as the bird reminds Katniss of her friend, and strengthens her will to win the Games. In *Catching Fire*, Katniss dreams of Rue being a mockingjay, who leads her onward.

As the story evolves, the mockingjay becomes a symbol for something more—strength, resistance, and defiance—and it is Katniss who begins to embody it. She first becomes aware of the symbol's prominence, when she sees it painted as graffiti, flashing by as her train rushes on. In the books, she encounters two women fleeing from a district, carrying a piece of bread stamped with the picture. Slowly, Katniss realizes that she has become "a catalyst for rebellion," and that the mockingjay sign is her banner, even though that was never her intention (Collins, 2009, p. 124). She thought her struggle was personal, until others adopted it to represent a larger social movement. This matters because signs can take paths of their own, independent from the intentions of those who create them. Katniss gave the rebellion a symbol and a face—and by doing so, it strengthened it.

The power of a sign is related to people's investment in it—and in this case, people are willing to sacrifice themselves for the Mockingjay. As far as Katniss knows, it begins with Cinna, her stylist, who dresses her for a television appearance in an outfit that would cost him his life. A victor, turned again into a tribute for the Quarter Quell, Katniss walks onto the stage wearing a white wedding gown; but when she twirls the dress goes up in flames, transforming into a black, winged costume. Katniss visually *becomes* a

mockingjay, and the symbolism is not lost on the audience, or President Snow.

From then on, in people's minds, Katniss fully embodies the Mockingjay, representing a particular ideological and social position. Several tributes sacrifice themselves for her, during the Games, as part of a plan that she is unaware of. It is not until she finds herself in District 13—subject to the pressure from President Coin—that she formally agrees to support the revolutionary effort, and "be" their Mockingjay (Collins, 2010, p. 38). Then, her assignment is to appear in a series of television spots, orchestrated with the intention of augmenting the rebellion's momentum and uniting the districts against the Capitol. Thus, the propaganda effort plays a role in a *symbolic* war, that runs parallel to the actual war being fought on the streets. Katniss, The Mockingjay, is powerful enough to help turn the tide, to the rebels' favor.

In semiotic terms, signs have ideological underpinnings, and are inscribed within multiple conceptual contexts, existing as psychic representations shared by a community (Silverman, 1983). Their meaning is not easily manipulated, even though people often try to do so, given the power that they can exert (Barthes, 1988, 2012). As Katniss realizes, during her visit to the rebel hospital, after agreeing to be the Mockingjay:

> I begin to fully understand the lengths to which people have gone to protect me. What I mean to the rebels. My ongoing struggle against the Capitol, which has so often felt like a solitary journey, has not been undertaken alone. I have had thousands upon thousands of people from the districts at my side. I was their Mockingjay long before I accepted the role (Collins, 2010, p. 90).

In the books, as the fight against the Capitol's power reaches its climax, the scope of Katniss's influence becomes threatening to District 13's hierarchy, so various attempts are made to control it (Collins, 2010). The conflation of the Mockingjay symbol with Katniss leads to mixed outcomes, and the rebellion's triumph is obtained at a great cost. Katniss succeeds in bringing down Snow's authoritarian regime, but she loses people she cares about; and her own physical and psychological well-being are hard hit. After a last act of defiance, she goes back to a simple life in her district, and the Mockingjay becomes a memory, deeply connected to those whose lives were lost. Even in this, there is a semiotic lesson: symbols can shape history, and tend to endure after those who helped develop them move on.

Conclusion

A complex text such as *The Hunger Games* allows for a variety of readings, and invites analysis from many different perspectives (Bartlett, 2012; Taber et al., 2013; Wilson, 2010). This chapter introduces a particular theoretical framework—semiotics—and illustrates an interpretive process, focused on two prominent signs presented in the series. There are other aspects we could discuss: the white rose that is emblematic of President Snow's power, for example, or the way that fashion is used to represent an indolent Capitol. From a semiotic perspective, the importance of signs and symbols stems from the complex and inter-related meanings they can evoke (Barthes, 1988; Silverman, 1983). Nothing is as simple as it may seem.

The Hunger Games functions as a cultural artifact, whose meaning intertwines with many other ideas, containing references that extend into social and political realms (Dunn & Michaud, 2012; Pharr & Clark, 2012). The films and the books are complementary, expanding the content of the story in different directions. Thus, the novels offer a better understanding of Katniss's inner life, while the movies are richer in audio-visual terms, inviting various levels of engagement. Core ideas presented throughout the series are anchored in symbols, such as the Mockingjay and the three-fingers-up salute. These are so rich in meaning that they have traveled across continents and beyond the realm of fiction, being adopted in real political struggles.

A last semiotic premise must be stated in light of all this: A sign is a powerful thing because it can stand for something beyond its immediate reality. Therefore, it can capture people's imaginations, subvert the establishment, invite self-sacrifice, and advance ideologies. Like the girl on fire, a sign can take on a life of its own.

Keywords from This Chapter

Inter-textual
Polyvalent
Semiotics
Signs

References

Barthes, R. (1988). *The semiotic challenge* (R. Howard, Trans.). New York, NY: Hill and Wang.
———. (2012). *Mythologies* (R. Howard, & A. Lavers, Trans.). New York, NY: Hill and Wang.

Bartlett, M. (2012). Appetite for spectacle: Violence and entertainment in *The Hunger Games*. *Screen Education, 66*, 8–17.

Berger, A. (2012). *Understanding American icons: An introduction to semiotics*. Walnut Creek, CA: Left Coast Press.

Chandler, D. (2007). *Semiotics: The basics* (2nd ed.). London, England: Routledge.

Cobley, P. (2010). *The Routledge companion to semiotics*. London, England: Routledge.

Collins, S. (2008). *The hunger games*. New York, NY: Scholastic.

———. (2009). *Catching fire*. New York, NY: Scholastic.

———. (2010). *Mockingjay*. New York, NY: Scholastic.

Dunn, G., & Michaud, N. (Eds.). (2012). *The Hunger Games and philosophy: A critique of pure treason*. Hoboken, NJ: John Wiley & Sons.

Eco, U. (1976). *A theory of semiotics*. Bloomington: Indiana University Press.

———. (2014). *From the tree to the labyrinth: Historical studies on the sign and interpretation* (A. Oldcorn, Trans.). Cambridge, MA: Harvard University Press.

Hénault, A. (2010). The Saussurean heritage. In P. Cobley (Ed.), *The Routledge Companion to Semiotics* (pp. 101–17). New York, NY: Routledge.

Houser, N. (2010). Peirce, phenomenology and semiotics. In P. Cobley (Ed.), *The Routledge Companion to Semiotics* (pp. 89–100). New York, NY: Routledge.

Margolis, R. (2010). The last battle: With 'Mockingjay' on its way, Suzanne Collins weighs in on Katniss and the Capitol. *School Library Journal*, August 1, 2010. Retrieved from: http://www.slj.com/2010/08/authors-illustrators/the-last-battle-with-mockingjay-on-its-way-suzanne-collins-weighs-in-on-katniss-and-the-capitol/

Mydans, S. (2014). Thai protesters are detained after using 'Hunger Games' salute. *The New York Times*, November 20, 2014. Retrieved from: http://www.nytimes.com/2014/11/21/world/asia/thailand-protesters-hunger-games-salute.html?_r=0

Pharr, M., & Clark, L. (Eds.). (2012). *Of bread, blood, and* The Hunger Games: *Critical essays on the Suzanne Collins trilogy*. Jefferson, NC: McFarland.

Saussure, F. (2013). *Course in general linguistics* (R. Harris, Ed. & Trans.). London, England: Bloomsbury.

Silverman, K. (1983). *The subject of semiotics*. New York, NY: Oxford University Press.

Signo. (2015). *Signo: Theoretical semiotics on the web*. University of Québec. Retrieved from: http://www.signosemio.com/index-en.asp

Taber, N., Woloshyn, V., & Lane, L. (2013). 'She's more like a guy' and 'he's more like a teddy bear': Girls' perception of violence and gender in *The Hunger Games*. *Journal of Youth Studies, 16*(8), 1022–37.

Wilson, L. (Ed.). (2010). *The girl who was on fire: Your favorite authors on Suzanne Collins' Hunger Games trilogy*. Dallas, TX: SmartPop, BenBella.

Semiotics, "the study of the symbolic construction of 'meaning,'" depends on the ability of language to evolve. The mockingjay in *The Hunger Games* evolved symbolically, from a genetically modified bird, to a sign of rebirth and revolution for the people of the Districts, just as words, symbols, and phrases are being assigned and re-assigned meaning by people every day. "Hashtag" comes to mind: a word which did not exist ten years ago, unlike its symbol, which was originally a number sign. I evoke the spirit of semiotics now, in asserting that .gif is pronounced "JIF." Yes, .gif stands for "graphics interchange format," and, as we can all plainly see, "graphics" begins with a hard "g," leading some to think that its abbreviation should also begin with a hard "g." However, no matter how the word was meant to be pronounced, it has been repurposed by internet-savvy speakers, in such a way that it rolls off the tongue. Thanks to the evolutionary nature of language, as examined through semiotics, sentences such as, "Dude, check out this sweet .gif," may be uttered again and again, perhaps five times fast, with little to no stumbling.

—Erika Davies

CHAPTER 8

Understanding Stuart Hall's "Encoding/Decoding" Model through TV's *Breaking Bad*

Garret Castleberry

This chapter introduces *Breaking Bad* as a way of understanding "encoding/decoding" in communication. *Breaking Bad* is created by writer Vince Gilligan, who served as executive producer and "showrunner," throughout the cable drama's run from 2008–2013. The term showrunner is unique to television. The **showrunner** functions similarly to a filmmaker or a composer, steering the program in terms of the script and delivery of lines, but often the look, sound, and scope of the series, as well. In shaping a TV product, showrunners wield dynamic persuasive appeal.

Academic theorists have a very similar job. Like showrunners, they shape how we view the world. Theorists offer informed insights, based on long-term research and analysis. For this reason, "theory" is often associated with heavy-lifting, due to the burden placed on extending language and knowledge. Like the showrunner, a theorist harnesses potential for longstanding persuasive appeal. Yet, whether persuasive appeal occurs through a theory, or from a television show, these artifacts matter because they change our perceptions. Following this rationale, *Breaking Bad* works well, in demonstrating Stuart Hall's theory of encoding/decoding. At the same time, Hall's method of analysis will help us interpret (or *decode*) the potential reasons that texts like *Breaking Bad* become popular with a variety of audiences, spanning race, class, and gender boundaries.

To accomplish this, first we will identify and define key terms. Then, we will briefly place Hall's theory in social, cultural, and academic context. Context will help us understand why Hall's essay represented a turning point, in communication and cultural studies. Then we will examine each of the key ideas at work in Hall's theory, and how they can be understood (and extended) through the cultural lens of *Breaking Bad*.

Context and Significance for Hall's Encoding/Decoding

Stuart Hall's encoding/decoding theory originated alongside the modern formation of critical/cultural studies. Hall worked in the Centre for Contemporary Cultural Studies (or CCCS), and developed a new branch of media

studies (Gray & Lotz, 2012; McQuail, 2006; Hall, Hobson, Lowe, & Willis, 2006/1980). While working for the Centre, Hall joined a team of researchers referred to as "The Media Group" (Hall et al., 2006/1980, p. 117). These theorists went rogue, to a certain extent, in breaking away from previous statistical emphases in media communication research. We can call this kind of transition in thinking a **paradigm shift**: a new way of thinking that leads to new methods. Hall and his colleagues departed from the method of analyzing mass communication that was traditional prior to the 1970s. Previous researchers were interested in studying **media effects.** Hall was more interested in **hegemony**, which, in theory, helps "maintain the status quo and solidify the role of the ruling classes in society" (Burger, 2012, p. 20). Hall developed criticisms that evaluate "the ideological role of media" (Hall et al., p. 117). **Encoding/decoding** also helps clarify the role of audiences, particularly the diverse ways they receive or decode meanings based on individual experiences (p. 118). These **decoding processes** include differentiating between *dominant-hegemonic, negotiated*, and *oppositional* readings of texts

Breaking Bad centers on an everyday, middle-aged, white, male teacher, Walter White. Walt is a brilliant mind, but finds himself at a point of crisis, as he faces insubordination in both his work and home life. Walt's wife gives him grief, including adjusting his diet to feature "veggie bacon" (on his 50th birthday, no less), and stays at home while he works multiple jobs. Walter also has a son, with a debilitating disease that he cannot control. Neither of Walt's jobs is fulfilling. As a chemistry teacher, Walter's charisma bottoms out in a classroom of millennials ignoring and defying his authority (and masculinity, by extension). A second job at a local carwash proves even less rewarding. Walt is, again, the subordinate to a Middle Eastern boss, and receives further demotion when forced to kneel and wash tires in the street. In this pilot scene, the use of physical space—outdoors, and low to the ground—signifies Walt's diminished social position.

Bottoming out in a depressed livelihood, Walt receives the unexpected diagnosis that he has late-stage lung cancer. While this news might drive a depressed individual to suicide, Walt chooses to end his life on his own terms. Thus, Walter White transforms his pathetic public persona into that of a mercurial meth-cook-cum-drug-kingpin, "Heisenberg." Heisenberg assumes all of the aggressive, masculine qualities that the former Walter lacks, and seeks new riches through subaltern, counter-cultural methods. These criminal acts start off innocently enough, mostly as attacks against the corporatized system encoded within American bureaucracy and (im)morality. Over

time, Walt's decisions shift from gray to black, as he becomes ensconced in the criminal underbelly in Albuquerque, New Mexico. Like the real Hall, the fictitious Walt prefers an oppositional path to the traditional one, yet his ultimate goals are couched in quite different ideological messages: power and greed.

In an effort to unpack messages and meaning, both in and out of *Breaking Bad*, let's return to Hall's theory. Recognizing how the encoding/decoding theory extends the communication model will help reinforce its importance, and clarify our uses of the cultural text *Breaking Bad*.

Encoding/Decoding as an Expansion Tier of the Communication Process

Hall's encoding/decoding model began in cultural studies, but it has had a profound impact on communication studies. This is clear when we look at the **communication process** or **communication model**: a simplified formula where a **sender** transmits a **message** along a **channel**, to a **receiver** who interprets the message. We can draw upon the example of television, to help this comparison. The initial television channel was broadcast from a singular location along radio wavelengths, and received by regional stations, towers, and, eventually, television sets at home. In the early history of television, this type of transmission indicates a one-to-many format (i.e., **mass communication**) where feedback is limited, if not altogether impossible. This contrasts starkly to the ways in which we consume television content today. Contemporary audiences respond in real time, in a number of ways, including posting to forums, live tweeting, or even re-interpreting the content for personal entertainment, such as the creation of Internet memes. We will get to modes of interpretation, in our decoding discussion. For now, it is convenient to consider traditional television as similar to the initial communication model.

Over time, theorists have found the communication model a bit too simple and have expanded it. For example, scholars have added interference, or **noise**, to the model. Noise functions as both an external and internal process, of selective receiving and interpretation (Lucas, 2012, p. 20–1). One type is **physical noise**, like the distraction of a person on his cell phone one row in front of you during a movie, or a dishwasher sloshing and clanging while you discuss bills with your roommate. In these examples, there is also a second type: **internal noise**, such as the stress associated with higher bills, or frustration at missing a key dramatic sequence in the film. Distractions hap-

pen in both accidental and intentional situations. Thus, noise or interference can and does occur, in any given communication exchange.

For a televisual example, imagine a cliffhanger moment in the season finale of your favorite drama. Now, imagine the reaction you might have if the local weathercaster interrupts to explain an upgrade from mild to moderately severe thunderstorms. On one hand, contemporary meteorologists have become more sensitive to audience displeasure at program disruptions (interrupting only during commercial breaks has actually become the new norm). On the other hand, local TV affiliate broadcasters regularly break FCC regulations by playing targeted ads at higher volumes during commercial breaks. In theory, this jarring effect might cause a passive viewer to come into the room and investigate, thus drawing attention to the ad itself. In reality, these tactics dissuade audiences from live viewing, instead investing in DVRs or streaming services that cut out commercials completely. We could assign an encoding mode of **interpretive noise** to cable channel AMC's promotional talk shows, which accompany series like *Breaking Bad* and *The Walking Dead*. Before we investigate this encoding method, let's finish connecting our communication model to Hall's encoding/decoding process.

The communication model sends a message along a channel, to a receiver who then interprets the message, and responds through feedback that may or may not experience noise or interference. Hall's method expands upon this model. He proposes that mediated messages like those produced by and for TV are strategically and purposefully encoded. The **encoding process** accounts for everything, from how a show is conceptually designed, written, cast, directed, and marketed, to when it airs, on what network or streaming service, with what accompanying commercials, and so on. In essence, there are no accidents, when it comes to televisual programming. Content is vetted carefully, even if it does not present information in a new or exciting fashion.

In the simplest terms, Hall's **decoding process** proposes three potential, interrelated categories for reading or interpreting a text: the *dominant hegemonic position*, the *negotiated position*, and the *oppositional position* (Hall, 2006/1980, p. 136–38). In each of these modes of interpretation, Hall argues that audiences receive and interpret messages differently. When these ideas first appeared, they proposed a massive change to the traditional understanding that all communication messages are received "correctly" and responded to accordingly. Not only does Hall present an expanded interpretation, regarding how we receive mediated messages from texts like TV, but also he effectively extends the most fundamental model in communication, into con-

versation with other scholars. We unpack some key language Hall uses, as we work through his model alongside our example text of *Breaking Bad*. First, consider what makes *Breaking Bad* a contemporary artifact worthy of attention.

The Communicative Chemistry of *Breaking Bad*

In interviews throughout *Breaking Bad*'s run on television, creator-showrunner Vince Gilligan often presented his text through the simplistic pitch, "How Mr. Chips becomes Scarface" (Frenan, 2010). The simple notion already communicates layered complexity, as audiences must receive and decode meanings about the identities of Mr. Chips or Scarface. (In case you are unfamiliar with these references, Mr. Chips is the title character of a sentimental novella [1934] and movie [1939] about a schoolteacher. Scarface is the title character of movies [1932 and 1983] depicting a cruel and ruthless drug lord.). Gilligan's suggestion speaks to another relevant term for scholars of media and mass communication: **intertextuality**, or "allusions within a text to another text or texts" (Danesi, 2012, p. 252). In this case, audiences looking for meaning in Gilligan's pitch would need to understand Mr. Chips as a fictional teacher of sympathetic means and high character, who then degenerates into Scarface, a gangster criminal based on real-world inspirations. In *Breaking Bad,* a sympathetic protagonist slowly transforms into a diabolical antagonist. This plays with audience expectations, regarding traditional television narratives. This combination of *imitation* and *innovation* is key to understanding **genre theory**, or how categories work to simultaneously meet, and/or alter, audience experiences. We can think of the mixture between imitation and innovation as a kind of chemical reaction, that, when applied correctly, enhances the pleasure of consuming a text like *Breaking Bad*. Based on critical and audience praise for the series, the show achieved a chemical response comparable to its own potent "blue" meth. Numerous critics, scholars, and fans have drawn comparisons, noting *Breaking Bad*'s "addictive" qualities. These qualities include the aforementioned recombination of imitation and innovation, combining aspects of both the gangster sub-genre of crime fiction and the pantheon of "family dramas" in TV history. Yet these two arenas of meaning only represent a fraction of the narrative and visual symbolism on which the show draws. For this reason, let's revisit several core ideas from Hall's "Encoding/Decoding" essay, in an effort to unpack the potency of *Breaking Bad*.

The Dominant-Hegemonic Position

One of the most powerful elements of television programs, especially those among the post-high definition, post-*Sopranos*, post-network era (Lotz, 2007), is the artistic layering that goes into productions and narratives. More than ever, televisual programs carry the look and feel of cinema, with topflight actors, producers, and directors involved at all levels. The steady influx of talent and money into the television industry since 2000, encodes television with legitimacy that it previously did not have. Throughout most of the twentieth century, television was viewed as lowbrow fare, in contrast to art or film. In addition to newfound legitimacy, the incoming talent and finances allow for attention to detail, in television production. This further encodes a program's content. It can be difficult for audiences to register forms of decoding that negotiate, if not oppose, the medium's message. Indeed most audiences watch their favorite programs *passively*, thus accepting the narrative structure as is—with no room or thought to question the messages. Due to this potential difficulty, we will investigate examples both within *Breaking Bad*'s narrative world, and in its **paratexts**: those outside examples that complement and contest the text.

Breaking Bad is a fascinating artifact in that it both reinforces typical dominant-hegemonic positions, while simultaneously opposing others. For instance, consider the premise of this drama. A white, middle-class, middle-aged, male teacher forgoes his declining American livelihood, and refuses to follow "the system's" instructions, on how to live in an upright manner. Instead, Walt enters a life of crime, where he jeopardizes his morality, rejects and breaks the laws of the land, and endangers his family more and more with each episode. On the surface, this premise appears relatively counter-cultural—pretty roguish, if not outright anti-American. Anti-American qualities are negative ideological messages that do not support the status quo. Sounds pretty oppositional, right?

But now, consider the key factors that in the paratext, or outside the text's narrative. Creator-showrunner Vince Gilligan is a white, middle-aged male of middle-to-upper-class socioeconomic means. Actor Bryan Cranston is a successful entertainer, and also a white, middle-aged male. *Breaking Bad*'s story takes place in Albuquerque, New Mexico, where the show is shot on location; but a majority of its cast and characters are white, English-speaking individuals. Jesse Pinkman, Walt's sidekick and foil (played by Aaron Paul), suffers from an on-again, off-again addiction to meth, yet his

teeth and key facial features remain in polished form throughout the series. This reinforces the dominant-hegemonic position held by the entertainment industry that illegal drug side-effects cause less damage than perceived. Minority characters move in and out of storylines, but often as corrupt Mexicans, addicts, and other pulpy tropes that complement the text's dominant reinforcement of conservative American fears. Even the concept of Walt, as an everyman antihero, suffers from contemporary overexposure across the TV landscape (cf. Lotz, 2013). From *The Sopranos*, *The Shield*, and *House*, to *Mad Men*, *Sons of Anarchy*, and *The Walking Dead*, the white male antihero has transitioned, from overburdened genre convention, to overused cliché, in a relatively few years. In a final example, Walt's root motivation exploits everyone but his family, at first, but then becomes his own self-centered obsession, at everyone's cost. The character arc moves from sympathetic social cause, to the privileging of self over others. Considering the dominant-hegemonic position, perhaps *Breaking Bad* doesn't so much shy away from the American dream as suggest a new one.

The Negotiated Position

One cultural studies theorist has noted, "The television text is, like all texts, the site of a struggle for meaning" (Fiske, 2011/1987, p. 93). Television has long been a great unifier, in terms of the broad scope of audiences that consume the medium and its content. Yet one important distinction occurs, in our diverse individual perspectives. Hall theorizes:

> We must recognize that the discursive form of the message has a privileged position in the communicative exchange … and that the moments of "encoding" and "decoding," though only "relatively autonomous" in relation to the communicative process as a whole, are *determinate* moments [emphasis in original] (Hall, 2008/1973, p. 908).

Through these words, Hall reinforces his message, that individual modes of interpretation reflect views and beliefs often influenced by economic status, racial profile, and gender norms. When Fiske (2011/1987) argues that TV texts represent sites for struggle and meaning, he is extending Hall's notion of encoding/decoding as **discursive practices**. For a better understanding of discursive practices, we can again examine both the text and paratext for insight.

Throughout *Breaking Bad*, Walt undergoes a negative metamorphosis that changes him from mild-mannered and sympathetic, to maniacal and apa-

thetic. From the beginning, Walt's character is adept at deception. He habitu-
ally lies to his wife, while keeping his nefarious machinations private. While
oral deception might pass as a morally gray area for some (is the "truth" ar-
guably worse than a white lie, in some instances?), a key shift in his meta-
morphosis occurs in the season two episode, "Phoenix." In this episode, Walt
chooses *not* to save the life of an innocent person, because their drug habit
risks the success of his newfound business. The death creates negative con-
sequences, in a kind of warped butterfly effect. As seasons pass, Walt's deci-
sions become even more callous and less passive. Walt transitions from
underdog, would-be hero, to overlord villain. The audience conspires with
Walt's greed and guilt. Given the narrative conventions of the crime genre,
expectations and audiences may "support" Walt, in the same way that audi-
ences root for *Scarface*'s Tony Montana to bury his face in cocaine and burst
through his palisade doors, with guns blazing. Such imagery combines the
epic with the *tragic*, and heightens audience **pleasure** in the spectacle of the
narrative's unraveling.

But what happens when the paratext negotiates a text's codes in unex-
pected ways? Not only does Walt break society's moral code, but he also
breaks the sacred vow of marriage, by risking his family's safety. His wife,
Skyler, also breaks her vows, through an affair. Although the Whites' mar-
riage is fractured from the show's onset, audiences voiced aggressive discon-
tent about Skyler online (Harris, 2013). The actress who played Skyler, Anna
Gunn, said in a *New York Times* op-ed:

> I finally realized that most people's hatred of Skyler had little to do with me and a
> lot to do with their own perception of women and wives. Because Skyler didn't con-
> form to a comfortable ideal of the archetypical female, she had become a kind of
> Rorschach test for society, a measure of our attitudes toward gender (Gunn, 2013).

Voicing their opinions on social media, audiences negotiate an acceptance of
Walter's sins, while communicating negative discourse concerning Skyler.
We observe, through these two paratextual examples, the kinds of ideologi-
cal issues embroiled in discussions of race, class, and gender.

There also exists the plurality of readings that can be made from the
show's narrative and visual world. The first season presents some of its most
macabre moments as black comedy. For instance, Walt's brother-in-law,
Hank, works for the DEA, and communicates overt racist, classist, and sexist
jokes. The character could be read as an amalgamation of U.S. border poli-
tics, complete with **ironic ethnocentrism**, lost among those viewers who

align ideologically with Hank's cynical perspective. Later seasons embrace space and place, to evoke the iconography of the Western, in ways that convert the crime drama from tragicomedy into visual poetry. Certain scenes even take on the perspectives of inanimate objects, through the use of trick camera mounts, colorful lens selection, and innovative cinematography, especially by television standards. This lends a polysemic quality to the text. **Polysemic** texts represent a combination of symbols and symbol systems that come to carry different meaning based on different reader orientations. Thus, although the dominant-hegemonic position is viewed as the *preferred meaning*, the negotiated position carries important weight for scholars of communication and television.

The Oppositional Position

One cultural studies scholar has written,

> Popular art must be able to work within the contradictions between the dominant ideological forms and the resistances to them that derive from the social experiences of the subordinate. ... The work of popular culture, then, provides the means both for the generation of oppositional meanings and for their articulation with that dominant ideology to which they are opposed (Fiske, 2011/1989, 75).

Oppositional positions can be difficult to peg down in television shows. Television is a social institution and an evolving medium, which wields dynamic social, cultural, and political sway. Thus, we can observe that television, in whatever form it assumes, holds a dominant ideological presence. How many restaurants, bowling alleys, concerts, and sporting events now emphasize televisual screens to project channels of content? Screens occupy space everywhere, and television, with its robust storytelling and alluring visuals, occupies a great number of those screens. But how might audiences escape the dominant, or even negotiated, position altogether?

One example might include movements to **unplug** from our digitized lifestyles. Another is the **digital cleanse**, which functions like a diet or fast, from devices that seduce much of our time and attention. These two examples, unplugging and digital cleanses, suggest movements away from television as an encroaching medium. But what might an oppositional reading of *Breaking Bad* look like in practice? Julie Davids (2013) writes about *Breaking Bad*, only to dismiss the show's crime fantasy premise, in favor of an all-out critique on immigration, the war on drugs, and the negative impact of drug culture on New Mexico and America. In effect, Davids displaces the

televisual narrative for one steeped in reality, or at least reality from her perspective. Consider Erin Gloria Ryan's (2013) "Goodbye and Good Riddance, Angry Little Men Who Hate Skyler White." Ryan's remarks dismiss the show, despite its success, due to its inadvertent rabble-rousing of hate speech.

These methods of discursive tactics interestingly leapfrog the text, in order to engage alternative discourses. We might read this oppositional position as one way that media-friendly users stay *plugged in* online, while refusing the dominant-hegemonic position of the entertainment industry. This is just one contribution of Stuart Hall's encoding/decoding to our interpretation of cultural artifacts like *Breaking Bad*.

Keywords in This Chapter

Channel
Communication model
Communication process
Decoding processes
Digital cleanse
Discursive practices
Encoding process
Encoding/decoding
Genre theory
Hegemony
Internal noise
Interpretive noise
Intertextuality
Ironic ethnocentrism
Mass communication
Media effects
Message
Noise
Paradigm shift
Paratexts
Pleasure
Physical noise
Polysemic
Sender
Showrunner
Unplug

References

Burger, A. Asa. (2012). *Media and society: A critical perspective*, (3rd ed.). Lanham, MD: Rowman & Littlefield.

Danesi, M. (2012). *Popular culture: Introductory perspectives* (2nd ed.). Lanham, MD: Rowman & Littlefield.

Davids, J. (4 October, 2013). Breaking bad habits: New Mexico cannot protect its kids from Mexican drug cartels while the borders are open. *VDARE.com*. Retrieved from: http://www.vdare.com/articles/ breaking-bad-habits-new-mexico-cannot-protect-its-kids-while-borders-are-open

Fiske, J. (2011/1987). *Television culture*. New York, NY: Routledge.

———. (2011/1989). *Reading the popular* (2nd ed.). New York, NY: Routledge.

Frenan, J. C. (29 March, 2010). Interview: Vince Gilligan. *Slant Magazine* [Website]. Retrieved from: http://www.slantmagazine.com/features/article/interview-vince-gilligan/P1

Gilligan, V. (Executive Producer & Creator). (2008-2013). *Breaking bad: The complete series* [Television series]. Albuquerque, NM: Sony Pictures Television.

Gunn, A. (23 August, 2013). I have character issues. *New York Times* [magazine Op-Ed]. Retrieved from: http://www.nytimes.com/2013/08/24/opinion/i-have-a-character-issue.html?_r=0

Hall, S. (2008/1973). Encoding, decoding. In M. Rya (Ed.), *Cultural studies: An anthology*. Malden, MA: Blackwell Publishing.

———. (2006/1980). Encoding/Decoding. In S. Hall, D. Hobson, A. Lowe & P. Willis (Eds.), *Culture, media, language: Working papers in cultural studies, 1972-79* (pp. 128–38). New York, NY: Routledge.

Hall, S., Hobson, D., Lowe, A., & Willis, P. (Eds.). (2006/1980). *Culture, media, language: Working papers in cultural studies, 1972-79*. New York, NY: Routledge.

Harris, M. (2013). Walter White Supremacy. In D. P. Pierson (Ed.), *Breaking Bad: Critical essays on the contexts, politics, style, and reception of the television series*. Lanham, MD: Lexington Books.

Lotz, A. (2007). *The television will be revolutionized*. New York, NY: New York University Press.

———. (2013) *Cable guys: Television and masculinities in the 21st century*. New York, NY:New York University Press.

Lucas, S. E. (2012). *The art of public speaking*, (11th ed.). New York, NY: McGraw Hill.

Ryan, E. G. (30 September, 2013). Goodbye and good riddance, angry little men who hate Skyler White. *Jezebel.com* [Website]. Retrieved from: http://jezebel.com/goodbye-and-good-riddance-angry-little-men-who-hate-sk-1428212877

I jumped into the *Breaking Bad* wagon, while it was headed into its 4th season. I remember binging on the first three seasons, in the course of an unproductive, popcorn-and-coke fueled Spring Break. It was like nothing I had ever seen before, my interpretations and perspectives colored by the inherent discursive tactics that Garret Castleberry discusses, using Stuart Hall's model of encoding/decoding.

The relationship between the viewer and the show is comparable. The viewer is the decoder, processing and integrating the encoded paradigms of the show. The show makes these paradigms transparent. For example, Castleberry mentions how Walter White is a Caucasian, middle-aged high school teacher, whose dreams of prominence and prestige were encouraged by his trusted colleagues. He has a family, a secure but unfulfilling job, and cancer at his heels. Instead of continuing to live the life painted by the dominant hegemony, he brews up a different vision.

As a student, my path is fixed, any higher ambitions forestalled until after graduation. But is that necessarily the case? My case is a negotiated position of Walter White's. He throws off his blanket of security, gets out of bed, and gets what he wants, knowing the risks and making devastating sacrifices. This is a fundamental aspect of the American Dream, marred by the tainted industry and the reprehensible actions that are involved. If Walter White had spent this effort on Grey Matter Industries, he would have achieved the same, for the same cost: his family. It is this ill-timed pursuit that makes Walter such an iconic antihero.

As Castleberry mentions, it is important to develop oppositional positions, as well. *Breaking Bad* brings up issues, such as the war on drugs, health conditions like cerebral palsy, bullying, family values, social expectations, and certain stereotypes. These problems take a back seat to the drama, but are important to a contextual understanding of the goings-on in the show, as well as to the improvement of these conditions in our society.

Ultimately, *Breaking Bad* opens up dialogue, on issues and circumstances that are atypical for the common Caucasian American. In this way, it introduces a sympathetic world to an audience that will receive it positively. As decoders, it is our job to respect the ambition of Walter White, but maintain a level of moral rectitude. We can discern the good and bad from the show, and influence or change the issues of the paratext. As a result, Hall's model of communication disperses and influences from one channel to many, a cycle of communication.

—Ali Shaik

CHAPTER 9

Postmodern Theory and Hip-Hop Cultural Discourse

Hunter H. Fine

Human communication is a fundamental aspect of cultural and public life. It also shapes the many ways we view the world. The way we talk about life influences the forms it takes. In this chapter, we examine the lyrics of hip-hop music. In doing so, we will delve into the symbolic structure that creates our experience of reality. Hip-hop, or rap music, occupies an important place in American consciousness, and many of you have grown up in a musical and communicative landscape heavily influenced by hip-hop discourse. A **discourse** is a collective "conversation," concerning a public topic or subject matter. Consequently, our worldviews have been influenced by the shared awareness and discussion of hip-hop in our culture.

Hip-hop first emerged in the 1970s, rising from New York City's Bronx borough. Hip-hop developed as a complete American culture. **Culture** is a system of shared meanings and assumptions that draws people together within a social context of power. We can call hip-hop a total culture, because it includes **visual** (graffiti), **oratory** (MC), **physical** (dance), and **auditory** (DJ) elements of expression. These cultural practices developed political language, contextual rituals, and historical norms. Over the years, these all came to present a counter-discourse, to mainstream American values. The counter-discourse shapes **identity**, the individual and collective understanding of oneself that emerges from cultural interaction. As the culture expanded, the discourse came simultaneously to resist and represent mainstream American values.

The theoretical lens of postmodern communication will help us in this chapter to analyze the rhetoric contained in contemporary hip-hop. We will also establish a connection between postmodern theory, and communication studies. In doing so, we will resist essentialist perspectives of historical narratives, identity, and space, within the context of power. An **essentialist perspective** is the assumption that people and things fundamentally contain value and personality. **Power** is a productive tension resulting from different societal positions.

Postmodernism is a theory that criticizes the power structures that place barriers on communication. In this regard, hip-hop discourse is an excellent example of **postmodern rhetoric**. Even if you don't like hip-hop personally,

you can see it makes up important "texts" in society. In this chapter, we examine hip-hop, and recognize how postmodern theory informs basic communication patterns. After doing this, perhaps you can try out postmodern theory on your own favorite form of music. This process of choosing a cultural form, and testing out a theory, is called **artifact analysis**. Let's begin by examining postmodern theory, and defining our terms.

Postmodernity

Postmodernity is the time period and cultural attitude "after modernity." **Modernity** is (in very simple terms) the time period and attitude that lasted from the nineteenth century through the 1950s, though scholars debate its length. Modernity embraces rationality and progress, above all. **Postmodernity** breaks with these ideas. Rooted in the social movements of the 1960s, postmodernity pays special attention to feminism, LGBTQ activism, race and ethnicity struggles, whiteness, and environmental movements. Modernity assumed that Western societies, such as the United States and Great Britain, were essentially homogeneous. The cultural period did not take into account the viewpoints of people who embody differences in gender, sexual orientation, race, or ethnicity. Postmodernity recognizes that the social environment is fragmented—because of these differences in identity, but also because we feel a disconnection between reality and *representations* of reality. Communication is so important to postmodern theory, because it exposes the processes of how we talk about, represent, and construct our reality.

Modern ideals of rationality and progress are examples of grand narratives. Jean-Francois Lyotard (1984) described **grand narratives** as stories that impose particular ways of thinking. Postmodern theory studies the way such grand narratives become disrupted. It also pays attention to communication as a symbolic system, which creates the structure of our society. John T. Warren and Deanna L. Fassett note that this thinking about the disruption of grand narratives, and the analysis of communication signs, becomes known as **postmodernism** (2011). Postmodernism is important for communication theory, because it regards communication as fundamental to the organizing of our shared reality.

Postmodern theory and communication studies share the realization that acts of description, previously assumed to be neutral, are in fact complicated by *power*. They are also complicated by technological media, and the fact that we are often far removed from "reality." These postmodern themes will,

perhaps, be clearer, if we take hip-hop as an example. In the rest of this chapter, I **"deconstruct"** hip-hop, which means to look closely at its contradictions and ambiguities. Some of the themes that will emerge include power through history, nomadic desires, simulations of reality, difference, and the grand narratives of Lyotard.

Narrative

Postmodern perspectives identify multiple cultural narratives, and recognize that within every discourse there are various levels of interpretation. There is no singular cultural narrative, just moments where certain forms of thinking, or ways of being, become subordinate to another, more accepted perspective. In its broadest definition, **culture** is a series of shared practices, including norms, values, and beliefs. It is important to remember that these all exist within a context of power. Hip-hop discourse responds to its own cultural influence, while also being situated within a larger power dynamic.

A **cultural narrative** is a way of viewing the world that comes to define a way of life. Hip-hop cultural narratives are constantly under scrutiny, and often become scapegoats for social ills. What way of life do you feel would resist repression, intrusion, or marginalization? In answering this question, you subscribe to a particular perspective, and further define an identity.

Hip-hop lyrical discourse contains narratives that both challenge and reinforce mainstream values. In doing this, hip-hop deconstructs dominant narratives. Entrenched in themes of authenticity, hip-hop discourse constantly disrupts its own narrative, in a continuous effort to "keep it real." The lyrics contained in mainstream hip-hop, present stories within language and popular culture. These stories shape our shared realities.

Hip-hop discourse deploys postmodern themes, in relation to dominant culture and its own historical narrative. It is as a discourse of both opposition and support. For example, when Lil Wayne (2007a) states, "Money controls where I go; it is the sail to my boat," he is celebrating consumer capitalist culture, allowing him social mobility. However, when he states, "I have just boarded a plane without a pilot" (Lil Wayne, 2007b), he questions the sustainability of material success. He also deploys what becomes the rap slogan of "Bling, Bling," announcing a value that is mainstream both in the come-up narrative of hip-hop, and also in the American Dream (B.G., 1998). Along with "Bling, Bling," Lil Wayne issues another popular hip-hop slogan, in the form of a disclaimer: "No Homo," which reaffirms heteronormative values,

but also allows masculinity to exist at the edge of gender and sexuality narratives (Lil Wayne, 2008).

The rapper Pusha T, whose name is a euphemism for selling drugs, often celebrates material gain, while advocating an unsanctioned way to achieve it. He recites, "I might sell a brick on my birthday, 36 years of doing dirt like it's Earth Day," referring to his age, his environment, and the selling of "bricks," or drugs, as a means of material gain (Pusha T, 2013). The reference to illegal activity clearly marks a successful counter narrative.

Popular hip-hop discourse challenges modernist narratives, and presents new ways of viewing reality, while reaffirming its own place within the dominant social structure. When Talib Kweli states, "How will I feed this baby? How will I survive? How will this baby shine? Daddy dead from crack in '85, Mommy dead from AIDS in '89," he situates himself within the cycle of drugs that Pusha T celebrates, while questioning his ability to provide otherwise (Kweli, 2010). He questions the cycle, in which capitalist values affect families within neglected areas, struggling to provide for themselves. No doubt you can identify other narratives that present alternative themes to mainstream values.

As another example, in "Love Is Blind," Eve questions the role of a female emcee, in a **patriarchal** society in which men possess more power. In the song she questions the reality of relying on a man, for access to power. She recites a narrative of a woman scared to leave an abusive partner, since she is unsure how she will support herself and her children: "She told me she would leave you, I admit it, she did, but came back, made up a lie about you missing your kids" (Eve, 1999). Eve highlights marginalized narratives, that expose behavior promoted in a majority of male-centric hip-hop lyrics. Similarly, Jean Grae questions the role of women in hip-hop, and within a society in which they have been historically marginalized: "She's got a good man; she's nineteen, he's twenty-one and sweet and honest, promised to love her, talk of marriage; she would never wanna be somebody's baby's mother" (Grae, 2002). Grae is apprehensive of promises, because of the history of women's oppression.

The role of female emcees becomes complicated, as they continually declare a counter narrative, within dominant readings of hip-hop discourse. As the title of Lauryn Hill's 1998 album, "The Miseducation of Lauryn Hill," reflects, a female emcee's job is to be aware of the miseducation gained through popular texts and narratives—including those within hip-hop. As her album begins, we hear a bell ring (Hill, 1998). Class is in session, as a teach-

er starts taking attendance, to find Hill absent. The implication is that texts—even dominant texts—can inform, just as much as misinform. Hill is getting her education elsewhere, perhaps just as the listener of the album is.

Kanye West shares a similar sentiment on his first album, *College Dropout.* In "All Falls Down," West also questions the come-up narrative, and the pursuit of wealth. As he states, "It seems living the American Dream, but the people highest up got the lowest self-esteem. The prettiest people do the ugliest things, for the road to riches and diamond rings" (West, 2004). By complicating the picture of the American Dream, West directly comments on and questions dominant collective narratives.

Identity

Postmodernity suggests a more fluid or **nomadic** conception of the self. Identity is constructed in relation to cultural texts. Such an identity exists as a fluid subject influenced by the shifting forces that construct it (Deleuze & Guattari, 1987). Hip-hop both affirms stable identities, and also disrupts them. Hip-hop narratives allow one to achieve success as a public figure, while presenting alternative modes of being.

An emcee's name, for example, becomes a fluid marker of identity, rather than an essentially fixed label. The rapper Eminem is a prime example of a fragmented identity, since he also identifies himself as Slim Shady and Marshall Mathers. The rapper Nas explains the development of his own identity by stating, "[I] went from Nasty to Nas to Nas to Escobar" (Nas, 1997). The reference to Nasty seems to comment on the individual's early lack of influence and power. The later reference to Escobar notes the criminalization that has occurred, through the influence and reception of his words. In a later verse, he utters the phrase, "Nas, my real name, stage name, same thing," to refer to a level of authenticity other emcees might not exhibit (Nas, 2012).

Hip-hop lyrics are celebrated, critiqued, and even used for the reporting of actual events. While songs often seem to depict a reality experienced firsthand, the narratives almost always reference the fluid identity of the emcee. This has the effect of framing most events as fiction. The narratives may have truth-value, in describing a condition or an environment; but they should not be received as firsthand accounts of actual events.

While emcees constantly strive to maintain a discourse of "keeping it real," they also actively employ and acknowledge a large amount of artistic and creative license. Emcees often acknowledge that, with success, come

challenges to authenticity, and dangers to existence. Hip-hop discourse is neither direct speech, nor embellished fantasy, but rather a postmodern, embodied account of both conditions, fueled by a context of power. This is painfully exhibited in the lines and lives of Tupac Shakur and The Notorious B.I.G. Shakur recites lines that foretell his demise and question his longevity, "painting a picture of my enemies killing me, in my sleep, will I survive till the morning" (Tupac, 1995), while B.I.G.'s two studio albums (1994; 1997) both reflect a morose reality, and foreshadow real events.

On "Dumb It Down," Lupe Fiasco comments on the dichotomy between voicing real concerns and appealing to the masses. A narrative voice questions Fiasco's rhetoric: "They're getting self-esteem, Lu, These girls are trying to be queens, Lu, They're trying to graduate from school, Lu, They're starting to think that smart is cool, Lu." After each assertion, the response, "Dumb it down," is heard, noting and resisting the forces of mainstream commercialization (Fiasco, 2007). This discourse reflects realistic social conditions, and refers to a genuine objective. It also exists within a global market that, at times, partially depends on the same conditions it critiques for profit.

Eminem represents a paradox of identity. In "Stan," the emcee presents a stable identity, as he receives a letter from a fan (also rapped by the emcee himself): "Dear Slim, I wrote you but you still ain't callin, I left my cell, my pager, and my home phone at the bottom. I sent two letters back in autumn, you must not-a got 'em" (Eminem, 2000a). The letter reveals that the constructed persona of Slim Shady had begun to take on a real identity, for the fan. Speaking as the fan, Eminem advances the dialogue that his identity fuels, but remains absent. In "The Way I Am," Eminem continues this theme, and questions his identity through the forces that construct it: "I'm so sick and tired of being admired, that I wish that I would just die or get fired. And dropped from my label, let's stop with the fables." In the chorus, he adds, "I am whatever you say I am, if I wasn't, then why would I say I am? In the paper, the news, every day I am" (Eminem, 2000b), concluding that he has lost the ability to control his actual identity.

Eminem is self-reflexive of his own identity construction within hip-hop. He is, also, in a postmodern position of both privilege and struggle, which is a hallmark of contemporary hip-hop. A young Nas comments on an entirely different contradiction of personality, years earlier on *Illmatic*. He describes growing up in the neglected site of the Queensbridge Projects, the largest housing project in North America. After looking out of the window to wit-

ness poverty, and the violence that comes with a lack of opportunity, he states: "I sip the Dom P, watching Gandhi till I'm charged. Then writing in my book of rhymes" (Nas, 1994). These lyrics note the struggle that comes with poverty, and the celebration that comes with an artistic outlet. He dwells in a world where he can sip expensive champagne, amidst senseless violence, watching a pop cultural artifact (the movie *Gandhi*) about nonviolence.

Place

Just as our understandings of identity within a postmodern communication landscape are fragmented, so are our conceptions of geography. Within the postmodern environment our real lives are often presented to us as a **simulacra**: an abstraction of what we know to be a genuine experience (Baudrillard, 1983). A simulacra is a copy without an original, a representation of a reality that might not exist. Disneyland is an example. These types of fantastical spaces have existed throughout history, and merely reify the concept of reality that lies outside of them. Hip-hop discourse extends and conflates this concept, by deploying an **omnitopian** notion of place. An omnitopia is a conception of space that exists both everywhere and nowhere (Wood & Todd, 2005).

Early hip-hop pioneers of site-specific rhetoric, Gil Scott-Heron and The Last Poets riffed, back in 1970, on the power of cultural, spoken-word discourse, to bring attention to site-specific conditions. Considered a precursor to hip-hop discourse they wrote, "New York where queen liberty tension is staying in the middle of pee green water telling a brother he's liberated. Yeah, he is liberated from the old Mississippi to the new Mississippi" (The Last Poets, 1970). Heron's first solo album, *Small Talk at 125th and Lenox* issues a social message intertwined with geographical place while exhibiting a title that would come to mark the location of the inception of hip-hop (Heron, 1970). The concern is for the specific site. Almost forty years later, in 2005, The Last Poets and Heron are featured on a Common and West hip-hop track, "The Corner." Here they present a much more general idea of space: "The corner was our time when times stood still, and gators, and snakeskins, and yellow, and pink, and colored blue profiles glorifying that. ... The corner was our magic, our music, our politics" (Common, West, & The Last Poets, 2005). In the time between these two songs, place has become detached from the origin story. Cultural creation out of neglect and

conflict gives way to spatial **abstraction** and a more **universal** understanding, in which various locations and generations can come together.

Examining commercial hip-hip discourse reveals a postmodern project intertwined with the complex process of hip-hop **commodification** where narratives, identities, and places become economic products with exchange value. Lyrics become rhetorical products that represent site-specific authenticity and global appeal. While, according to some, these forces "have corrupted hip-hop, appropriated Black cultural production, and in the deal, seriously marginalized progressive, political or "conscious" alternatives" (Forman, 2002), they are also inseparable from the cultural power of hip-hop discourse. Hip-hop is both a counter narrative and a dominant narrative, that effectively fragments identity, while overlapping place.

More recently, Dr. Dre and Kendrick Lamar apply place as an omnitopia in "The Recipe" (on Lamar, 2012). They appeal to the ever-present, yet distant, mentality, and the distant place of Compton. The place persists throughout the work of Kendrick Lamar, who (revealed in his album titles) raps as "*The Rose that Grew from the Concrete*" (2010), a "*Good Kid*" from a "*m.A.A.d City*" (2012), and in a "*Compton State of Mind*" (2009). The essence of Kendrick Lamar's early identity as an emcee remains connected to his geographical origins. Hip-hop discourse deploys a concept of place that is simultaneously everywhere and nowhere, as place and space merge. Hip-hop perpetuates the oppression and neglect that often affect inner-city sites, while challenging them at the same time.

Hip-hop discourse has become a product of both specific local places and also transnational global interests. This reflects the fragmented identity of voices and bodies that are products and producers of postmodern discourse. This discourse contains various symbols that refer to space, employed by artists such as Kendrick Lamar (Compton), ASAP Rocky (Harlem), and Wiz Khalifa (Pittsburgh). We can find more examples in major artists such as Lil Wayne (New Orleans), Nas (Queens), Jay-Z (Brooklyn), and Kanye West (Chicago). These emcees use and redefine these places, to reflect a personal, as well as global, narrative of spatial identity.

Roll calls have long been a recurring element in hip-hop discourse. Roll calls initially emphasized friends and crews. Recently, these lists have changed, to be about places, instead of people. Lamar raps on "The Recipe": "You might catch me in Atlanta looking like a boss. New Orleans and then Miami. Party in New York. Texas I be screwed up, Chi town I be really pimpin'. But nothing like my hometown I'm forever living" (on Lamar, 2012).

There is no question of where the hometown is: it is both Compton, and everywhere. By mentioning disparate and contradictory places, the specific place is both obscured and celebrated. Nicki Minaj's final verse on "Beez in the Trap" similarly grounds the song, and gives the lyrical content mass appeal. "I'm a Detroit Player, man it's north-south cats. Ohio, Pittsburgh, got St. Louis on deck. It's Delaware, Connecticut, it's New Jersey got hella bricks. It's Queens, Brooklyn, and yea they're wildin'. The Bronx, Harlem, and Staten Island" (Minaj, 2012). The roll call dislocates spaces. instead of bringing them together. It's the postmodern "party over *here*, forget you over *there*." Postmodern theorists have shown that **dislocation** "dislodges place from geography, eschewing the potential for particular stances and histories, constructing a free-floating location without locale" (Wood & Todd, 2005). Hip-hop lyrics often represent a highly communicative dialogic discourse that invites the listener to participate in deconstruction. Deconstruction has been explained throughout this chapter. Perhaps the best definition to end with is that it is an analytical process of trying to decipher what is being said in a text (like hip-hop lyrics) by recognizing the inherent contradictions. This is prevalent in the functioning of societal narratives, personal identity, and dislocated place.

Conclusion

This chapter has discussed postmodern theory, communication studies principles, and hip-hop cultural discourse. By deconstructing hip-hop lyrics, we identified elements of narrative, identity, and place. If this theory interests you, you may want to go on to find out more about its major thinkers: Gille Deleuze, Felix Guattari, Jacques Derrida, Michel Foucault, and Jean Baudrillard. I hope that this chapter offered you a compelling example of artifact analysis. Try testing this method of applying communication principles and poststructuralist theory to other types of music, or different art forms, that you enjoy. Deconstruction can help you think through the contradictions and problems we face in society today, and help you fight them, as well.

Keywords from This Chapter

Abstraction
Artifact analysis
Auditory

Commodification
Culture
Cultural narrative
Deconstruct
Discourse
Dislocation
Essentialist perspective
Grand narratives
Identity
Modernity
Nomadic
Omnitopian
Oratory
Patriarchal
Physical
Postmodernism
Postmodern rhetoric
Postmodernity
Power
Simulacra
Universal
Visual

References

Baudrillard, J. (1983). *Simulations* (P. Foss, P. Patton & P. Beitchman, Trans.). New York, NY: Semiotext[e].
B. G., featuring Hot Boys & Big Tymers. (1998). Bling, bling. On *Da drought 3* [CD]. New Orleans, LA: Cash Money, Universal Motown.
Common, West, K., & The Last Poets. (2005). *Be* [CD]. New York, NY: Sony.
Deleuze, G., & Guattari, F. (1987). *A thousand plateaus: Capitalism and schizophrenia* (B. Massumi, Trans.). Minneapolis, MN: University of Minnesota Press.
Eminem. (2000a). Stan. On *The Marshall Mathers LP* [CD]. Los Angeles, CA: Aftermath, Interscope, Shady.
———. (2000b). The way I am. On *The Marshall Mathers LP* [CD]. Los Angeles, CA: Aftermath, Interscope, Shady.
Eve. (1999). Love is blind. On *Let there be Eve...Ruff Ryders' first lady* [CD]. New York, NY: Ruff Ryders, Interscope.
Fiasco, L. (2007). Dumb it down. On *The cool* [CD]. New York, NY: 1st & 15th, Atlantic.
Forman, M. (2002). *The 'hood comes first: Race, space, and place in rap and hip-hop.* Middleton, CT: Wesleyan University Press.
Grae, J. (2002). Lovesong. On *Attack of the attacking things* [CD]. New York, NY: Third Earth Music.

Hill, L. (1998). *The miseducation of Lauryn Hill* [CD]. Los Angeles, CA: Ruffhouse, Columbia.

Heron, G. S. (1970). *Small talk at 125th and Lenox* [LP]. New York: Flying Dutchman, RCA.

Kweli, T. (2010). For women. On *Reflection eternal* [CD]. New York, NY: Rawkus, Blacksmith.

Lamar, K. (2009). *Compton state of mind* [CD]. Los Angeles, CA: Top Dwag, Aftermath, Interscope.

———. (2010). *The rose that grew from the concrete* [CD]. Self-published.

———. (2012). *Good kid, m.a.a.d. city* [CD]. Los Angeles, CA: Top Dwag, Aftermath, Interscope.

The Last Poets. (1970). New York, New York. *The last poets* [LP]. New York: Various.

Lil Wayne. (2007a). Live from the 504. On *Da drought 3* [CD]. New Orleans, LA: Young Money.

Lil Wayne. (2007b). I feel like dying. On *Da drought 3* [CD]. New Orleans, LA: Young Money.

———. (2008). Lollipop. On *Tha Carter III* [CD]. New Orleans, LA: Cash Money, Universal Motown.

Lyotard, J. F. (1984). *Driftworks* (R. McKeon, Ed.; R. Lockwood, J. Maier, A. Matejka & R. McKeon, Trans.). New York, NY: Semiotext(e).

Minaj, N. (2012). Beez in the trap. On *Pink Friday: Roman reloaded* [CD]. New Orleans, LA: Young Money, Cash Money, Universal Republic.

Nas. (1994). The world is yours. On *Illmatic* [CD]. New York, NY: Columbia.

———. (1997). Escobar '97. On *Men in black: The album* [CD]. Los Angeles, CA: Columbia, Sony.

———. (2012). Back when. On *Life is good* [CD]. New York, NY: Def Jam.

Notorious B.I.G. (1994). *Ready to die* [CD]. New York, NY: Bad Boy.

———. (1997). *Life After death* [CD]. New York, NY: Bad Boy.

Pusha T. (2013). Numbers on the boards. On *My name is my name* [CD]. Los Angeles, CA: GOOD Music, Def Jam.

Shakur, T. (1995). So many tears. On *Me against the world* [CD]. Los Angeles, CA: Interscope.

Warren, J., & Fassett, D. (2011). *Communication: A critical/cultural introduction.* Thousand Oaks, CA: Sage.

West, K. (2004). All falls down. On *The college dropout* [CD]. New York, NY: Roc-A Fella, Def Jam.

Wood, A., & Todd, A. M. (2005). "Are we there yet?": Searching for Springfield and the Simpsons' rhetoric of omnitopia. *Critical Studies in Media Communication, 22*(3), 207–22.

As a stressed-out law student, one my favorite ways to recharge and re-connect with society, after reading textbooks for hours, is to turn on some hip-hop music and go for a run. Reading about Hunter Fine's interpreta-tion of hip-hop, and its role in the study of postmodern theory, helped me to understand that one of my favorite genres of music was a window into postmodern narratives and identities, as well as postmodern concepts of geography.

Fine wrote about how postmodernity suggests a more fluid or nomad-ic concept of selfhood, and how hip-hop simultaneously affirms and dis-rupts stable identities, insofar as hip-hop enables individuals to embrace differing and contradicting personas. Fine cites various artists who em-brace different stage names, and he discusses how emcees' names can act as fluid markers of identity, as opposed to established identifiers. As I was reading about this notion, I began to think about some of my favorite artists, who have similarly taken on fluid identities. One of the most prominent artists who presents herself with differing names is Beyoncé Knowles, who will occasionally refer to herself as "Yoncé," in some of her recent songs. Similarly, in Nicki Minaj's "Roman's Revenge," Nicki Minaj becomes Roman Zolinski, and is accompanied in the song by Eminem, or (as he is called in the song) Slim Shady. In "Roman's Re-venge," Roman starts in immediately with, "I am not Jasmine, I am Alad-din." While there are various interpretations of these lyrics, one of the most popular interpretations is that Nicki wished immediately to assert her dominance, and show that she was no longer going to be the featured artist in hip-hop songs: her identity is now that of the lead singer, just as Aladdin is the main character.

Fine also discussed how the dialogue of hip-hop was created out of a combination of transnational global interests and specific local places. I enjoyed reading Fine's analysis of the various specific, local places that various hip-hop artists cite, especially with respect to Wiz Khalifa and his allusions to Pittsburgh. I reflected on how one of my other favorite, trans-national artists who hails from Pittsburgh utilizes localities from the Pitts-burgh area in his hip-hop discourse: Mac Miller. Mac Miller's album "Blue Slide Park" pays homage to Pittsburgh's Frick Park. I really en-joyed reading about Fine's viewpoint on postmodernity, and its influence on hip-hop.

—Hillary Cox

Seen but Not Heard—Exploring Muted Group Theory in Pixar's *The Incredibles, WALL-E,* and *Brave*

Bruce W. Finklea & Sally Bennett Hardig

At some point in your childhood, an adult probably told you that children should be seen and not heard. At that moment in your life, you became part of a muted group. In this example, the dominant group (i.e., adults) placed limitations on the way a subordinate group (i.e., children) was able to communicate. Taking away the children's voice both literally and figuratively makes them a muted group. Children's voices are not heard, nor are they given equal standing in our culture.

In this chapter, we will introduce you to the concept of **Muted Group Theory** (MGT), by providing a brief overview of its development. We will then examine three popular Pixar films—*Brave, WALL-E,* and *The Incredibles*—to demonstrate not only how MGT theory works, but also how it is prevalent in modern–day media.

Theoretical Background

Muted Group Theory is a critical theory that provides one way of analyzing how language functions to create and maintain power structures throughout a culture. The theory was first introduced by anthropologists Edwin and Shirley Ardener, who observed that many ethnographers were creating "black holes" in research, by ignoring female speech, when coding or describing cultures. They argued that this lack of voice, or "**mutedness**," was a reflection of the powerlessness and lack of status of certain groups in society (1975, 2005).

Communication scholar Cheris Kramarae (1981) further developed and modified MGT, by arguing that the theory applies most appropriately in the context of gender. She claimed that the language of a culture is not equally representative of all speakers, because the words and norms for use were created, and are governed, by the **dominant group** (white men). Women (and other subordinate groups) are "muted," because they are not free to articulate their thoughts equally.

Kramarae (1981) made three primary assumptions about MGT, when applied to communication between men and women:

1. Women perceive the world differently from men, because of women's and men's different experiences and activities, rooted in the division of labor.
2. Because of their political dominance, the men's system of perception is dominant, impeding the free expression of the women's alternative models of the world.
3. In order to participate in society, women must transform their own models, in terms of the dominant system of expression (p. 21).

These assumptions imply that because of the male dominance in society and the fact that men serve as "gatekeepers of communication," women must transform their communication style in order to have a voice, and are often unable to express themselves as effectively, especially in the public sphere. From this view, traditionally feminine forms of communication are viewed as weaker and less valued.

Applying MGT to Pixar

Ardener (2005) emphasized that the muting of a subordinate group occurs in many different "**social spaces**," including seating arrangements, prestige and power, religion, and speech (p. 51). Of course, another social space shared by billions of people around the world is screens—TV screens, movie screens, computer screens, and smartphone screens. In a time when nearly anyone can create media products that can be seen by billions around the globe, it would seem that it would be hard to mute any group of people. That, however, is not the case; and we see this especially in Pixar's blockbuster feature films. Very few Pixar films prominently feature female characters, but they are present. However, although they are seen, these women are not truly heard.

As outlined by Kramarae (1981), our "society and communication system are defined by men" (p. 21). When we examine Pixar films as mainstream cultural texts, we see that this statement is overwhelmingly true. Pixar Animation Studios, now owned by Disney, is a multi-billion–dollar company created and headed by men. In addition, most of Pixar's film directors are men. In fact, to date, the only Pixar movie to have a woman director is *Brave*—and that director, Brenda Chapman, left the film before it was finished. Although she received a directing credit, Pixar brought in a male director to complete the film. Thus, the messages seen in Pixar films are

created and crafted by men. Women's voices are largely left out of the filmmaking process.

Research into Pixar films found that male characters overwhelmingly outnumber females by a ratio of 3:1 (Decker, 2010). Therefore, not only are there simply fewer female voices to hear, we argue that several of those female characters are muted, through Pixar's patriarchal storytelling techniques.

Before we begin our analysis of MGT in *Brave*, *WALL-E*, and *The Incredibles,* we will provide some quick summaries of the films' plots.

Brave focuses on Princess Merida, who is old enough that she must pick a suitor. Merida, however, does not want to follow tradition. After arguing with her mother, Queen Elinor, who is determined to see her daughter adhere to their people's custom, Merida asks a witch for a spell that will change her mother's mind. The spell does not go as planned, and rather than changing her mother's mind, it transforms the queen into a bear. In their adventures to try to change her mother back, Merida and Queen Elinor bond. Eventually, the queen does change her mind, and agrees to allow Merida to pick a suitor at the time of her choosing. At the end of the film, their true love for each other returns the queen to her human form.

WALL-E is about a trash-compacting robot, who longs for a romantic relationship. Alone on Earth, WALL-E works day after day, cleaning up all of the garbage left behind, when humans left the planet. One day a ship lands, and deposits a flying robot, EVE. In a case of love at first sight, WALL-E falls for EVE, who has no interest in a relationship of any kind with him. EVE's purpose is to scan the surface for signs of vegetation, so that mankind will know when Earth is capable of once again sustaining life. When the ship returns to collect EVE, WALL-E climbs aboard. When they arrive at the *Axiom*, the large spaceship where humans live, WALL-E and EVE work together to overthrow the ship's malevolent robotic autopilot. After being seriously damaged, WALL-E appears to have lost his unique personality; however, in an act of love, EVE "kisses" him (really, an electrical spark jumps between them), and he returns to normal. They appear to live happily ever after.

In *The Incredibles*, superheroes must live in a Witness Protection–like program, concealing their identities and super powers. Bob Parr, who was once revered as Mr. Incredible, works at an insurance company, and is generally unhappy with his life. He is contacted by a mysterious woman who offers him the chance to do some secret superhero work. It turns out that the

woman works for Syndrome, the film's villain. When he was a child, Syndrome wanted to become Mr. Incredible's sidekick; but Mr. Incredible told him that he works alone. Bob's wife, Helen (formerly Elastigirl), thinks he's having an affair and tries to find him. Ultimately, Mr. Incredible learns the value of teamwork, by working with his family to defeat Syndrome and his evil robot.

MGT Assumption 1: Women See the World Differently

Kramarae's (1981) first assumption about MGT is that women view the world differently from men, because of differences inherent in the division of labor. Pixar films show men and women's experiences to be very different, based on often-stereotypical roles for males and females. *Brave* shows that men are viewed as brave warriors, while women adhere to more domestic roles. Early in the film, Princess Merida's mother, Queen Elinor, is heard listing the stereotypical qualities of a princess: "A princess must be knowledgeable about her kingdom. She does not doodle. ... A princess does not chortle, does not stuff her gob [eat messily], rises early, is compassionate, patient, cautious, clean, and above all, a princess strives for ... well, perfection." The queen's restrictions and rules confine Merida; she is not able to be her authentic self. Merida wants to enjoy days riding her horse, exploring nature, and shooting her bow, but as she laments, her life is full of the responsibilities of a princess, which keep her from pursuing her passion. Meanwhile, Merida's triplet brothers are shown running amok, gobbling down food, and pretty much doing the opposite of everything the queen expects of Merida.

The other films also exemplify how division of labor causes characters to see the world differently. WALL-E essentially works as a garbage man, but he cherishes and collects some of the items that he discovers while working. EVE, on the other hand, is solely focused on her job. She does not see the value in the objects that WALL-E collects. Whereas WALL-E sees the world with a sense of wonder, EVE views it with a laser-focused sense of purpose.

Near the beginning of *The Incredibles*, Bob Parr is on his way to his wedding, but when superhero duties arise, he jumps in to save the day. Ultimately, he's late to his own wedding. He places a greater importance on his superhero duties than on his personal relationships. Throughout the early parts of the film, we see Bob at his office, and experience his general unhappiness, while Helen focuses on housework and raising their children. It is

evident that they do not have similar views on their quality of life. Helen is trying to make the best of the situation, while Bob is clearly unhappy with his life and his job.

These three movies show us that male and female characters view the world in different ways, and that those differences can lead to female characters being muted in various respects: *WALL-E* literally mutes EVE, by putting her in Sleep Mode after she finds the plant. *The Incredibles* mutes Helen Parr, by confining her to the home and showing her defer to her indifferent husband, who repeatedly puts his own desires above the needs of his family. Merida's mutedness will be discussed in an upcoming section.

MGT Assumption 2: Men's Worldview Overpowers Women's

The second assumption of MGT examines the "restrictions of a white, middle-class, hetero-male oriented language upon those whose perspectives of the world may be quite different" (Kramarae, 2005, p. 55). Because men wield the most societal power, women's ability to express their own perceptions is limited. We see this perhaps most clearly in *Brave*. Throughout the film, Princess Merida struggles to make her voice heard. She wants the freedom to find her own path in life. Interestingly, we see that Merida's muted condition comes from an unexpected source: her own mother. Rather than having a stern father figure trying to control his daughter (like King Triton, struggling to control the rebellious Ariel, in Disney's *The Little Mermaid*), *Brave* introduces a woman who has used societal power within her royal position to be the champion of the patriarchal norm.

Although at first glance, *Brave*'s ending seems to imply that Merida has indeed succeeded in breaking with tradition and the pressures of patriarchy, she is still muted by the cultural expectations imposed on a princess. Merida convinces her mother not to force her to pick a suitor immediately. However, Merida agrees to comply eventually with patriarchal demands that she marry. After informing the lords of the queen's change of heart, Merida defers to male authority: "The queen and I put the decision to you, my lords. Might our young people decide for themselves who they will love?" The lords agree to break with tradition, but with the underlying assumption that Merida will still marry. Lord MacGuffin says, "Let these lads try to win her heart before they win her hand—if they can." (Some may view the last part of Lord MacGuffin's remark as an acknowledgement of Merida's independence, but his delivery seems to imply that it is said more as a challenge to the

suitors, as if to say, "… if they're man enough." The statement shifts the focus and power back to the male suitors, away from Merida.) So even when she has seemingly chosen her own fate—a desire that she verbalizes throughout the film—Merida is essentially choosing the same outcome (although somewhat delaying it) that was originally intended for her, thus muting her voice of rebellion. (We should note that it is positive to see Pixar include its first female protagonist, and we do not wish to downplay her presence. But, viewed through the critical lens of MGT, the message her character articulates is not yet fully powerful.)

In *The Incredibles*, Bob's use of language mutes Helen, by rarely calling her by name. He repeatedly calls her "Honey," or describes her as "Mommy." Her identity is confined to how others see her. Moreover, it should be noted that her superhero moniker also rhetorically signifies her inferiority to the men. She is Elasti*girl*. Other superheroes, both men and women, are given either gender-neutral names (e.g., Gazerbeam, Maelstrom, Slipstream, Splashdown) or adult male names (e.g., Dynaguy, Multiman). The only other character with a child-like name is Incrediboy, who is actually a child.

The film also demonstrates how the government mutes Helen's Elastigirl persona. In the film's opening montage, Elastigirl scoffs at the idea of domestic life, saying, "Settle down? Are you kidding? I'm at the top of my game! I'm right up there with the big dogs! Girls, come on! Leave the saving the world to the men? I don't think so!" However, domesticity is forced upon her by the (presumably male-run) government, as part of the Superhero Relocation Program. Helen is also muted after her husband travels to do secret superhero work. Before his trip, Helen and Bob were shown arguing quite often. However, upon his return, we see their relationship change. Because Bob is more engaged with his family, she has nothing to complain about, and therefore does not speak. In fact, the "happy family" montage does not contain any dialogue among the characters, implying that Bob's involvement as a spouse and parent has solved all of the problems we saw the family complaining about earlier in the film.

In *WALL-E*, patriarchal dominance is evident in the role of the *Axiom*'s captain. When the captain realizes he overslept and missed morning announcements, he literally turns back the ship's clock, from midday to morning. He is able to singlehandedly control every aspect of life aboard the ship. Food menus change from lunch to breakfast, transportation reverses, and even the artificial sun returns to its morning position. Everyone aboard the ship is subjected to the captain's whims.

EVE is another prime example, of how male perceptions overpower a female's take on the world. Neither WALL-E nor EVE follows gender stereotypes. WALL-E is portrayed as a hopeless romantic, who is very emotionally expressive (Finklea, 2014), while EVE is seen as aggressive, unemotional, and career focused. Essentially, WALL-E displays characteristics that are generally coded as more feminine, while EVE displays more stereotypically masculine traits. While some would be quick to say that EVE has successfully found a voice, to function in a male-dominated society, at the end of the film, it becomes clear that Pixar essentially "breaks" EVE's strong, powerful character, and reconstructs her as a more "appropriate" feminine one, meaning she becomes romantic and desires a relationship with WALL-E. By forcing EVE back into a "softer" stereotypical female role, her alternative take on what it means to be a female is muted. Her original characterization was "too tough" to be acceptable. The treatment of EVE's character is significant, because it also supports Kramarae's third assumption about MGT.

MGT Assumption 3: To Be Accepted, Women Must Change Their Communication Models

Kramarae's (1981) third assumption suggests that in order to function in a male-dominated society, women must adapt their language to match men's methods of communicating. Merida, Elastigirl, and EVE all provide examples of how female characters adapt, to find a voice.

Merida changes her communication models to try to communicate better, in the patriarchal society depicted in *Brave*. After voicing her objection to the suitors, Merida resorts to participating in the shooting contest designed for the male competitors. However, when she tries to shoot her bow, the constricting dress, picked out by her pro-patriarchy mother, is too tight. "Curse this dress!" Merdia exclaims, as she uses her strength to bust the seams, so she can properly shoot an arrow. Not only does Merida have to take part in the male competition to help make her point heard, she must figuratively and literally break free of the dress, which is symbolic of the gender norms and expectations that are muting her. Additionally, Merida is easily identifiable by her unruly red hair. However, the dress's skullcap-like headpiece hides her hair completely. As a form of rebellion, Merida pulls a single curly lock out from beneath the covering. That single curl is an act of defiance that shows Merida's resistance to being muted.

As previously discussed, EVE does not follow traditional gender norms for a female character by embodying masculine traits of aggression and lack of emotion. When she arrives on Earth, she is shown holding an important job, and being capable expected to work alone (traits generally associated with stereotypical masculinity). WALL-E also does not follow stereotypical gender norms, which is counter to one of Kramarae's (1981) assertions about men: "Men also suffer, and cause others to suffer, from an inability or unwillingness to self-disclose, to discuss feelings, and to do interaction support work" (p. 22). Pixar, however, has consistently portrayed male characters (including Mr. Incredible) as capable of transforming, into what has become known as the New Man (Finklea, 2014; Gillam & Wooden, 2008). Pixar's male protagonists routinely learn to express emotions and invest in their relationships (Finklea 2014; Gillam & Wooden 2008). Therefore, since the time Kramarae wrote about masculine qualities in the early 1980s, we have seen progress made, in the ways males are represented and communicate. (For further reading about the change in masculinities and the media in the 1980s and 1990s, see Jeffords, 1994, and Malin, 2005.) Because Pixar promotes a newer version of masculinity that contrasts with long-held masculine stereotypes, this means that some female characters must also adapt to fit these new modes of male-centered communication. For *WALL-E*, this means realigning EVE in a way to put her on par with WALL-E, which means adopting what are often seen as more feminine characteristics.

Elastigirl, as previously mentioned, uses phrases about being "at the top of my game" and "up there with the big dogs," which could be coded as more masculine forms of speech. She uses this language to show that she should be treated as an equal to her male counterparts. Just before the film's climactic battle scene, she again changes her mode of communication to get through to Mr. Incredible, who wants her to stay away from the fight and protect their children. "Wait here and stay hidden. I'm going in," he says. She, however, is not content to sit this one out: "While what?" she quips. "I watch helplessly from the sidelines? I don't think so!" Mr. Incredible says, "I'm asking you to stay with the kids." To which she responds, "I'm *telling* you, not a chance!" Her language is firm, stern, and unyielding, and it gets her message across. But it took talking like a man, to be treated as an equal.

Conclusion

These films illustrate Muted Group Theory by providing examples of "muted" characters both struggling against and overcoming (to various degrees of success) the limitations imposed by the patriarchal structure. If these films are any indication, strides have been made in the area of gender, and women have more opportunity and voice than in the past. However, work still needs to be done to make explicit these underlying biases and assumptions, so that they can be addressed and overcome, thus empowering these characters and their real-life counterparts, ensuring they are both seen *and* heard.

Keywords from This Chapter

Dominant group
Mutedness
Muted Group Theory
Social spaces

References

Ardener, E. (1975). Belief and the problem of women. In S. Ardener (Ed.), *Perceiving women* (pp. 1–17). London, England: Malaby Press.

Ardener, S. (2005). Ardener's "muted groups": The genesis of an idea and its praxis. *Women and Language, 28*(2), 50–54.

Decker, J. T. (2010). *The portrayal of gender in the feature-length films of Pixar animation studios: A content analysis* (Master's thesis). Auburn University, Auburn, Alabama. Retrieved from: http://etd.auburn.edu/etd/handle/10415/2100

Finklea, B. W. (2014). *Examining masculinities in Pixar's feature films: What it means to be a boy, whether human, fish, car, or toy.* Retrieved from: ProQuest. (Dissertation number 3620090)

Gillam, K., & Wooden, S. R. (2008). Post-princess models of gender: The new man in Disney/Pixar. *Journal of Popular Film and Television, 36*, 2–8.

Jeffords, S. (1994). *Hard bodies: Hollywood masculinity in the Reagan era.* New Brunswick, NJ: Rutgers University Press.

Kramarae, C. (1981). *Women and men speaking: Frameworks for analysis.* Rowley, MA: Newbury House.

———. (2005). Muted group theory and communication: Asking the dangerous questions. *Women and Language, 28*(2), 55–61.

Malin, B. J. (2005). *American masculinity under Clinton: Popular media and the nineties "crisis of masculinity."* New York, NY: Peter Lang.

Growing up, I lived in constant fear of angering my mother. Nothing would rile her more than poor manners and rowdy behavior. During family parties, when my cousins and I became too energetic, she would halt my antics with a deadly glare, one that I knew meant consequences once we returned home. I suppose it was this glower that I feared most, the look which held the full force of the phrase "children should be seen and not heard." My mother muted me with this single look, taking away my (albeit irritating) voice in the same manner described in the article.

The authors' introduction to Muted Group Theory (MGT) through this lens of childhood is incredibly relevant and appropriate to the article. Not only does this illustration demonstrate the concept of a muted group, but it also reflects the nature of Pixar films, which are primarily marketed towards children and families. Additionally, Pixar proves to be a fantastic example of MGT, as evidenced by the compelling argument made in the article. The societies portrayed in Pixar films strikingly reflect our own society; therefore, to examine MGT through the lens of these films is to examine cultural values, and, ultimately, to critique our society. Thus, Pixar films are an appropriate and valuable means by which to examine MGT.

The article beautifully demonstrates the concept of MGT through its diverse selection of film examples. *Brave* and *The Incredibles* both portray the ways in which women experience muting in different cultures and eras, through countering traditional societal norms. *WALL-E* provides a contrast to these films, showing how MGT is applicable to situations involving reversed gender roles. This concept shows that MGT is applicable to more instances than those involving traditional gender roles. These diverse film selections allow for a thorough, well-reinforced argument for the portrayal of MGT in Pixar films.

While the article proves extremely informative, it might be made stronger through connecting MGT and Pixar films back to its reference of children as a muted group, in the introduction. While a thorough examination of this idea would be too lengthy and would broaden the focus of the article, a few sentences or a paragraph connecting these ideas might have proven beneficial. MGT appears to be a feminist argument, yet the introduction focuses on children rather than feminism. While the introduction is intriguing, it is misleading and only makes sense in retrospect; thus, a brief explanation would be beneficial to the reader.

Overall, the article is a fantastic explanation of MGT. It eloquently il-lustrates this widespread issue faced by females, of being unable to be heard in a male-dominated culture. Yet, while the article focuses on the experiences of women, MGT includes all those who are "seen and not heard." The theory can be applied to even the smallest members of socie-ty, who can be silenced with a single glare—which is likely for the best, as rowdy children can only be tolerated for so long.

—Kathryn Kerr

Knope vs. Pope: A Fantasy Theme Analysis of *Scandal* vs. *Parks & Recreation*

Krystal Fogle

When asked their opinion of American government, most citizens will not respond favorably. This reaction is interesting, considering the number of politically focused television shows emerging on major networks, cable, and the internet. It seems that although Americans feel negatively toward their government, they are still fascinated by the goings-on of government officials. Still, many of these shows contribute to the shadows associated with government dealings. Two very popular government-centered shows deal with similar themes, but come to very different conclusions about how America's government should be viewed. *Scandal* is a dark show, filled with brooding people. *Parks & Recreation*, on the other hand, leaves viewers feeling bubbly and light, enjoying the antics of characters, while admiring the hard work Leslie and her coworkers put in to running their local government. Which depiction is accurate? Possibly both. This chapter delves into how American government is represented in popular television shows, using a fantasy theme analysis.

Fantasy Themes

Through the term "**fantasy themes**" may evoke visions of unicorns and magical elves, it actually refers to the way groups understand their identity. Ernest Bormann, renowned communication scholar, clarifies that fantasy, in this field, does not connote what people think of when reading "fantasy" literature—fairies, talking animals, and epic adventures. Rather, "**fantasy** within this theory is the way that communities of people create their social reality [and should be understood to be] the imaginative and creative interpretation of events that fulfills a psychological or rhetorical need" (Bormann, 1982, p. 52). He elaborates on fantasy themes, in his **symbolic convergence theory**, explaining:

> In symbolic convergence, the term *fantasy* means the creative and imaginative shared interpretation of events that fulfills a group's psychological or rhetorical need to make sense of its experience and anticipate its future. ... The fantasy theme is the pun, figure, or analogy that characterizes [a significant] event, or it is a narrative that tells the story in terms of specific characters going through a particular line of action (Bormann, 2003, pp. 41–42).

These connotations generally fit into certain preconceived frameworks of understanding, such as cultural norms (or, in the case of television, the story-line of the show). Then, these themes become **norms** for a group's communication, providing reference points for the group in developing a common understanding.

Fantasy themes exist below the surface of our perceptions of the world. We would not be able to define a certain fantasy theme, but would simply know that a story or event "makes sense," thanks to the hidden framework of the fantasy theme underlying it. When a person watches television, her interpretations are shaped by societal themes. She weighs the content of the show against these expectations, whether consciously or subconsciously.

This chapter will provide what communication theorists call a **fantasy theme analysis**. Specifically, it seeks to answer the question: How do television shows depict American government? This question will be explored using two shows, ABC's *Scandal* and NBC's *Parks & Recreation,* and evaluating fantasy themes found in each program. Fantasy themes fall into three categories: setting, action, and character.

Characters in *Scandal* and *Parks & Recreation*

It is important that you meet the characters first, if you're not a regular viewer of these programs. The analysis portion features quotations from the shows, to describe and give an example of each fantasy theme.

Scandal

The following are recurring characters, and/or appear in the episode I will analyze in this chapter, "A Criminal, A Whore, An Idiot, and A Liar." This is a "flashback episode" that reveals new information about Fitzgerald Grant's presidential election, and whether or not it was rigged.

Olivia Pope: a consultant and "fixer." She fixes impossible situations—but she is most known for rescuing failing political campaigns. She gained notoriety by helping President Fitzgerald Grant get elected to his current office.

President Fitzgerald "Fitz" Grant: President of the United States. Olivia Pope's most significant client to date, and also her lover.

Mellie Grant: Fitz's wife, the First Lady, and Olivia's biggest enemy.

Cyrus: the President's staffer, who brought Olivia on to the campaign, and is now Fitz's Chief of Staff. He allies himself alternately with Olivia and Mellie.

Big Jerry: Fitz's father, a renowned political figure in his own right. Against Fitz's wishes, Mellie brings Big Jerry in to consult on Fitz's failing presidential campaign.

Hollis Doyle: a well-connected lobbyist from Texas, who confronts Olivia with the possibility of rigging the election.

Verna Thornton: agrees to participate in rigging the election, in exchange for a position on the Supreme Court.

Parks & Recreation

These characters recur in the show, and star in the episode, "How a Bill Becomes a Law," where Councilwoman Leslie Knope is trying to improve her town (Pawnee, Indiana), by legislating longer hours for the pool in the summer.

Leslie Knope: a newly elected Councilwoman to the town of Pawnee, who had spent many previous years as Assistant Director of Parks and Recreation. She is kind, caring, and idealistic about the ability of local government to improve the lives of its citizens.

Councilman Jeremy Jamm: a local dentist, who also serves on the town council. He doesn't care whether or not the children's swim team gets more hours at the pool; he just wants to cut a deal with Leslie, to take her private restroom in the city office building, in exchange for his vote on her swimming pool bill.

Tom Haverford: Leslie's coworker in the Parks and Recreation department. He tends to be self-centered, but always ends up doing the right thing.

Ben Wyatt: Leslie's boyfriend (later husband), currently working on a campaign in Washington, DC.

April Ludgate: Leslie's former coworker, and Ben's intern.

Joan Callamezzo: the provocative host of Pawnee's daily talk show.

The rest of this chapter will analyze the two shows, comparing and contrasting how similar themes are represented in both. While both represent American government, and both feature a female protagonist who must make a difficult ethical choice, there are also many differences, especially in how the two lead characters approach their decisions, and the attitudes they bring

to the table toward their government, the people they represent, and the personal relationships they cultivate.

Setting Themes

The setting of these shows is defined not only by their physical locations, but also by the mood of that location. Two main "setting themes" are evident, in both *Scandal* and *Parks & Recreation*: the end justifies the means, and history's role in reality.

The End Justifies the Means

> CYRUS: It comes down to two questions, Olivia: Does he deserve to be President? And if you believe he does, do you think he can win it on his own? If you can say "yes" to both, then we'll never discuss election rigging ever again.

In government, difficult choices must often be made. Government officials must choose between two evils, and decide which option will hurt the fewest people. The biggest decision Olivia must make in the episode at hand is whether to rig the election. She ultimately agrees to go along with the plan, because, as Hollis claims, rigging this election is "doing the patriotic thing." Olivia believes that this decision, though unethical, will bring about the greatest good. Olivia's decision hinges on what Cyrus says to her: Olivia believes that Fitz deserves to be president, and that he is the best choice for the American people. However, Olivia does not believe he will win on his own. Therefore, to preserve the greater good, Olivia decides rigging the election is the best option for everyone concerned.

> LESLIE: You can have my office.
>
> JAMM: Okay, why don't you sweeten the pot?
>
> LESLIE: You can have my parking space.
>
> JAMM: And?
>
> LESLIE: And I will get Invisaligns from you.
>
> JAMM: And?
>
> LESLIE: And, that is enough! And shut up.

Like Olivia, Leslie must also make a decision, based on the end result, as she is seeking to push legislation through a hostile environment. Leslie is an-

gered that Jamm wants her office: she grumbles, "This isn't even about poli-cy?" Leslie believes government should be run with the people in mind, and her bill will do good for the people of Pawnee. Jamm, however, is making his decision from a selfish motivation. Leslie's ethics tell her that she should not bribe other City Council members. However, the end result of the bill getting passed—benefiting citizens—leads her to make a compromising de-cision.

History's Role in Reality

History shapes the current reality of the shows in two ways: through the characters' past experiences, and through the representation of American history in the modern settings.

BIG JERRY: These young guys today think they invented politics.

Big Jerry's past successes shape how everyone views him now. His comment demonstrates that the political players of today should not forget past prece-dent, and those who came before them. Although the younger characters on the show might wish to forget more recent history—for instance, Fitz would prefer to forget his father's past political success—they do include subtle memorials to American history. For example, Fitz wears a flag pin through-out the campaign, and all of the men choose patriotic colors for their ties. Thus, history shapes the current moment in material ways, and recent (espe-cially family) history determines how members of the show interact with one another, forming the reality experienced by the characters.

LESLIE: Councilman Milton was first elected as a city councilor in 1948, as a member of the Dixiecrat Party. Their platform? De-integrate baseball.

Leslie must operate within a City Council that is set in its ways. The elected officials have staid values and precedents, and are resistant to change. Coun-cilman Milton is an elderly man, and his values have not changed much since he was elected. Tom, Leslie's co-worker, takes a bite of salad at lunch with Councilman Milton and quips, "You can taste the racism!" Thus, the history of how things have been done in the Pawnee City Council shapes the current reality that Leslie faces. Her preference is to shake up the City Council and push great legislation through, but she encounters either apathy or prejudice from the other—all male—councilmembers. Thus, Leslie must shift her op-erations, to accommodate the existing modes and assumptions.

Action Themes

"Action themes," the second category of fantasy themes, revolve around the actions taken by characters, and the outcomes of those choices. There are two main action themes in *Scandal* and *Parks & Recreation*: overcoming rivalries, and the purpose of government.

Overcoming Rivalries

> BIG JERRY: Look, I realize you don't think I know anything, but I've done more in the past twenty years than you'll do in an entire lifetime. You'll want me in Florida.

Both Mellie, Fitz's wife, and Fitz have reason to hate Big Jerry. He has done significant harm to both of them, and irrevocably damaged those relationships. He does not apologize or ask for forgiveness for his behavior, but continues to defend himself. Though Mellie could easily have ignored Big Jerry for most of her life, she is the one who suggests bringing him to help the campaign. Once he arrives, Fitz is very resistant to Big Jerry's help. However, as Fitz continues to decline in the polls, he decides to listen to Big Jerry, and to attempt to mend some of the broken relationship. Mellie and Fitz recognize that political survival depends on overcoming past rivalries.

> BEN: Oh, I'm excited to bond a little with April. She's like the little sister I never had. Because the little sister I do have is normal and not terrifying.

April, Leslie's coworker, and Ben, Leslie's boyfriend, are more tangential characters in *Parks & Recreation*. However, they represent the overall spirit, of overcoming rivalries and general friendship, evident in the show. Ben and April have temporarily moved to Washington, DC, for work. They decide to take a road trip to visit their friends in Pawnee. April and Ben have never been close, and April has even attempted to turn some of their new coworkers against him. However, rather than becoming angry, disenfranchised, or scheming, they decide to overcome their differences and drive together. This same spirit of reconciliation and friendship is seen throughout the show, as the members of the Parks department support one another, rather than using each other to further their own careers. Clearly, then, government employees do not have to use cutthroat competition, and rivalries do not have to jeopardize friendships.

Purpose of Government

> CYRUS: Fitz is clean as a whistle. He's the real deal. A patriot. A believer. How rare is that? How often does that come along? Once in a generation, if you're lucky. I'm just saying, this is our chance to put a man with integrity inside that big white house.

Characters' words and actions reveal their opinions about the purpose of government. For many characters on *Scandal,* government and power are tools for personal fulfillment. However, Fitz believes that government is about making people's lives easier, about representing the will of the people. Cyrus's comments above indicate that Fitz's team truly believe he wants to be president for the right reasons. Although his team may have their own motives for getting him into the presidency (especially personal power), they also know that Fitz is truly the best man for the job. Thus, although many characters do use governmental power for their own ends, at their core, they know that the purpose of government is to facilitate a good life for the American people.

> JOAN: Leslie, the City Council has done very little over the past few years, and what they have accomplished has been embarrassing.
>
> LESLIE: The City Council has some political gridlock and some partisan bickering, but we're actually about to pass a bill—the Leslie Knope Fun in the Sun Act—which will extend public pool hours citywide.

Joan invites Leslie on to her talk show, to discuss the state of the City Council. For Leslie, the purpose of government, and her reason for running for City Councilwoman, is to help citizens. Additionally, because the Pawnee City Council has been ineffectual, Leslie's new purpose for her role, is to prove to her constituents that the City Council is valuable and capable of benefiting them. For Leslie and the members of her Parks Department team, government *facilitates* real life, rather than government *becoming* real life. In other words, though Leslie believes that government should absolutely be a firm priority, there are more important things in her life. Her relationships take precedence.

Character Themes

Television shows are character-driven; they thrive on creating believable yet engaging characters, with whom the audience can identify. Two "character

themes" arise in *Scandal* and *Parks & Recreation*: cultivating alliances, and choices defining attitudes.

Cultivating Alliances

CYRUS: No, the only way we trust each other is if everybody's [reputation] is on the line. If it's not unanimous, we don't do it.

The biggest alliance, in the episode of *Scandal* we have been discussing, is the alliance formed to decide whether to rig the election. Cyrus's comment demonstrates that alliances must have mutual benefits, as well as mutual downsides. For this alliance, if it were not unanimous, the members could back out, and pose a risk of one person ratting out the others. In *Scandal,* characters rarely form true friendships. Rather, relationships are formed around alliances and mutually beneficial associations. These alliance members may not actually like each other, but they have agreed to work together to achieve a common goal. Thus, *Scandal*'s depiction of American government indicates that in government, friendships are a liability. Alliances—in which one always has ulterior motives—are the only way both to protect oneself and achieve goals.

JAMM: Not my initials, but thank you so much.

TOM: Hey, so we're still all good on Leslie's bill, right?

JAMM: Actually, Tommy, we need to talk.

In this interaction, Tom was trying to show Jamm something he had purchased for himself; but Jamm mistook the object as a gift. Tom used the opportunity to ask Jamm about Leslie's bill—since he has just given Jamm an unplanned present, he thought it would be an ideal time to broach the subject. However, Jamm had decided he no longer wanted to work with Leslie on the bill. This interaction was the start of Leslie's attempt to cultivate an alliance with Jamm, and other members of the City Council, to get her bill passed. Certainly, alliances are integral to Leslie's survival as a government official. However, friendships are overwhelmingly more important to Leslie than her alliances. Although Leslie realizes she must cultivate alliances with people she may not enjoy spending time with—this is a necessity of her government life—she prefers building real, lasting friendships with those she cares about.

Choices Define Attitude

FITZ: I want a divorce.

This simple statement by Fitz is the end result of many poor decisions, which shaped the emotional states of the three characters involved. Mellie was sexually assaulted early in her marriage to Fitz, but decided to stay quiet about it. As a result of the assault, and of her silence, she became emotionally distant from Fitz. Her decision not to tell him forever altered how they interacted. Because he felt distant from his wife, Fitz decided that it was acceptable to pursue an affair with Olivia. Similarly, Olivia was able to justify her affair with a married man, since his wife was so remote. However, they both face guilt and shame over the affair, and Mellie is furious when she discovers their duplicity. In other words, their conscious choices define their experience and attitude toward life. Inadvertently but significantly, they each chose to be miserable.

LESLIE: Here are my clocks: Pawnee and Washington, DC

BEN: Same time zone.

Though humorous, this interaction demonstrates a difference between how the characters in *Scandal* and *Parks & Recreation* deal with adverse circumstances. Though Leslie and Ben must be apart, and they are sad about the distance, Leslie makes the best of the situation. In her new office, which she is showing to Ben on Skype, she has set two clocks, to the two different cities' times. However, as Ben notes, they are actually in the same time zone. Still, Leslie's decision to display both clocks demonstrates both her devotion to Ben, and also her positivity in the face of challenges and emotional difficulties. As Leslie tells Tom, when facing the challenge of her bill potentially not passing, "Our positive attitude is our greatest asset."

Conclusion

In all parts of American government, people must make choices every day. These choices are made for the well-being of American citizens, but often involve difficult ethical dilemmas. The fantasy themes explored in this chapter elucidate the ways in which popular television shows represent the American government to viewers. Both *Scandal* and *Parks & Recreation* demonstrate that televised representations lead viewers to believe that government officials operate under the assumption that the end justifies the

means. Compromising one's values may be necessary to further the good of the country. However, the shows provide two very different attitudes toward these decisions. Olivia and her friends carry unhappiness and shame through life, while Leslie and her coworkers strive to see the good, even in difficult circumstances.

The overall rhetorical vision found in both shows is this: decisions are made, in government, to preserve the greater good. Each quotation discussed in this chapter emphasizes this principle, with both Olivia and Leslie, as well as their many supporting characters, making it their daily goal to serve the good of everyone. In revealing the beliefs and motivations underlying a major area of modern identity—our relation to our government—these shows present useful cases for fantasy theme analysis.

Keywords from This Chapter

Fantasy theme analysis
Fantasy themes
Norms
Symbolic convergence theory

References

Bormann, E. (1982). The symbolic convergence theory of communication: Applications and implications for teachers and consultants, *Journal of Applied Communication Research*, *10*(1).
———— (2003). Symbolic convergence theory. In R. Y. Hirokawa, R. S. Cathcart, L. A. Samovar, & L. D. Henman (Eds.), *Small group communication: Theory and practice*. Los Angeles, CA: Roxbury Publishing.

This chapter was intriguing to me because of my interest in pop culture, television, and politics. The way Krystal Fogle sought to analyze two television shows, *Scandal* and *Parks & Recreation,* through fantasy themes was both new to me and interesting. I do believe that American attitudes towards government can be shaped by television shows. Being a fan of *Scandal*, I can see the tough choices that most of the characters, including Olivia, Fitz, and Cyrus, have to make in each episode. As stated in this chapter, many of these choices tend to be an ethical battle, in choosing the lesser of two evils. Situations like this do create a possible negative view of how the American government makes decisions, but I think it brings to light the difficulties that government officials face. On the other hand, also being a fan of *Parks & Recreation*, I agree that the role of choices in that show is also significant. Although on a smaller governmental scale, Leslie Knope is always struggling to make decisions, when it comes to her friendships and workplace duties, knowing how her choices affect her relationships. Overall, I think both shows create a depiction of the American government that viewers can analyze, and use to clarify their own outlook. Understanding these shows through a fantasy theme analysis shows that, even though the plots are so different, the issues brought to light, as well as character actions, can be very similar.
—A. J. Vogt

Part III

Media and Technology

CHAPTER 12

The Smartphone as Permanent Substitute Teacher

Brian Gilchrist

The smartphone has been a ubiquitous presence among students for many years. This chapter addresses the following question: What are the implications of smartphones for contemporary American public education? This inquiry is explored using Marshall McLuhan's approach to media ecology. First of all, McLuhan's perspective on media ecology is examined, to provide theory for analyzing the media effects of smartphones. "Theory" comprises a "set of statements ... coded in terms of words or in terms of mathematical equations" (Ruesch, 1972, p. 393). Secondly, some significant hardware and software features of smartphones are identified, to position smartphones as media that promote the pursuit of information. Third, smartphones are interpreted as permanent substitute teachers, because, in a sense, they have replaced teachers as guardians of information in the American public education system.

McLuhan's Media Ecology

Media ecology has grown into a robust area of study within the communication discipline, over the last fifteen years. Neil Postman defined **media ecology,** as a study of the reciprocal relationship between human beings and communication media within mediated environments. If we can agree on that general definition, then the scope of media ecology can be expanded greatly. Media ecology examines the impact of technology on cultures, and how human beings interpret reality through media (Anton, 2011, p. 99; Ellul, 1964; Farrell, 2012, p. 56; Gilchrist, 2012; Innis, 1999, p. 9; McLuhan, 2000, p. 57; Ong, 2009, p. 79; Postman, 1993, p. 17; Strate, 2012, p. 99). These concerns about the impact of technology on culture are not new. Plato operated as a media ecologist in *Phaedrus*, when he warned that the new invention of writing would weaken the memory, and could make unintelligent people seem smarter than they really were (Plato, trans. 1997). Ironically, Plato embraced the medium of writing to attack writing, and to spread his philosophy through his published dialogues.

Media ecology neither champions nor condemns technology. The inventors of new technologies may predict the benefits of their creations, but they

seldom foresee any negative consequences. McLuhan (1999) speculated about "a deep-seated repugnance in the human breast against understanding the processes in which we are involved" (p. 72). Millions of people share ideas across the globe using Facebook and Twitter, but they may also engage cyber-bullying. Cyber-bullying is the use of electronic technology to harass and attack others (What is cyberbullying, n.d.). You might know victims of cyber-bullying, or you may have attended school assemblies about its prevention. Technology begins as value-neutral, but each medium has positive and negative consequences for society.

Marshall McLuhan (1911–1980) functioned as one of the founding voices of media ecology. He began his academic career as an English professor, but he soon turned his attention to media studies. *The Mechanical Bride*, published in 1951, featured McLuhan's examination of advertisements. His analyses were revolutionary, because he focused his study on each ad's medium, rather than its content. An advertisement in an issue of *Life* magazine, and a commercial on television, might feature the same product; but the different media altered the consumers' experiences of each ad. McLuhan (2003) later expanded his research into other forms of media, to the degree where he even suggested that "the medium is the message." This phrase is widely familiar, though few people know it came from McLuhan, and even fewer understand his meaning.

"The medium is the message" proposes that the medium of a communication has greater significance than its content. The medium affects how the message can be delivered and understood by the audience. The four televised 1960 presidential debates, between Richard M. Nixon and John F. Kennedy, provide an example through which to better comprehend this concept. During the first televised debate, Kennedy understood that the television stimulated the eyes of the viewers, so he tried to appear presidential. The candidate shaved, used makeup to endure the bright studio lights, and wore a blue suit so that he would "pop" through the black-and-white television sets across the United States (Kennedy-Nixon Debates, 2004.). Kennedy also knew which camera was recording him, so he spoke directly to those cameras, rather than speaking to Nixon. Let's contrast Senator Kennedy's approach with that of Vice President Nixon.

Richard M. Nixon did not grasp the nuances of television, and he failed to respond to that medium's demands. He neither shaved nor applied makeup. In fact, he was ill at the time, and he looked rather haggard. Viewers noticed that his gray suit made him blend into the background. Nixon

lacked certainty about which camera to use, so he shifted his eyes multiple times, whether he was speaking or not. "Following the first debate performance, the majority of television viewers claimed that Kennedy won the debate, while the majority of radio listeners argued that Nixon won (Cosgrove, 2014)". This is a clear example of McLuhan's theory that "the medium is the message." Nixon might have sounded presidential, but Kennedy looked presidential. Kennedy's appearance fit the visual needs of the medium of television.

McLuhan's media studies presupposed connections among media, technology, language, and human beings. Technology and media function as interchangeable metaphors. Languages are media (Postman, 2006, p. 15). Languages are technologies. McLuhan (2003) even claimed that the spoken word was mankind's first and most significant invention (p. 85). Media and technologies also enhance and extend parts of the human body (McLuhan & Powers, 1989, p. 28). The wheel extends the foot. Writing extends the sense of vision. Numbers extend the sense of touch. Electricity extends the human nervous system. Mass communication technologies, such as radio, television and the internet, extend the human consciousness.

The introduction of new media or technology transforms cultures. Although each medium responds to a particular set of problems within that society, the new medium creates a different set of challenges in its wake. McLuhan and Powers (1989) posited that "Westerners" often are willing to "adopt anything that promises an immediate profit and to ignore all side effects" (p. 69). The automobile is a striking example.

Americans enthusiastically embraced the automobile as their preferred method of transportation. This vehicle allowed drivers to travel great distances alone, or with a few passengers. Yet, the automobile also created a demand for paved roads, highways, and parking lots. New laws were created that required people to obtain driver licenses, purchase car insurance, and obey traffic laws. Let's not forget the many negative consequences of automobiles, such as car accidents, drunk driving, and road rage.

This section of the chapter has provided a brief sketch of media ecology, and Marshall McLuhan's media theories. Media ecologists study the relationships among human beings, technology, and both real and virtual environments. Media, technology, and language serve as equivalent metaphors. New forms of media fundamentally transform society. The next section examines the media effects of smartphones.

Smartphone Technology

Smartphones are cellular phones with sophisticated hardware and software features that offer users a broad range of activities, with actual telecommunication being one of the least used functions among them. "Simon" was the first smart phone introduced in 1992, and was made available to consumers in 1994 (Aamoth, 2014). Simon, which sold for $1,100, weighed over one pound, reached 8 inches in length, had a touch screen and email capabilities, but lacked a web browser. Before discussing the cultural impact of this technology, let's review some hardware and software capabilities.

People may purchase a variety of smartphones according to brands, amounts of memory, sizes, and processing speeds. Most smartphones easily fit into the palms of adult hands. The Samsung Galaxy Note 4, called a "phablet," or combination of a smartphone and a tablet, comes with a stylus for writing messages on the touchscreen; the Apple iPhone 6 Plus offers a large display screen; the Sony Xperia Z3 has the processing capabilities to compete with Android, HTC, and LG phones (Dolcourt, 2015). Many smartphones contain digital cameras that are capable of taking pictures and recording video.

Innovative software has facilitated the completion of personal tasks, and fostered the spread of information across the globe. Users may communicate through video calls using Skype, or FaceTime if they have an iPhone. Applications or "apps" enable multiple activities for the purposes of entertainment, travel, finance, or even fitness. Although McLuhan did not live to experience apps, he anticipated that type of technology when he warned that "the old pattern of education in answer-finding" would not succeed in the "global information environment" where information that surrounds us "by answers, millions of them, moving and mutating at electric speed" (McLuhan & McLuhan, 1988, p. 239). Apps provide answers, but the number of apps has grown so extensively that some users might have difficulty finding the correct app for their specific needs. Multitasking emerges as a negative consequence of these apps, because we cannot focus our attention on any one particular activity at a time. Unfortunately, we may also ignore the people around us, to concentrate on our smartphones. Perhaps you have seen a family at a restaurant interacting with their smartphones, tablets, and other electronic devices, rather than participating in a conversation.

This section of the chapter has provided a summary of the hardware and software features of smartphones. These enable us to purchase items we

want, but they also erode our ability to concentrate. The next section analyzes how smartphones have disrupted the educational experience in American public schools. Our students have turned smartphones into their permanent substitute teachers.

Permanent Substitute Teachers

The contemporary public education system in the United States uses the factories of the mid-nineteenth century for its model. McLuhan (2001) suggested that the encyclopedia approach remained the basis for a classical education in the West, especially in the United States and Great Britain, until around 1850, when the demand for vocational training grew to meet the needs of the Industrial Revolution (p. 42). This era featured Vanderbilt, Rockefeller, Carnegie, and Morgan, captains of industry, who exercised their power to reinvent the American economy and acquire vast sums of wealth in the process (McCormick & Folsom, 2003, p. 708). As a native of Southwestern Pennsylvania, I learned that many towns along the Allegheny, Monongahela, and Ohio rivers developed near steel mills. Although the thriving steel industry left the region many decades ago, the industrial model remains alive, but unwell, in public schools across America. Let's explore the steel mill as an example.

The steel mill thrived because thousands of "mill hunks" performed their specialized roles. Loud whistles indicated shift changes, whereby a new set of workers would take over. They concentrated on specific tasks, such as fixing pipes, coordinating the activities of their crews, or even working in the blast furnace, where fuel, iron ore, pig iron, limestone, and coke were heated at temperatures around 1,000 degrees C. to create steel (Fabian, 1967). The movement from raw materials to finished goods proceeded through the atomization of labor: the manufacturing process was divided into very small segments, and workers at each stage performed very simple but highly repetitive tasks.

I want to compare the steel mill to an American public high school. McLuhan (2003) argued that "education has long ago acquired the fragmentary and piecemeal character of mechanism" (p. 471). Education has been atomized, because the average class day is segmented into periods where the students carry out simple but repetitive learning tasks. Students might thoroughly enjoy the Pythagorean theorem in geometry class, but then a loud bell stops class and signals a shift change. Students must abruptly leave, and walk

to another classroom. The signal of another bell begins English class, where they begin to write a five-paragraph essay.

A bell, again, indicates an end to drafting the essay, and the start of a long walk to biology class. Students have one period to unlock the secrets of stratified squamous epithelium or mitochondrial DNA, before their lunch period. Ruesch (1972) suggested that education emerged as acquiring vast amounts of technical data, and effective "coding and recall of such information" (p. 270). Each class has a series of learning outcomes, tied to the pursuit of new information. Assessment activities, such as quizzes or tests, evaluate how well students have retained this information.

Each teacher functions as a foreman or manager of the students, by creating a series of tasks for each class. Teachers introduce new information, and later assess student recall of that material. Postman (1993) warned that efficiency and interest described the purposes of learning in the contemporary American school system, which lacked reflection in educational philosophy (p. 171). The ability to recall information carries greater weight than the ability to understand information.

Teachers operate as guardians of knowledge. The instructor edition of the class textbook contains more information than the student version. Administrators consider classroom management—the ability to persuade students to follow directions and behave in a civil manner—one of the leading indicators of successful teachers (Freiburg, Huzinec, & Templeton, 2009; Reese, 2007; Weiner, 2003). Particularly challenging students often require the teacher to devote more energy to classroom management. Consequently, some teachers spend more time keeping students on task than discussing the academic lessons.

Although all students are expected to understand the new information by the time of the assessment activity, teachers must adapt their lessons to fit the diverse learning needs of their students. While students may differ according to learning styles (auditory vs. visual) or learning abilities (advanced vs. remedial), they all share the same basic learning outcome: to recall new information. Students in American public schools, representing different cultures, ethnicities, religions, socio-economic classes, and other values, share common educational experiences: the obligation to memorize new information, and be evaluated on their recall abilities. How they learn this information, and the amount of time needed to digest it, often separates the students into different tracks, such as remedial, traditional, or advanced.

Smartphones have transformed this American public education paradigm. **Paradigms** are sets of assumptions or lenses, through which we interpret reality (Kuhn, 1996). Smartphones have displaced textbooks as sites of information, and have allowed students to replace teachers as guardians of information. Neither the instructor nor student edition of the textbook can compete, with the amount of information available through the smartphone's internet connection. Students turn to smartphones as sites of information, rather than their textbooks or their teachers.

Smartphones have enabled students to trade positions with their teachers as keepers of knowledge. They may search multiple websites or databases to find possible answers, rather than limit their inquiries to a few pages in a textbook. McLuhan cautioned that people's anxiety levels increase when "trying to do today's job with yesterday's tools—with yesterday's concepts" (Coupland, 2009, p. 177). Teachers face the unenviable task of persuading students to memorize arbitrary data that is narrow in scope and derived from a textbook, when more complex information from multiple perspectives can be found only a few clicks away. Textbooks provide students with information that has not changed, from the first day of class to the last day of class.

Smartphones have made the **information-based education system** obsolete in American public schools. This different paradigm requires an alternative pedagogical model. Instead of focusing lessons on introducing and pursuing new information, instructors could teach students how to make information meaningful, and develop knowledge into wisdom. Educators could adopt a **communication-based system**. Ruesch and Bateson (1968) define "communication" as "the matrix in which all human activities are embedded" (p. 13). Communication establishes relationships between people and objects, through interrelated systems. Context situates information in narratives or value-laden stories, ethical systems, histories, or cultural assumptions. Communication equals information, plus context.

A communication-based system would challenge students to comprehend the significance of information. Standardized tests evaluate students' abilities to recall material. This skill no longer seems as relevant, in contemporary American society, where students can access information through smartphones and other personal electronic devices. Who delivered the Gettysburg Address? President Abraham Lincoln. Educators could revise tests to determine students' capabilities to explain the relevance of information, or to present a persuasive argument about that information. Why was the Gettys-

burg Address such an important speech? How did the Gettysburg Address change the American political landscape? These questions demand greater cognitive ability, rather than simple recall.

Interpretive essays of varying lengths could replace quizzes or tests comprised of fill-in-the-blank, multiple choice, and true-or-false questions. Teachers could even conduct lessons that promote the use of smartphones in class. Imagine asking students to locate data using their smartphones, but then engaging in a class discussion, to make that information meaningful.

I wanted to raise the issue of smartphones, as technology that has disrupted the status quo of American public education. My suggestions for instructors serve merely as "**probes**," what McLuhan (2003) described as pathways of thinking. Probes initiate conversations, and invite responses about issues from many voices. I cannot say for certain how educators should address this problem, but continuing to operate under an obsolete paradigm hinders the potential success of our administrators, teachers, and students.

Conclusion

By using Marshall McLuhan's approach to media ecology, this chapter suggests that students have turned smartphones into permanent substitute teachers. Students have less incentive to engage in information-based lesson plans from teachers, when smartphones can provide a far greater volume and variety of information. Smartphones enable students to replace teachers as guardians of information. Students can find many more possible answers through Google, than in any of their class textbooks. Although smartphones disrupted the American public education paradigm, contemporary educators have yet to provide fitting responses. Unless instructors adjust their pedagogy, students will continue to use their smartphones as permanent substitute teachers. This chapter urges students to explore a communication-based system for their education. Educators cannot generate more information than smartphones, but they could work with them, to make that information meaningful. This is just one application of the theories of media ecology.

Keywords from This Chapter

Communication-based system
Information-based education system
Media ecology
Paradigms

Probes
Smartphones
The medium is the message

References

Aamoth, D. (2014). First smartphone turns 20: Fun facts about Simon. *Time*. Retrieved from: http://time.com/3137005/first-smartphone-ibm-simon/

Anton, C. (2011). *Communication uncovered: General semantics and media ecology*. Fort Worth, TX: Institute of General Semantics.

Cosgrove, B. (2014). The Kennedy-Nixon debates: When TV changed the game. Life. Retrieved from: http://life.time.com/history/ kennedy-nixon-debates-1960-the-tv-landmark-that-changed-the-game/#1

Coupland, D. (2009). *Marshall McLuhan*. Toronto, Canada: Penguin Canada.

Dolcourt, J. (2015). Best phones of 2015. *CNET*. Retrieved from: http://www.cnet.com/topics/phones/best-phones/

Ellul, J. (1964). *The technological society* (J. Wilkinson, Trans.). New York, NY: Vintage Books.

Fabian, T. (1967). Blast furnace production planning: A linear programming example. *Management Science*, *14*(2), B1–B27.

Farrell, T. J. (2012). Ong's call for a revolution in our thinking. In T. J. Farrell & P. A. Soukup (Eds.), *Of Ong & media ecology: Essays in communication, composition, and literary studies* (pp. 45–70). New York, NY: Hampton Press, Inc

Freiburg, H. J., Huzinec, C. A., & Templeton, S. M. (2009). Classroom management—A pathway to student achievement: A study of fourteen inner-city elementary schools. *The Elementary School Journal*, *110*(1), 63–80.

Gilchrist, B. (2012). Surfing Foucault's panopticopolis: Facebooking our way to a panoptic world. *Explorations in Media Ecology*, *11*(1), 45–55.

Innis, H. (1999). *The bias of communication*. Toronto, Canada: University of Toronto Press.

Kennedy-Nixon Debates (2014). Mary Ferrell Foundation. Retrieved from https://www.maryferrell .org/wiki/index.php/Kennedy-Nixon_Debates

Kuhn, T. S. (1996). *The structure of scientific revolutions* (3rd ed.). Chicago, IL: The University of Chicago Press.

McCormick, B., & Folsom, B. W. (2003). A survey of business historians on America's greatest entrepreneurs. *The Business History Review*, *77*(4), 703–16.

McLuhan, M. (1999). *The medium and the light: Reflections on religion*. E. McLuhan & J. Szklarek (Eds.). Eugene, OR: Wipf and Stock Publishers

———— (2000). *The Gutenberg galaxy: The making of typographic man*. Toronto, Canada: University of Toronto Press.

———— (2001). *The mechanical bride: Folklore of industrial man*. Berkeley, CA: Gingko Press.

———— (2003). *Understanding media: The extensions of man*. W. T. Gordon (Ed.). Corte Madera, CA: Gingko Press.

McLuhan, M., & McLuhan, E. (1988). *Laws of media: The new science*. Toronto, Canada: University of Toronto Press.

McLuhan, M., & Powers, B. R. (1989). *The global village: Transformations in world life and media in the 21st century*. New York, NY: Oxford University Press.

Ong, W. J. (2009). *Orality and literacy*. London, England: Routledge.

Plato (1997). *Phaedrus*. In J. M. Cooper (Ed.), *Plato: Complete works* (A. Nehamas & P. Woodruff, Trans.) (pp. 506–56). Indianapolis, IN: Hackett Publishing Company

Postman, N. (1993). *Technopoly: The surrender of culture to technology*. New York, NY: Vintage Books.

Postman, N. (2006). *Amusing ourselves to death: Public discourse in the age of show business*. New York, NY: Penguin Books.

Postman, N. (2009). What is media ecology? *The Media Ecology Association*. Retrieved from: http://www.media-ecology.org/media_ecology/index.html

Reese, J. (2007). The four c's of successful classroom management. *Music Educators Journal*, *94*(1), 24–9.

Ruesch, J. (1972). *Semiotic approaches to human relations*. Paris, France: Mouton.

Ruesch, J., & Bateson, G. (1968). *Communication: The social matrix of psychiatry*. New York, NY: W. W. Norton.

Strate, L. (2012). Sounding out Ong: Orality across the media environments. In T. J. Farrell & P. A. Soukup (Eds.), *Of Ong & media ecology: Essays in communication, composition, and literary studies* (pp. 91–116). New York, NY: Hampton Press.

Weiner, L. (2003). Why is classroom management so vexing to urban teachers? *Theory into Practice*, *42*(4), 305–12.

What is cyberbullying? (n.d.). *Stopbullying.gov*. Retrieved from: http:// www.stopbullying.gov/ cyberbullying/what-is-it/

In his chapter, Gilchrist explores smartphones through media ecological, historical, and educational lenses. I agree with his premise—that smartphones have replaced teachers—but I feel that various aspects of his approach can be critiqued. First of all, he talks about media ecology. Unfamiliar with this term before reading this chapter, I now notice that the focus is on the medium and not the content, when dealing with human communication. I would like to have seen a challenge to media ecology, and how a media ecologist would respond to such a challenge. For example, Gilchrist notes, "Media ecology neither champions nor condemns technology." Marx said in *The Poverty of Philosophy*, "The hand-mill gives you society with the feudal lord; the steam-mill society with the industrial capitalist." What would a media ecologist say in response to that, especially in relation to smartphones? One could imagine a response from Marx in a smartphone argument as, "A dumbphone gives you the ability to telecommunicate; a smartphone gives you the ability to telecommunicate, browse the internet, and cyberbully."

Gilchrist then talks about smartphone technology. I feel this section would have been better served with a more thorough background of the smartphone, and how it came to be in our pockets. What was once the businessman's staple is now in the hands of a majority of Americans. The Pew Research Center has data from 2000 regarding device ownership (www.pewinternet.org). In 2000, just 53% of Americans had a cell phone of any kind (smart or dumbphones). As of October 2014, 64% have a smartphone, and 26% have a dumbphone. In this chapter, all that was included was a brief introduction of the very first smartphone, Simon. Related to this, it would be interesting to see data of smartphone usage among teens. It seems everywhere we go these days, we run into middle and high school-aged people on their smartphones. Also, to an extent for my generation, and definitely for the generation currently in high school, all we have ever known is smartphones. When I think of my younger relatives, their first phones were smartphones, and thus every phone after will likely be as well. Smartphones have become widely ingrained in our lives. Gilchrist then argues that smartphones have replaced teachers "as guardians of information." But was this ever really the case? Pre-technology, if your teacher did not know the answer, you consulted a book or encyclopedia.

Now, if your teacher does not know the answer, you can search for it, and Wikipedia will likely be among the first few results. So, instead of finding faults with smartphone usage in schools and proposing a systematic change (one that would be very politically and feasibly difficult), I would argue, along with Gilchrist, that schools should simply *embrace* technology. Interweave it with their lessons and teachings. Schoolteachers are not all-knowing experts on what they teach—nor should they be expected to be.

—Scott Butler

CHAPTER 13

Media and Technology—Metal and Mutation in the *X-Men* Films

Paul A. Lucas

There was a point in time, years ago, when superhero fiction exploded on the scene, ushering in an era of interest in comic books, and in the idea of heroes who could save the day. According to Darowski (2014), "The superhero genre has two clear antecedents: classical mythology and American adventure stories" (p. 4). Decades later, superhero fictions have exploded again, this time drawing mainstream audience interest to an array of films that feature the comic book characters, in familiar, and sometimes new, storylines.

Cartoons, television shows, and even increasingly present comic conventions have furthered attention and curiosity, from a very diverse fan base. Despite the decline in print media, comic books are as popular as ever, with millennials now being among the heavy consumers. In order to re-create their fan bases continually, "the superhero genre … doesn't seem to be going away in the foreseeable future, but it will inevitably change and alter, along with the society that consumes these stories" (Darowski, 2014, p. 15). In line with that effort, "comic book creators have long acknowledged that they were teaching and motivating in addition to entertaining youth" (Gerde & Foster, 2008, p. 247), so there are enjoyment and commentary aspects of the comic book stories to consider.

The X-Men

Marvel's X-Men are an immensely popular superhero team, and their popularity has sparked a number of comic titles, and, at the time of writing, seven live action films. Though issues of "**identity discourses**" and "identity" (Zingsheim, 2011, p. 224) are vital to the appeal and understanding of *X-Men*, there is more to the team and characters that draws interest.

In the Marvel Universe, the mutants, including the X-Men, are unique; unlike most other superheroes, they were born with their powers. The term "mutant" is given to them because it is genetic mutation, present from birth, which results in their superhuman abilities. For some mutants, their powers emerge at birth, but for most, it happens later in life. The mutants are publicly categorized for their differences, and themes of prejudice appear throughout the *X-Men* storylines. Other Marvel superheroes are not categorized this

way, and appear more accepted for the most part. For example, Iron Man possesses a suit that grants him abilities; Spider Man was bitten by a spider; Hulk was affected by gamma radiation; and the Fantastic Four gained powers after being exposed to cosmic rays. In these cases, each hero is human, or, at least, was human. The mutants in *X-Men* are never really considered human at all.

So what you have in the X-Men and their fellow mutants is a biological characteristic. No radioactive spider, or special suit on the cutting edge of technology; just a genetic mutation that they are born with. As Trushell (2004) stated, "The X-Men were born different" (p. 153). In some *X-Men* storylines, the term applied to mutants is homo superior, a testament to the distinction between the mutants and the homo sapiens—the humans.

Wolverine and Lady Deathstrike, two characters who appear in the *X-Men* films, belong to a kind of subset of mutants. They are mutants, and their powers are a result of their mutations, but they have also undergone procedures to enhance their abilities further. Wolverine had adamantium grafted to his skeleton in the Weapon X Program, and Lady Deathstrike experienced a similar procedure. In order to explore one way in which *X-Men* stories draw in millennial fans, and one way in which communication theory can be applied to the films, this chapter will examine how mass media concepts and ideas, seen in these characters, can help us to understand how technology has become inseparably linked to us and the way we live our lives.

Theoretical Applications

Specifically, McLuhan (1964) claimed that each **"medium"** can be considered an "extension of ourselves" (p. 7), which articulates this link. In his view, it is "not the machine, but what one did with the machine, that was its meaning" (p. 7). In a culture that is inundated and increasingly obsessed with technology, it is important to remember that mass and social media, as well as the various machines and devices we use, function only through us. In addition, we would now be hard-pressed to live without our technology, and it is this same symbiotic and intimate connection that permeates the character of Wolverine (and Lady Deathstrike, though she is much less central to the plots).

To highlight and explore these themes, this chapter will focus on elements from the *X-Men* films, primarily dealing with Wolverine. The comic book and movie industries have been intertwined in recent history, with the

"'comic book movie'" being "synonymous with a superhero movie" (Darowski, 2014, p. 3). Examples from the *X-Men* films illustrate a comment on **media technology**: that technology has become inseparably linked to us. It supposedly makes us better—"enhances" us—but is nonetheless completely ingrained within our lives.

Metal and Mutation

In the first *X-Men* film, simply titled *X-Men* (Singer, 2000), we are introduced to Wolverine, a character with a mysterious background. Wolverine has little memory of his past, so we do not get much information on him until later films. Until fairly recently, much of Wolverine's past was left unknown in the comic book storylines, as well. What we do learn in the first film is that he has a remarkable healing factor, which is a direct result of his mutation. Among other benefits, Wolverine's healing ability allows him to rapidly recover from injury, and he also ages much more slowly than human beings. Courtesy of the character Jean Grey's analysis, we also learn that Wolverine has had adamantium, a metal in the Marvel Universe, known to be almost completely indestructible, laced to his entire skeleton. Wolverine's apparent amnesia affords him little memory of the events of the procedure, where the metal was grafted to his skeleton, nor does he remember who did it to him.

Two later films added a significant amount to Wolverine's backstory: *X2: X-Men United* (Singer, 2003), and a prequel, *X-Men Origins: Wolverine* (Hood, 2009). In *X2: X-Men United* (Singer, 2003), William Stryker and the Weapon X Facility are introduced, so audiences get to see where the adamantium procedure took place, and the individual who was central to initiating the procedure. Additionally, Lady Deathstrike fights Wolverine and other X-Men in the film, and as a result, Wolverine discovers that at least one other mutant with a healing factor has had a similar procedure done. In *X-Men Origins: Wolverine* (Hood, 2009), we actually see Wolverine having the Weapon X procedure performed, gaining glimpses into his life prior to the adamantium being grafted to his skeleton. Jackson (2010) referred to Wolverine as a "popular cyborg character" (p. 46), because of this grafting. The end result is a state of being "more and more enslaved to technology" (Jackson, 2010, p. 47).

Even though Wolverine and Lady Deathstrike possess healing factors as a result of their mutations, they also have additional characteristics afforded to them, by the surgical enhancements that implanted metal into their bod-

ies—in other words, by technology. Both Wolverine and Lady Deathstrike emerge from their procedures as something more than their mutation; they are biology mixed with technology, in a virtually inseparable way, because the success of the procedure done to them was dependent upon their mutations. Having the metal implanted into their skeletons would have killed an ordinary person—which is why these fast-healing mutants were sought out for the procedure to begin with. Since "meaning" is created by "what one [does] with the machine" (McLuhan, 1964, p. 7), Wolverine and Lady Deathstrike make sense: the technology that has been added to them would not work, without their biological characteristics. Drawing from Wolverine's fiction and reflecting on McLuhan's theory, Jackson (2010) posed the question: "When does the body cease being a natural construction?" (p. 47).

The technology is an extension of these characters, since, in both the metal and the grafting, it enhances who they are. They would both be powerful with their healing factors alone, but with the metal on their skeletons, they are nearly indestructible *and* still capable of healing. The technology acts as an extension of their physical bodies and abilities.

Media Usage

In today's society, there is concern about "overuse" of media (Baer, Saran, Green, & Hong, 2012, p. 729). Technology is very important to us, to the point where time "spent in front of screens implies a necessary loss of other recreational activities" (Baer et al., 2012, p. 733). There are legitimate concerns with addiction, in light of increasing interests in technology and media; but if media can be considered extensions of self, as McLuhan (1964) perceived, there is the possibility of media and technology making us better, as well.

Throughout his work, McLuhan (1964) offered a variety of examples as to how we are enhanced through the things we possess. Though not technology exactly, one of the simplest ways to understand the relationship is through McLuhan's (1964) account of "**clothing**," which he claimed is "an extension of the skin," since it "can be seen both as a heat-control mechanism and as a means of defining the self socially" (p. 119). We are able to gain from the things we have, and devices such as tablets, cell phones, and televisions are no different, since each has the capacity to extend some aspect of our biology, such as our fingers or our eyes, in much the same way that clothes can do with our skin.

The question that emerges is this: If media and technology are extensions of ourselves, to what extent can we part with them? Mass and social media have become so intertwined in our lives, it is hard to imagine reducing their presence now. For example, Finn (1992) described the importance of "viewer control and responsibility" (p. 435), when discussing television addiction. Song, LaRose, Eastin, and Lin (2004) spoke of "habitual Internet use" (p. 390). We feel very much attached to our technology and media, a sentiment that is also echoed in the *X-Men* films.

In *X-Men Origins: Wolverine* (Hood, 2009), Wolverine agrees to the adamantium grafting procedure, once he sees it as the only way to get revenge on and defeat Sabretooth. Later on in the film, viewers discover that Sabretooth was plotting against Wolverine, and that his end goal is to have the procedure done on himself—a desire that does not come to fruition in the film series. In this instance, Sabretooth's desire is to have the same technology that Wolverine possesses.

In *The Wolverine* (Mangold, 2013), Wolverine saves the life of a young man named Yashida. Years later, Yashida develops the technology to take Wolverine's healing ability away, and implant it in himself. This use of technology is so central to Yashida's life that it becomes an obsession. He wants Wolverine's healing factor supposedly to cure himself from a disease, though Yashida also sees it as a way to retain youth and have a much longer life. Interestingly, even though he is primarily interested in Wolverine's healing factor, which is his biological ability, he still gathers adamantium as part of his obsession with Wolverine—and, ultimately, for the purpose of attempting to force Wolverine to give up his healing factor.

In the cases of both Sabretooth and Yashida, we see a certain addiction to the technology, as Sabretooth wants the procedure, and Yashida builds technology to steal the healing factor. Though they both exist without the technology, they feel incomplete without it, and both see technology as a potential path toward being better, which is in line with McLuhan's (1964) idea of extension. For Wolverine, this overlap between biology and technology is even more complete.

An Inseparable Connection

X-Men: The Last Stand (Ratner, 2006) adds an interesting dimension to the plot of the *X-Men* films: the cure. The cure is derived from a mutant named Leech, who has the ability to negate the mutant powers of those in close

proximity. When injected into a mutant, the cure removes his or her powers—thought to be permanently, at least at first. During the film, the cure begins to be used as a weapon, loaded into guns and fired at mutants, for the purpose of removing their abilities.

Wolverine never gets within close proximity of Leech, and he never has the cure used against him. At least in part, this is due to the fact that, if Wolverine lost his powers, he would likely die. A human without the healing and immunity powers Wolverine possesses would never be able to live with metal coated over their bones, inside of their bodies. In *The Wolverine* (Mangold, 2013), a mutant named Viper poisons Wolverine, causing his healing factor to slow down significantly. Near the end, Yashida saps Wolverine's healing factor to gain it for himself. In neither instance does Wolverine lose his healing factor entirely; again, if he did, he would likely die as a result of the adamantium in his body.

In that regard, Wolverine is linked to the metal in his body in a complicated way, since if he lost his healing factor, he would no longer be able to tolerate his interior technology. McLuhan (1964), again, stated that "meaning has to do with what one [does] with the machine" (p. 7), and Wolverine makes the best use of the metal implanted within him, because of who he is genetically. His healing factor is a necessary complement for his adamantium. Together, they make him better; from the combination, he has a nearly indestructible skeleton that makes him all but un-killable. To lose either one, he would lose his enhanced sense of self. As individuals in a technology-based era, we may not want to give up our original sense of ourselves; however, we recognize that we can be enhanced—extended—by technology, and we would prefer not to give that up, either.

In many ways, Wolverine and Lady Deathstrike demonstrate that great balance for fans. Their powers are not only biologically based, nor only technologically based; they are both. The characters are able to have their technology, because of who they are genetically, which echoes a bit how people make use of media and technology today. The metal grafted to the characters' systems—or the smartphones "grafted" to our hands—functions as a technological "extension" (McLuhan, 1964, p. 7) that allows the self to be augmented, improved, and enhanced. In the cases of both Wolverine and Lady Deathstrike, they are connected in a symbiotic, almost inseparable way to their metal.

Keywords from This Chapter

Clothing
Identity discourses
Medium
Media technology

References

Baer, S., Saran, K., Green, D. A., & Hong, I. (2012). Electronic media use and addiction among youth in psychiatric clinic versus school populations. *The Canadian Journal of Psychiatry, 57*(12), 728–35.

Darowski, J. J. (2014). The superhero narrative and the graphic novel. In G. Hoppenst and (Ed.). *Critical insights: The graphic novel* (pp. 3–16). Ipswich, MA: Grey House Publishing/Salem Press.

Finn, S. (1992). Television "addiction?" An evaluation of four competing media-use models. *Journalism Quarterly, 69*(2), 422–35.

Gerde, V. W., & Foster, R. S. (2008). X-Men ethics: Using comic books to teach business ethics. *Journal of Business Ethics, 77,* 245–58.

Hood, G. (Director). (2009). *X-Men origins: Wolverine* [Motion picture]. USA: Twentieth Century Fox Film Corporation.

Jackson, V. E. (2010). *Critical theory and science fiction: A lens into technology in education.* Minneapolis, MN: Mill City Press, Inc.

Mangold, J. (Director). (2013). *The Wolverine* [Motion picture]. USA: Twentieth Century Fox Film Corporation.

McLuhan, M. (1964). *Understanding media: The extensions of man.* New York: McGraw-Hill Book Company.

Ratner, B. (Director). (2006). *X-Men: The last stand* [Motion picture]. USA: Twentieth Century Fox Film Corporation.

Singer, B. (Director). (2000). *X-Men* [Motion picture]. USA: Twentieth Century Fox Film Corporation.

———. (Director). (2003). *X2: X-Men united* [Motion picture]. USA: Twentieth Century Fox Film Corporation.

Song, I., LaRose, R., Eastin, M. S., & Lin, C. (2004). Internet gratifications and Internet addiction: On the uses and abuses of new media. *Cyber Psychology & Behavior, 7*(4), 384–94.

Trushell, J. M. (2004). American dreams of mutants: The X-Men—"pulp" fiction, science fiction, and superheroes. *The Journal of Popular Culture, 38*(1), 149–68.

Zingsheim, J. (2011). X-Men evolution: Mutational identity and shifting subjectivities. *The Howard Journal of Communications, 22,* 223–39.

Technology does not only extend the capabilities of the physical body in comic books and superhero movies. Humans have utilized various forms of technology over thousands of years, to enhance biological limitations. The axe is an extension of the arm—stronger, harder, and sharper. The telephone allows people to communicate across great distances, without raising their voices. The automobile can outrun the fastest man or the strongest horse. Like Wolverine and Lady Deathstrike, people have developed technology to work with their biology, in order to reach various aims. This is how we evolved from our ancestors, eventually causing the more primitive hominids to die out.

Mass and social media technology, though, feels different. These tools, as Lucas states, have become so much a part of our daily lives that we are virtually inseparable from them. This connection is almost as natural as breathing. It is equivalent to the adamantium that was laced throughout Wolverine's skeleton. Although it has made him practically indestructible, it is a power he carries without thought. It is in his bones. For so many of us in today's age, using our phones, tablets, and computers has become a reflex reaction. Our devices are an unconscious source of information and power at our fingertips.

Technology not only allows information to be consumed, however. There is another side to this extension of self: creation. Mass and social media have not only made limitless information available to those with an Internet connection, but they have also forged a way for people to share their ideas. From a single laptop, a person can send out a spark that has the potential to reach everyone in the world. Thoughts, art, music, poetry, dance. Action and reaction. Cat videos, lip syncing to *Frozen* songs, and flash mob proposals.

In this sense, technology acts as a way to extend our minds, much like Professor X's machine, Cerebro. It functions by amplifying the Professor's ability to read, communicate with, and influence people's minds. Through Cerebro, the Professor is able to connect with any person in the world, mutant and non-mutant alike. Although lacking in the Professor's marvelous genetic mutation, we are similarly able to reach others, using technology as a vehicle of expression. As Lucas states, "The technology that has been added to [Wolverine and Lady Deathstrike] would not work without their biological characteristics." From this perspective, technology is so innovative, because of the people who use it. Despite tremendous

developments, an equal to the human brain has yet to be discovered. In a sense, maybe we're all mutants, and our superpowers are simply what go on in our heads.

—Claire Stetzer

Hashtag Television Advertising—The Multistep Flow of Millennial TV Usage, Commercial Viewing, and Social Media Interaction

Andrew Sharma & Chrys Egan

In the media world, most of you millennials are a much sought-after commodity. You are in the coveted 18-to-34-year-old demographic, and television aggressively courts you (The Nielsen Company, 2014a). It's likely you watch TV live in the traditional manner like other viewers; but you also are distinct as a generation. First of all, you prefer to watch TV content on almost any other device than a television. Secondly, while watching the TV program, half of you multitask on several screens, while conversing with your friends on social media (Cheredar, 2014; Lella & Lipsman, 2014), a practice that is only predicted to increase (Marketing Charts, 2014).

Advertising has responded to your habits with a new form that originates on television, but continues on social media platforms. You may have seen it: it's a marketing technique that uses embedded "**hashtags**." These are key words leading to an online link, displayed on TV advertisements for the shows and advertised products, to generate discussion on social media (also called "**chatter**"). These multistep conversations reflect your values and attitudes, layered within the programs and commercials you are watching. Conversations on social media validate or challenge these values. This communication process, where you integrate media content, personal conversations, and social influence, is known as **Multistep Flow**. Put simply, in Multistep Flow, media messages overflow, from the mass media into interpersonal conversations with influential people, and shape public opinion (Katz & Lazarsfeld, 1955; Katz, 1957; Lazarsfeld, Berelson, & Gaudet, 1944).

Despite new media content and new technologies, outdated cultural stereotypes are still pervasive. Exposure to these distortions can have a negative effect on your worldviews. But, as a group, you are talking back on social media, about stereotypical portrayals, overuse of hashtags, and companies afraid to try new methods (Say Daily, 2014).

Traditional and Contemporary Media

Mass communication enables interaction in society (Aikat, 2009). Dissemination of ideas is essential. Throughout history, mass media has taken many forms: from town criers, to folk street-theater, to modern television. Although newer media has emerged, television still remains a prime source for disseminating information. Using data from 2009 to 2014, Statista, a media analysis firm, projected that an average American will spend nearly 290 minutes per day with TV (cable and broadcast) in 2018, making it the most-consumed medium (Statista.com, 2014).

Traditional vs. Millennial TV Viewing

Although there are similarities in content through the years, what is changing is the nature of the viewing audience. Millennials now comprise what has traditionally been the most coveted and trend-setting demographic, in marketing: 18-to-34-year-olds. Content creators strategically try to capture your attention, through both the traditional, one-direction TV content, and in interactive, two-way internet content. For example, *The Rachel Maddow Show*, popular with many of you, is aired on MSNBC during prime-time broadcast. It is also available through website, podcast, iPad app, blog, Twitter, and Facebook. Although currently in a nascent state, social media companies also have their own delivery system, for advertising commercials and other brand marketing.

Millennial Approach to Technology

"Twitter represents the public pulse of the planet" (IBM Big Data & Analytics, 2015). While that claim may be overstated, it most aptly describes the millennial demographic (Prensky, 2001). You have probably heard your generation described as **digital natives**, fluent speakers of a technological language, who grew up using particular technologies. Much different are the **digital immigrants**, older people who had to learn technology as a "foreign language." While digital-immigrant Baby Boomers cite "work ethic" as their defining generational characteristic, you view "technology use" as your unique generational feature (The Nielson Company, 2014b). Not surprisingly, you have the most positive view of technology and social media, among the generations, seeing them as the means to connect to the world and other people. The Realtime Report (2014) confirms that you use social media more than email, demand customized content, expect rapid responses, turn to so-

cial media first to learn about the world and other people, and connect to companies and products through social media.

Traditional vs. Millennial Advertising Viewing

This new wave of advertising originates on television, but continues on social media platforms. For instance, in 2014, Twitter created real-time marketing conversations with fans during live events, generating 25 million Super Bowl–related tweets during the game. Twitter also introduced "Cards," giving media partners a way to share content that is more than just words. The Cards display media-rich news, photos, and videos, turning Twitter into a more visual platform that entices users to a brand's website, videos, or commercials. Facebook already has advertising on its platform, and is experimenting beyond its network, to **provide mobile ads to outside apps,** using their consumer data to target audiences, no matter where they are. According to Adweek, in 2015 the social media competition is expected to be more intense, with YouTube, Facebook, and others trying to draw users to their sites (Adweek, 2015b).

Creating embedded, hashtag, TV advertisements for the shows and advertised products, generates chatter on social media. Hashtags are prefixed with the number sign #, also known as the hashtag or pound sign, followed by a word (e.g., #love) or an un-spaced phrase (e.g., #picoftheday). Hashtags are attached to electronic messages, which then start an ad hoc discussion forum. Social media, such as Twitter, Facebook, Instagram, and others, use these hashtags to generate discussions for various topics, including advertising. For advertising, a brand runs a commercial on television, featuring an embedded hashtag on screen (e.g., #doritos), which viewers then use to interact with each other and the company, on Twitter. Alternatively, hashtags are also originated on social networks, and then the chatter is included in a television commercial. For example, HGTV television network asked fans to share photos on Twitter or Instagram, labeled with the hashtags #lovehome and #hgtv. Adweek (2013) reported that some lucky fans got to see their images included later, on TV ads and on the company blog.

Multistep Flow Theory

It may surprise you that **Multistep Flow** originated during the 1940 US Presidential election. Researchers interviewed 2,400 residents of Erie County, Ohio over six months to chart voters' decision-making process. The re-

searchers noted that messages spill over from the mass media, into interpersonal conversations. They defined **opinion leaders**, influential individuals who translate mass media content into persuasive personal messages that impact the people in their social circles (Lazarsfeld et al., 1944). In the case of the 1940 election, the first step in the communication multiflow contained traditional mass media messages, such as political advertisements, campaign slogans, and broadcast speeches. The second step involved influential people, like local religious or business leaders, shaping the opinions of the people around them, by sharing their own views on the election.

Multistep Flow has been a new and fresh approach compared to previous theories. **Powerful Effects Model**, **Magic Bullet Theory**, and **Hypodermic Needle Theory** all presumed strong, uniform, universal, direct media effects on all audience members. Multistep Flow is different. It posits a **Limited Effects Model**, where the influence of media is more individual, and considered within the context of a person's whole life experience. While offering a multistep model is an improvement over simplistic theories, it does have its own limitations, such as times when the media does appear to have a direct effect, or when opinion leaders are not concerned with shaping opinion on a particular topic.

Although interconnectivity and technology have grown vastly more complicated since the original 1940 study, the basic tenets of the model can be applied readily to your contemporary television and advertising programming, as they flow into social media and in-person conversations. First of all, the original study claimed that *all media is social*, since the media give people shared content to discuss and debate, from the weather, to current events, to memorable TV commercials. Secondly, contemporary advertisers have strategically applied the multistep process to social media engagement with products and companies, in large part to target you and your peers. The multistep process might involve enticing you to a brand's social media page, getting you to like or promote the site, offering you incentives to share information or recommendations with your social networks, cultivating your willingness to click on targeted advertisements, encouraging user-generated brand content, and so on. As Facebook founder and CEO Mark Zuckerberg explains to advertisers: social media users will "help you create some of the best ad campaigns you've ever built" (Klaasen, 2007).

Stereotypes

One interesting side effect of this multistep flow, from traditional advertising to social media chatter, is the creation, reinforcement, challenge, and destruction of stereotypes.

Cultural Stereotypes

There are rich definitions for the term **stereotype**. One way to see stereotypes is as a reflection of inaccurate or narrow images, based on preconceptions derived from existing sources of information (Wei, 1999). They comprise a mental "shorthand which helps to convey ideas and images quickly and clearly" (Courtney & Whipple, 1983). In general terms, a stereotype is one group's generalized and widely accepted perception about the personal attributes of members of another group (Ashmore & Del Boca, 1981; Dates & Barlow, 1990). Despite these varying definitions, stereotypes definitely reflect one reality: unequal relations, in society and in the world.

Stereotypes in the Media

Stereotypes can oversimplify or falsely state the complexity of people (Crawford, 1998). For example, Dyer (1993) mentions that culturally a "blonde" woman refers to more than just hair color; it can also carry an association with an inability to behave and think rationally. This is clearly represented in a television advertisement for a Mercedes automobile (Mercedes-Benz, 2008). The ad opens with an attractive, blonde woman, who walks up to another woman behind a desk and orders a hamburger, fries, and a milkshake. The unusual situation here is that the setting is actually a library, and the woman behind the desk informs the blonde woman of that fact. At this point, the camera pulls back and reveals that it is, indeed, a library. The blonde woman looks around, takes stock of the situation, leans in to the librarian, then repeats the same order for her food, but this time in a stage whisper (as often used by patrons in a library, when conversing with one another). The ad ends with the tagline, "Beauty is nothing without brains."

Stereotypes are also an effective way to invoke consensus about the way we think about a social group, and imply that all members of society arrived at the same definition collectively (Dyer, 1993). This is evident in commercials that reaffirm traditional gender norms. In their recent study, Pedelty and Kuecker (2014) offer an example: Apple's Siri feature, for the iPhone 4. In the advertisement (Apple, 2011), several people are shown asking Siri for

help. Each of their queries represents traditional gender roles. The men in the ad seek support with tying a bow tie, scheduling a business meeting, and informing his spouse what time he will be home from work. The women in the advertisement ask Siri to give directions to the nearest hospital, send someone to fix a flat tire, remind her to call a friend, and remind her to go grocery shopping.

In media, another approach is to look at stereotyping by omission. Minorities are still under-represented in the media, and the absence or omission of these groups acts to reaffirm traditionally held views (Crawford, 1998). For example, couples in advertising are overwhelmingly white. Even rarer are the images of mixed-raced couples and families. Cheerios cereal is one of the only brands to challenge these stereotypes (e.g., General Mills, 2013). Shockingly even in India, where there are no indigenous white people, the advertising still shows people of Caucasian descent; if Indian actors are used, they very much resemble Caucasians in their skin tone (Picton, 2013).

Millennial Social Media Pushback

Exposure to these distortions can have a negative effect on our worldviews, but you are talking back on social media. The most popular protests about content and advertising include stereotypical portrayals, any mockery of your generation, overuse of hashtags, outdated gender images, and companies afraid to try new methods. One example is the response to GoDaddy, a web domain company. On the same day it released its 2015 Super Bowl ad online (GoDaddy, 2015), the company quickly reacted to a wave of criticism on social networks, and agreed not to air the spot during the game. Their ad seemed to be an attempt at satirizing Budweiser's highly anticipated "Lost Dog," a follow-up to 2014 Super Bowl favorite "Puppy Love." The twist, in the 30-second GoDaddy ad, is that a golden retriever puppy finds its way home after falling out of a truck, only to learn that its owner has used GoDaddy to set up a website that lets her promptly sell the dog to a new owner. According to Adweek (2015a), many in the animal rescue community swiftly pointed out that dogs purchased online often come from "puppy mills," and the hashtag #GoDaddyPuppy became a rallying point for critics. Using social pressure to force GoDaddy to pull its TV advertisement before it even aired is not only a fitting example of multistep flow, but of the power of your millennial mind-set in the current media culture.

Conclusion

You, the millennials, are an influential and much courted group in the media and business worlds. But, your technologically savvy generation requires marketing and media that are creative, innovative, and individualized. Marketers interested in appealing to you must appreciate the Multistep Flow-approach to information and entertainment, as your demographic values multitasking, rapid response, customization, social interaction, and increased diversity. As you begin to take positions of power in media and business, we can expect even greater use of Multistep Flow communication, merging mass media, social media, and culture.

Keywords from This Chapter

Chatter
Digital immigrants
Digital natives
Hashtags
Hypodermic Needle Theory
Limited Effects Model
Magic Bullet Theory
Multistep Flow
Opinion leaders
Powerful Effects Model
Stereotype

References

Adweek (2013, March 15). Marketers cheer Facebook's reported hashtag adoption. *Advertising Age*. Retrieved from: http://www.adweek.com/news/technology/marketers-cheer-facebooks-reported-hashtag-adoption-147976

Adweek (2015a, January 27). GoDaddy pulls Super Bowl ad after complaints about 'puppy mill' humor. *Advertising Age*. Retrieved from: http://www.adweek.com/news/advertising-branding/godaddy-pulls-super-bowl-ad-after-complaints-about-puppy-mill-humor-162590

Adweek (2015b, January 29). How 6 advertisers are taking Twitter to the next level during the Super Bowl. *Adweek*. Retrieved from: http://www.adweek.com/news/technology/how-6-advertisers-are-taking-twitter-next-level-during-super-bowl-162625

Aikat, D. (2009). Traditional and modern media. In R. Luthra (Ed.), *Journalism and Mass Communication*, 1, 1–17. United Nations: EOLSS Publishing.

Apple. (2011). iPhone 4S ad. Retrieved from http://www.youtube.com/watch?v=9038u9ngPOQ

Ashmore, R. D., & Del Boca, F. K. (1981). Conceptual approaches to stereotypes and stereotyping. In D. L. Hamilton (Ed.), *Cognitive processes in stereotyping and intergroup behavior* (pp. 1–36). Hillsdale, NJ: Erlbaum.
Cheredar, T. (2014, October 14). Millennials really like watching TV on anything other than a TV. *Venture Beat.* Retrieved from: http://venturebeat.com/.
Courtney, A., & Whipple, T. (1983). *Sex stereotyping in advertising.* Lexington, MA: Health.
Crawford, J. (1998). *Media, stereotypes and the perpetuation of racism in Canada: Professional and theoretical issues in educational technology.* Saskatoon, Canada: University of Saskatchewan Press.
Dates, J. L., & Barlow, W. (Eds.). (1990). Split image: African Americans in the mass media. Washington, DC: Howard University Press.
Dyer, R. (1993). *The matter of images: Essays on representations.* London, England: Routledge.
General Mills. (2013) Cheerios commercial with interracial family. Retrieved from: http://www.youtube.com/watch?v=X4T4S7Gat6A
GoDaddy. (2015) Superbowl puppy ad. Retrieved from: http://www.youtube.com/watch?v=blDezzNEX3E
IBM Big Data & Analytics. (2015). Business decision making will never be the same. Retrieved from: http://www.ibm.com/big-data/
Katz, E., & Lazarsfeld, P. F. (1955). *Personal influence: the part played by people in the flow of mass communications.* New Brunswick, NJ: Transaction Press.
Katz, E. (1957). The two-step flow of communication: An up-to-date report on a hypothesis. *The Public Opinion Quarterly, 21*(1), 61–78.
Klaassen, A. (2007). Facebook's big ad plan: If users like you, they'll be your campaign. *Ad Age.* Retrieved from: http://adage.com/.
Lazarsfeld, P. F., Berelson, B., & Gaudet, H. (1944). *The people's choice: How the voter makes up his mind in a presidential campaign.* New York, NY: Columbia University Press.
Lella, A., & Lipsman, A. (2014, October 14). *The US total video report.* ComScore, Inc.
Marketing Charts. (2014, April 3). *Top TV multitasking activities, by generation.* Watershed Publishing.
Mercedes-Benz. (2008) "Dumb blonde" commercial. Retrieved from: http://www.youtube.com/watch?v=eBPo0t69bi4.
Nielsen Company. (2014a). *Reports.* Retrieved from: http://www.nielsen.com/us/en.html
Nielsen Company. (2014b). Millennials: Technology = Social Connection. Retrieved from: http://www.nielsen.com/us/en/insights/news/2014/millennials-technology-social-connection.html
Pedelty, M., & Kuecker, M. (2014). Seen to be heard? Gender, voice, and body in television advertisements. *Communication and Critical/Cultural Studies, 11*(3), 1–20.
Picton, O. (2013). The complexities of complexion: a cultural geography of skin color and beauty products. *Geography, 98*(2), 85–92.
Prensky, M. (2001). Digital natives, digital immigrants. *On the Horizon, 9*(5), 1–6.
The Realtime Reports (2014, August 01). *Social Media Statistics.* Retrieved from http://therealtimereport.com/category/statistics/
Say Daily Editors. (2014, August 15). *The five biggest mistakes most marketers make when targeting millennials.* Retrieved from: http://www.saydaily.com/
Wei, W. (1999). The nature and problem of stereotypes. In M. A. Shea (Ed.), *On diversity in teaching and learning: A compendium* (pp. 18–21). Boulder, CO: University of Colorado Press.

This chapter is essential in understanding the changes that have occurred over only a couple of decades. I can remember the emergence of the internet, as a young girl. It was a time when dial-up internet prevented the simultaneous use of a house phone, and AOL ruled the scene. I was far too young to understand what was going on around me, but now, I can see how my generation has been characterized as the millennials, who pride ourselves on technology use.

I completely agree with the research that shows we are likely to watch TV on any other devices, and more importantly, are constantly multitasking while watching TV, using social media. I am guilty of this, and I have observed many friends who are, as well. When I find the time to sit down and watch television, it is seldom the only thing I am doing. Like many of those in this generation, I can be caught on my cellphone, especially during commercial breaks, eating, or even doing homework, while watching television.

Cell phones have become a necessity, with any choice of social media demanding my generation's attention. Many of those using social media have accounts on multiple avenues, including Facebook, Twitter, Instagram, Vine, and Snapchat. These sites have certainly created a new space for advertising, and companies are taking complete advantage of this new, often free, advertising space.

In the last couple of years, it has become clear that advertisers are, in fact, catering to us and our technological needs. The use of hashtags has become a primary technique to reach millennials. Flipping through the cable channels themselves, it is now common for television shows to have a predetermined hashtag for the consumer to use. It is definitely a marketing technique that I see on a daily basis, and one that is only growing. It is clear to see that a multistep flow is being incorporated in today's media.

Growing up with the emergence of technology has in fact made the millennials lovers of technology and social media. It is what we are accustomed to, and what we have learned to utilize best. This is the outlet that advertisers have to reach, to grab our attention. The authors name stereotypes as a side effect of multistep flow. I personally do not see a strong connection between stereotypes and the millennial social values. Commercials that are produced that omit or stereotype reflect just that producer.

I do not think the advertising commercials necessarily give millennials a negative worldview. On contrary, millennials use the internet as an outlet, to gain knowledge about stereotyping and racism, and use social media as a way to state their opinion and make a difference.

In essence, we, the millennial generation are primarily absorbed in technology and social media. We were born into it, and we accepted every technological advance, without hesitation. We are influential and have created a new world, one that differs from the past and does require new advertising techniques and creativity. For companies to reach this demographic successfully, they have to appeal to our technological view.
—Avize Batalova

Zombie Apocalypse, Haitian Vodou, and Media Ecology—A Cautionary Tale for Our Technological Future

Brent Sleasman

A zombie roaming the hillside in search of human flesh is, in large part, the invention of the 1968 film *Night of the Living Dead*—a creative decision intended to situate the film within the growing horror genre. The latter part of the twentieth century witnessed an expansion of books, comic books, films, and television shows exploring various aspects of the "zombie apocalypse," and the (mostly) failed efforts of human beings to survive in the midst of great crisis. At the time of writing, there are 59 zombie films indexed on the website Box Office Mojo, and hundreds of movies on the "List of Zombie Films" on Wikipedia. Interestingly, excluding the flesh eating characteristic, there is some historical precedent for the depiction of zombies in many of these productions, including the landmark *Night of the Living Dead*, the more recent *World War Z,* and AMC's hit television series, *The Walking Dead.* According to Alfred Métraux, a respected sociologist and author of *Vodou in Haiti* (1959), "a Zombi is a person from whom a sorcerer has extracted the soul and whom he has thus reduced to slavery. A *zombi* is to a certain extent a living corpse" (p. 378). *The Serpent and the Rainbow* (Davis, 1985) is a non-fiction account by Wade Davis (adapted to film in 1988 by director Wes Craven), documenting experiences in Haiti, and providing further evidence of the existence of zombies and the Vodou sorcerers who control them. As noted in the museum exhibit, "Vodou: Sacred Powers of Haiti," "Communication with the spirits … is at the heart of Vodou" (Beauvoir-Dominique, 2014). This intersection between human communication, Haitian Vodou, and zombies leads to the guiding question for this chapter: How can the zombie film genre assist in our understanding of human communication?

Introduction: Zombies and Haitian Vodou

Shaun of the Dead ends with a rather humorous scene, in which the main character, Shaun, is seen playing video games with his best friend Ed, who is now a zombie. A news report heard in the background states that the remaining zombies can be utilized for manual labor, and can actually serve the causes of the larger society. This scene not only affirms the depth of the

friendship between Shaun and Ed, but also draws on historical fact, in its depiction of the uses of zombies. When a Haitian Vodou sorcerer is success-ful in turning a person into a zombie, he "is a beast of burden which his mas-ter exploits without mercy, making him work in the fields, weighing him down with labor, whipping him freely and feeding him on meagre, tasteless food" (Métraux, 1959, p. 282). The zombie willingly complies because he "has no memory or knowledge of his condition," and "remains in a misty zone which divides life from death" (p. 282). Despite the fact that most twenty-first-century Americans refer to popular culture depictions as their reference point for calling zombies "walking dead," the historical connection with Haitian Vodou religious practices is significant.

Vodou is "a conglomeration of beliefs and rites of African origin, which, having been closely mixed with Catholic practice, has come to be the reli-gion of the greater part of the peasants and urban proletariat of the black re-public of Haiti" (Métraux, 1959, p. 15). As Métraux notes, zombies are "the living dead" (p. 282). Although questions about life and death are central to Christian practices, "Catholic beliefs about the after-life are of little concern to Voodooists, even to those who profess to be practicing Catholics" (p. 258). The cultural concern about zombies was enough that the 1864 Haitian Penal Code stated:

> Also to be termed intention to kill, by poisoning, is that use of substances whereby a person is not killed but reduced to a state of lethargy, more or less prolonged, and this without regard to the manner in which the substances were used or what were their later results. If, following the state of lethargy the person is buried, then the at-tempt will be termed murder. (as cited in Metraux, 1959, p. 281).

Through an elaborate process, captured well in *The Serpent and the Rain-bow*, a sorcerer possesses poison that allows the victim to be reduced to noth-ing more than a corpse. The family of this person, in an effort to keep him from "re-animating" or "turning," takes decisive action to end the life, so that he cannot become a zombie in the service of the sorcerer. "Normally, the dead person is killed a second time by injecting poison into him, strangling or firing a bullet into his temple" (Métraux, 1959, p. 282). Again, the idea of becoming a zombie through being bitten by a zombie was an intentional cre-ative decision, to add to the suspense and gore of the horror films.

In this introduction, to move beyond the depiction of zombies in popular culture, I have anchored the concept more deeply within the religious prac-tices of Haitian Vodou. Next, I will provide an overview of one possible def-

inition of communication that emerges from watching modern zombie films. Walter Ong, whose work is explored in the following section, fits within the academic framework of **media ecology**, the focus of the subsequent section. This path allows us to glean insights about human communication (specifically its basis in presence, not just in the exchange of information), the limits of technological advancement, and, ultimately, how oral communication allows us to become fully human.

Defining Communication

If we can move beyond their obvious physical and behavioral differences, such as feasting on human flesh, the following question comes into clearer focus: *What differentiates zombies from human beings?* I recently asked this question to some of my students, and one of the first responses was that zombies do not possess the ability to speak. Perhaps this answer is obvious to many, but it provides great insight into a starting point for defining communication.

Historically, human beings learned to interact with others through the spoken word, prior to the written word; biologically, children learn to speak before reading or writing. According to Walter Ong (2000), an **oral society** predates a culture built around the **written word**, and consequently, "writing is a derivative of speech, not vice versa" (p. 21). Therefore, stripping away this fundamental and primary human ability quickly distinguishes zombies from human beings, in both a historical and biological sense. This lack of speech alone reveals zombies to be less than their prior, human selves. It is not an overstatement to suggest that one's ability to speak is a fundamental part of his or her humanity, and, lacking this ability, the zombies roam around in a state not only of physical but also social death. Kathleen Glenister Roberts (2007) makes a related point while exploring Euripides' play *Medea*, that social death in some cultural settings is worse than physical death: "It is clear from Euripides' clues that exile for foreigners was a fate worse than death" (p. 27). If fully human, zombies would notice their outcast status, but since living in their reduced condition, they are unaware of their death on every level: physical, societal, and relational.

The zombies in most contemporary depictions lack the ability to speak, possess no sense of time, and are only interested in survival (i.e., eating their next victim), not the experiences of life. Many positive human activities, such as storytelling, require time and physical proximity. In order to tell a

story to another person, we must be in the presence of others, perhaps gathered around a dinner table, or on a long road trip. The printed word takes physical space, but it does not demand immediacy to the same extent as oral conversations do. There is no way to put aside a face-to-face talk and say "I'll listen to it later," in the way we do with books and other printed media.

Too often, according to Macke (2010), communication is defined in terms of information theory, rather than a more accurate understanding that fully accentuates our humanity. "'Commerce' and 'communicate' do not issue from the same set of roots." Instead, communication is "a word having deep roots in the West, a word whose meaning is tied to the very notion of 'community'" (p. 47). This distinction is significant, since it separates an understanding of human communication tied to information theory (**commerce**), from one that emphasizes human embodiment and a more holistic approach (**community**). Human life, when fully embraced and lived, has much more in common with a **communicative event**, as opposed to a mechanical process. Experiences like watching a sunset, playing on a losing team, riding for long stretches in a car with loved ones while no words are uttered, all transcend the mere exchange of information.

Unfortunately for zombies, these are the very experiences that their limitations preclude. In many ways, the zombies experience the complete reversal of human interpersonal relationships. Without language, memory, or awareness, they form no bonds over eating the remains of a human victim, swap no stories after trapping someone in a corner from which they cannot escape. The communicative possibilities pass entirely unnoticed. A zombie meal is the pure definition of process: "a series of actions or steps taken in order to achieve a particular end" (Process, n.d.). According to Steve Duck (1998), we typically seek out friends with whom we share similarities in physical appearance and behavior. While zombies can see, they only sense humans, who can serve as the next meal. They have no radar for detecting other zombies, and are thus essentially alone. The first season of *The Walking Dead* and the film *Shaun of the Dead* both work with this idea. Rick and Glen, key characters in *The Walking Dead*, cover themselves in blood and guts, so that they can walk through a street filled with "walkers," while going entirely unnoticed. It is not until the rain washes the disgusting scent off their clothes that their true identity is discovered. Shaun and Ed, along with a few other survivors, practice walking with arms extended, while moaning, in order to avoid being detected. They are discovered only after moving too

quickly, and making use of the spoken word, to try to solve their immediate dilemma of where to hide.

In summary, to experience a moment of communication, whether verbal or symbolic, we must move beyond self-expression and arrive at some level of meaning shared with all those involved. Understood in this way, human communication is more than an exchange of information or ideas; it involves the intangible emotions that accompany the presence of another person, and often transcends the mere words that are spoken. One can communicate even without words; and words alone are not enough to communicate well.

Media Ecology and the Limits of Technological Advancement

In many of these projects, such as *The Walking Dead*, an exact cause for the creation of the zombies is never offered. Even those films where the cause of the zombie outbreak is clear, such as the *Resident Evil* franchise, can be viewed as cautionary tales about the limits of human technology. The ambiguity of the problem's origins allows for an exploration of what happens when human beings attempt to push medicine and technology, beyond what they are ethically capable of being. From the viewer's perspective, this lack of a logical explanation creates an irresolvable tension, between our present historical circumstances and the proposed chaos of the coming zombie apocalypse. Even when a cause is suggested, it is never fully proven, and leaves more questions than it answers. One scientist, in the *Night of the Living Dead*, suggests that a probe returning from Venus contained too much radiation and exploded upon re-entry into the earth's atmosphere, thus creating the conditions for the creation of the zombies. *World War Z* provides a montage at the beginning of the film, and hints that some virus mutated from animals to humans; but they are never able to locate "patient zero." These depictions provide examples of the potential technological overreach that can occur by humans who push the boundaries of what technology and medicine are able to accomplish. What happens when something unknown, specifically a medicine or technology, is introduced into the existing culture or environment? I next provide an example from our local waterways that serves as a metaphor to better understand the significance of this point.

Presque Isle State Park is situated on the shores of Lake Erie, one of the five Great Lakes. In the late 1980s this entrance to the lakefront experienced the introduction of a non-native species commonly referred to as zebra mussels, a mollusk that has earned the label "invasive species," since it is not

part of the original environmental ecology of the lake. One of the interesting qualities of an invasive species, such as zebra mussels, is that it can permanently alter the ecological environment. Even if the new arrival is eliminated, the changes brought about by its introduction into the local environment remain, far beyond the time of its elimination. In other words, Lake Erie and Presque Isle State Park will never return to what they were like before the introduction of zebra mussels.

Interestingly, not all invasive species are bad (Arnold, 2011). Another recent example from politics can assist in expanding this idea. Since democracy is not native to the Middle East, it could, by this understanding, be considered an "invasive species." Although not native to the Middle East, democracy is arguably having a positive impact upon the governments throughout the region, changing not just political systems, but also the entire culture of countries and geographic regions of the Middle East. To fully appreciate the impact of the newly introduced species, whether biological or political, one needs to consider what the environmental, religious, and communicative environment was like, prior to the introduction of the invasive species, and observe the changes that have occurred since its arrival. The recent emergence of zebra mussels as a major pest in the Great Lakes region, as well as the introduction of democracy in the Middle East, can serve as metaphors for how the advent of a new technology can permanently alter the communicative environment it enters. Whether known or unknown, the cause of the zombie apocalypse is at the crux of many modern zombie tales, and is directly tied to technological development, whether an invention or an attempted medical advancement. The zombie apocalypse raises the question: What happens when an unknown or future invasive technological species enters the existing environment?

The focus should not just be upon the specific technology or medicine introduced, but also upon the environment that each creates. The work of Neil Postman (1985) is instructive in considering how technological innovations create new media environments, which place focus not just on the technological tools but also on the environments created by those tools. This distinction, between **technological tools** and the **media environment** they create, can be better understood by considering the difference between the "mind" and the "brain" (pp. 84–85). The human **brain** is a tangible, physical apparatus, or tool, while the **mind** is something intangible, completely dependent on the brain for existence, but at the same time unique and separate. Through application of this metaphor to media studies, one can begin to dis-

tinguish between the technological tool (i.e., brain), and the media environ-ment created by the tool (i.e., mind). The new media environment does not exist in a vacuum, independent from the technologies that gave it shape. It is not helpful to isolate an individual software or digital device, and analyze it independently from the environment that it creates; thus, it is part of a **media ecology**. Ultimately, Postman (1992) believed, society becomes a "**tech-nopoly**," in which the "goal of human labor and thought is efficiency, [and] technical calculation is in all respects superior to human judgment" (p. 51). We, as creators and consumers, shape our media; but our media also shape us, and our perception of the world. In many ways, the contemporary elec-tronic age dominated by the internet has returned us to a media ecology in which the habits of mind associated with oral conversation are dominant (connection, immediacy); but we can never fully recover the habits of mind and culture that existed in the pre-literate age. Ours is, as Walter Ong (2012) writes, an era of "**secondary orality**," in which Print Age habits of literacy retain wide influence. Even now, as we are transitioning into "secondary orality," we are able to begin to see the implications—positive and nega-tive—of living in a culture and society built on the printed word.

Media ecology, and specifically the work of Walter Ong, can be under-stood as a **philosophy of communication** that provides insight into making sense of the various communicative dimensions at play in the zombie film genre. In reverse, the zombie film genre is helpful in making sense of how media ecology, and the work of Ong, can function as a philosophy of com-munication.

Conclusion

So, is there any hope for humans after experiencing a zombie apocalypse? Fortunately, the film *Warm Bodies* suggests one way to overcome the seem-ingly hopeless state of the zombies. Despite his zombie-fied state, R, the main zombie character, falls in love with Julie, a human. As Julie comes to accept R, and their connection develops, his human characteristics slowly return. When R wakes from a restful and dream-filled sleep, something un-known to zombies, he realizes his full feelings for Julie. As R regains his humanity, he is also able to express his thoughts and feelings through the spoken word. But, it is not the mere exchange of information, or even words that transforms R. It is the joy of human interaction, the thrill of driving a car, and the exhilaration of a first kiss, that cure R of his zombie state.

As noted previously, human communication is based on the physical presence of others, and cannot be reduced to the simple exchange of information. While technology can aid us in so many ways, we must remember the limits of technological advancement, and reconsider the importance of our spoken words and their ability to help us become fully human. It is a fitting irony to end with the note that zombies, the undead, can draw our attention to what truly makes us alive.

Keywords from This Chapter

Brain
Commerce
Communicative event
Community
Media ecology
Media environment
Mind
Oral society
Philosophy of communication
Secondary orality
Technological tools
Technopoly
Written word

References

Arnold, C. (2011, August 31). Are all invasive species bad? *US News & World Report*. Retrieved from: http: //www.usnews.com/science/articles/2011/08/31/are-all-invasive-species-bad.

Beauvoir-Dominique, R. (2014, November 20) *Vodou: Sacred powers of Haiti* [Special Exhibit]. Field Museum, Chicago.

Davis, W. (1985). The Serpent and the Rainbow: A Harvard Scientist's Astonishing Journey into the Secret Societies of Haitian Voodoo, Zombis, and Magic. New York, NY: Touchstone.

Duck, S. W. (1998). *Human relationships* (3rd ed.). London, England: Sage.

Macke, F. J. (2010). Intrapersonal communicology: Reflection, reflexivity, and relational consciousness in embodied subjectivity. In D. Eicher-Catt, & I. Catt (Eds.), *Communicology: The new science of embodied discourse* (pp. 33–62). Madison, NJ: Fairleigh Dickinson University Press.

Métraux, A. (1959). *Voodoo in Haiti*. New York, NY: Pantheon.

Ong, W. J. (2000). *The Presence of the word: Some prolegomena for cultural and religious history*. Binghamton, NY: *Global Publications*.

———. (2012). *Orality and literacy: 30th anniversary edition*. New York, NY: Routledge.

Postman, N. (1985). *Amusing ourselves to death*. New York, NY: Penguin Books.

————. (1992). *Technopoly: The surrender of culture to technology.* New York, NY: Vintage.

Process. (n.d.). Retrieved from: http://www.dictionary.com

Roberts, K. G. (2007). *Alterity and narrative: Stories and the negotiation of Western identities.* Albany, NY: State University of New York Press.

This chapter's use of the zombie apocalypse, as a vehicle of warning for a potentially dystopian future, caused by inflated belief in technology and medicine, is very successful. I was at first drawn in by the idea of vodou (which I have always spelled voodoo, but now know can be spelled both ways) sorcerers; but I stayed interested, because of the connections made to the present day.

The author's acknowledgement of zombie-isms' constantly murky origins is interesting, because the lack of origin story allows the viewer's mind to come up with personal theories, rather than attempt to poke holes in the theories each film would need to provide. It also means that the viewer cannot come up with an opposing theory, one that would show why humans would never allow the original theory to come to fruition. Storytelling in the media is often used as a warning, but if you tell people how something starts, they can change their behavior to avoid it. As an example, if you knew you were allergic to peanut butter, and you were given a peanut butter and jelly sandwich, you wouldn't eat it, because you could die. If we knew what was going to cause the zombie apocalypse, we could avoid it. Zombies are scary because they are seemingly unavoidable, even though they do not exist yet.

The idea of media ecology is not something I thought about, prior to reading this chapter. Thinking about the history of media, you could say that the invention of gossip changed the landscape of news-sharing, just as much as the invention of the newspaper, radio, television, and internet have. It made people begin to question validity, and sparked the need for ethics and honor codes. Just as zombies are dependent on eating flesh, so are we currently dependent on our technology. If zombie-ism is going to be caused by an over-dependence on, or inflated belief in, technology or medicine's capabilities, then the way to stop it is to lessen that dependence. By un-plugging and spending more time in the "real world," we can lessen media's hold on society. While we will never be as independent as we once were, we can at least give ourselves more time, before we all turn into zombies.

—Amanda Woods

Uses and Gratifications Theory in *How I Met Your Mother*—True Story

Linnea Sudduth Ward

The critically acclaimed television program *How I Met Your Mother* told the story of five friends navigating their love lives in New York City. For nine seasons, viewers saw Ted fall in love—and out of love—with countless women, in his attempt finally to meet his future children's mother. Close friends were integral to Ted's story. These included his college roommate Marshall Erikson; Marshall's girlfriend (and later wife), Lily Aldrin; his "legendary" friend Barney Stinson; and his on-and-off girlfriend, Robin Scherbatsky. Although the series focused heavily on the characters' romances, it also delved into other topics relevant in emerging adulthood, including the purpose of work, changing parent-child relationships, and parenthood.

One plotline that unfolded throughout the series is Barney Stinson's relationship with his father. The son of a single mother, Barney never knew his father's identity. To fill this hole, he developed a parasocial father-son relationship with Bob Barker, the host of *The Price Is Right*. **Parasocial relationships** are one-sided, interpersonal relationships between media (e.g., television) viewers and media characters or personalities (Horton & Wohl, 1956). For Barney, Bob Barker filled a paternal void, by providing support, encouragement, and a sense of identity. Barney's parasocial relationship with Bob Barker can be seen in the season two episode "Showdown," though this overarching storyline is readdressed at several key points throughout the series (Kellet & Fryman, 2007).

Although few viewers likely consider their favorite television personalities to be their long-lost fathers, the prevalence, permanence, and invasiveness of media—both traditional (e.g., newspaper, radio, television, etc.) and new (e.g., the internet, mobile telephones)—mean that the role of media in our lives cannot be ignored. Indeed, communication students must be prepared to ask critical, multifaceted questions, about the role of media and its influence on its users. For instance, communication students must now consider questions like: Why do people choose certain types of traditional and new media over others? What makes certain communication technologies popular? What is the role of personality in media usage? What do people get out of using media? And, do people get what they expect? **Uses and gratifications theory** (also referred to as "uses and grats") provides insight into

these and related questions. Before looking at uses and gratifications theory in more detail, let's consider how the theory came to be.

How We Met Uses and Gratifications Theory

Uses and gratifications theory assumes that people are active media consumers. This view of **"audience activity"** contrasts with other theories of media use that consider users to be passive. Informed by the **hypodermic needle theory**, early media research viewed media viewers as passive beings, and focused on finding some magic message that would affect everyone in the same way (Bineham, 1988). Media, it was believed, affected everyone uniformly, and exerted a powerful—perhaps even dangerous—influence.

In the 1950s, Lazarsfeld and his colleagues began to challenge the hypodermic needle theory. The alternative they introduced is called **limited effects theory** (Bineham, 1988). This perspective argued that media did not directly influence media users. Limited effects theory suggests that the media's influence in people's lives is facilitated by other factors, such as influential people or an individual's personal beliefs. In other words, Lazarsfeld ushered in a tradition of media research that focused on how people *use* media, and not just what it *does* to them.

Consistent with Lazarsfeld's research, uses and gratifications theory draws attention away from simply how media affect people, and toward how people interact with media (Pearce, 2009). The researchers who first proposed the theory (in the mid-1970s) argued that people purposefully use media to fulfill certain needs, though those needs are not always fulfilled (Katz, Blumler, & Gurevitch, 1973).

Viewers of *How I Met Your Mother* can see uses and gratifications theory at work in many of the show's plotlines. From "The Gang's" love of Star Wars, to their incessant internet searching, viewers see these five characters engage with media to fulfill varied—and sometimes ill-informed—goals. Barney's parasocial relationship with Bob Barker provides an excellent example of uses and gratifications theory at work.

Uses and Gratifications Theory's Legen-dary Assumptions

Many researchers have written about uses and gratifications in media use. For this chapter, I will talk about a recent explanation of the theory. Rubin (2009) identifies five assumptions, all explained below.

Assumption #1: People select and use traditional and new media for goal-directed, purposeful reasons.

BARNEY: The reason I'm going on *The Price Is Right* is because I've decided that it's time for me to meet my real father. ... My father is [pause] Bob Barker ("Showdown").

The first assumption of uses and gratifications theory is an empowering one: media users typically use media in active, strategic, and purposeful ways, to fulfill certain goals. Media does not just "happen to them." Instead, media are tools that people use strategically to accomplish their objectives. Rubin (2009) calls this type of media use **instrumental**. For instance, Barney watched *The Price Is Right* to fulfill certain goals: to feel a sense of connection with a father (even an imagined one), and to feel better about himself. *How I Met Your Mother* depicts several other instrumental media uses. For instance, Barney and Robin used the internet to gather information about Ted's date ("Mystery vs. History"). Meanwhile, Ted played *World of Warcraft* to accomplish another goal: to meet women and with any luck woo his wife ("How I Met Everyone Else").

Although uses and gratifications theory argues that media use tends to be instrumental, it also allows for the existence of **ritualized** media use (Rubin, 2009). Ritualized media use is habitual, may or may not be strategic, and may not even be conscious. For instance, Ted and Marshall habitually watched the original *Star Wars* trilogy every three years ("Trilogy Time"). Watching the series became part of their relationship—so much so that their dialogue was unconsciously rich with *Star Wars* references. People who turn on the television upon arriving home, check their email every morning at work, and access their Facebook page before bed engage in this ritualized use of media.

Assumption #2: People select and use media to fulfill certain needs, though those needs are not always obtained.

BARNEY: Mom, who's my dad? All the other kids at school know who their dad is. Who's mine?

LORETTA: Oh, I don't know. That guy [points to Bob Barker in an episode of *The Price Is Right*] ("Showdown").

If, as uses and gratifications theorists argue, media use is generally purposeful and strategic, then media users have some goal in mind. Uses and gratifications theory suggests that this ultimate goal is to fulfill certain needs, which, in reality, people may or may not actually obtain.

In *How I Met Your Mother*, Barney's decision to watch *The Price Is Right* was motivated by his desire to fulfill his need for a father. From an early age, Barney felt the absence of a father figure in his life, especially when he realized that his friends at school enjoyed father-son relationships. After asking his mother about his father's identity, Barney happily accepted her answer that Bob Barker was his father. He then began regularly to watch *The Price Is Right*, to develop a parasocial father-son relationship, and to fulfill his needs for companionship, a sense of identity, and personal guidance.

Indeed, early uses and gratifications research argued that the role of needs in motivating media behavior was so strong that people could actually articulate the reasons behind their media selection and usage to researchers. Although this assumption has received considerable criticism, the power of needs in guiding media behavior cannot be ignored. In fact, Barney articulated to his friends at least one of the reasons that he chose to view Bob Barker as his father. Barney explained that having a celebrity dad like Bob Barker helped him feel special, especially when he was young and feeling insecure ("Cleaning House").

Assumption #3: People's social environment and individual predispositions shape their expectations toward the media.

BARNEY: So now I'm gonna go to L.A., be on the show, win the Showcase Showdown, make him proud of me, and then tell him who I am.

TED: You're gonna tell Bob Barker that you're his son on national television?

BARNEY: Why is this so hard for you people to believe? ("Showdown")

Barney clearly desired a father figure in his life. Bob Barker fulfilled that need. Yet, an important question remains: Why did Barney accept the outlandish notion that Bob Barker actually was his father? Indeed, Ted voices this question when Barney announces to The Gang his intention to appear on *The Price Is Right*. The rest of The Gang expresses similar skepticism.

The third assumption of uses and gratifications theory provides insight into this question. This assumption suggests that how people select and use media is influenced by their social environment and personality traits (Rubin, 2009). In their environment, people tend to have a limited number of **functional alternatives**—or available communication channels that are capable of fulfilling the same function or need. These functional alternatives influence how people use media (Rubin, 2009). For instance, growing up in the 1980s, Barney only had traditional media channels (e.g., television, mail, newspaper, etc.) and non-mediated (i.e., face-to-face) channels available. The internet was not yet available to the public. Barney's socio-economic status and his year of birth determined the number of functional alternatives available for Barney to fulfill his father-son relational need. In essence, Barney could only fulfill his need for a father figure through finding a surrogate face-to-face, or in a traditional media product.

How people interact with media is also influenced by their personality. Personality seems to affect three things: the media technologies people select, the motivations for media use (sensation seeking, passing the time, etc.), and the type of media content they consume (scary movies, game shows, etc.) (Krcmar and Strizhakova, 2009). For instance, Barney's parasocial relationship with Bob Barker can be partially explained by his personality. Throughout the series, Barney is depicted as an outlandish, fantastical, even gullible person. In addition to believing Loretta's story that Bob Barker was his father, Barney accepted other falsehoods Loretta told him. For instance, Barney believed that he was asked to quit the Pee Wee basketball team because he was too good, that no one attended his eighth birthday party because the Postmaster General lost all the invitations, and that he received a Valentine's Day card from every girl in the third grade ("Cleaning House"). Therefore, Barney's acceptance of Bob Barker as his father is consistent with his trusting personality.

Even further, Barney admits that he suffered from low self-esteem as a youth, and as a result, he felt special by viewing Bob Barker as his father. Uses and gratifications theory supports this relationship between self-esteem and the development of parasocial relationships. Derrick, Gabriel, and Tippin (2008) found that individuals with low self-esteem feel better about themselves by developing a parasocial relationship with a media personality that they admire. In essence, these low self-esteem individuals receive the benefits of real relationships, without the fear of rejection. Thus, as an individual

suffering from low self-esteem, Barney may have felt safe fulfilling his need for a father figure with Bob Barker, because Barker, unlike a real father, could not reject him.

Assumption #4: Media compete with other forms of communication, to fulfill a user's needs and wants.

TED: Why didn't you tell him?

BARNEY: Well, it's just ... If you lived your whole life thinking one thing, it would be pretty devastating to find out that wasn't true. I just don't think Bob could have handled it.

TED, MARSHALL, LILY, ROBIN: Bob. Yeah. [Sarcastic] ("Showdown")

This fourth assumption argues that functional alternatives compete to fulfill people's needs and wants (Rubin, 2009). These functional alternatives compete at two levels. At the first level, media compete with *other media types* to fulfill people's needs. For example, Barney had a variety of media personalities available to fulfill his need for a father figure. For instance, in addition to being a fan of *The Price Is Right*, Barney also developed a parasocial relationship with *The Karate Kid*'s William Zabka. Barney's parasocial relationships with William Zabka and Bob Barker thus competed against each other, to fulfill Barney's need for a father. Perhaps because William Zabka was younger than Bob Barker, Barney selected Bob Barker to fulfill his need for a father.

At the second level, media compete with *other forms of communication* to fulfill needs. The user's selection is determined by personality, social situation, and the degree to which the medium fulfills the need. For Barney, the functional alternatives of a parasocial relationship with Bob Barker (mediated) and an reciprocal relationship with a non-celebrity (face-to-face) competed with one another to fulfill Barney's needs. Barney seemed to have few positive interpersonal relationships with older men in his young life. Loretta was not willing to allow Barney's actual father to have contact. Loretta never married, and seemed not to interact with her own father (Barney's grandfather) or introduce any influential men into her sons' lives. As a result, Bob Barker fulfilled Barney's need for a father figure, because no interpersonal relationships competed to fulfill this need.

Barney's background highlights an additional element of the theory. Uses and gratifications theory emphasizes that researchers must suspend personal value judgments on people's media use. Instead, researchers must strive to understand the media user and what the medium represents to the user, before making judgments about a certain medium's effectiveness in fulfilling a person's needs. If we pretend for a moment that Barney is a real person, this means that uses and gratifications theorists studying Barney's parasocial relationship with Bob Barker would be challenged to remember that Bob Barker met Barney's needs for a father figure for many years. They should avoid downplaying the importance of this relationship in Barney's life. Indeed, while Barney argues that Bob Barker would be devastated if he found out that Barney was not his son, Barney actually means that *he* would be devastated. He stands firm to the conviction that Bob would be disappointed until Barney's half-brother, James, meets his father several seasons later ("Cleaning House") and Marshall loses his ("Last Words"). This begins Barney's search for his actual father ("Legendaddy").

In addition, this fourth assumption provides insight into how people's relationships with media can change. Although for many years Barney's parasocial relationship with Bob Barker satisfied his needs, later it did not. After this parasocial relationship no longer was a functional alternative for Barney (it no longer fulfilled his need for a father), he had to fulfill his needs in another way.

Assumption #5: People are typically more influential than the media, though not always.

BARNEY: Look, Dad, I got straight A's!
Hey, Dad, guess who I'm going as for Halloween?
Want to play some catch, Pop? ("Showdown")

Barney's experience runs counter to this final assumption. In essence, uses and gratifications theory argues that interpersonal relationships are typically (though not always) more influential than media, in fulfilling people's needs. Why was this not the case for Barney? In other words, why did Barney fulfill his needs for a father figure with a parasocial relationship, instead of seeking an interpersonal relationship with a real father figure?

Media dependency theory, which relates to this fifth assumption, helps provide insight into these questions. **Media dependency theory** suggests that the more media matters to a person, the more dependent they become on

it, and the more effects it has on an individual (Pearce, 2009). This can start a self-perpetuating cycle, where media become more and more influential in a person's life. Media users with functional alternatives are less likely to become dependent on a particular media type. Yet, when media users come to rely upon a certain type of media more than the people in their lives, parasocial relationships become more prevalent (Rubin, 2009).

Viewers of *How I Met Your Mother* see this media dependency cycle taking place in Barney in his younger years. After his mother indicated that Bob Barker was his father, Barney became more and more involved with the television show, *The Price Is Right*. Barney showed Bob Barker his report card, dressed up as him for Halloween, and attempted to play a game with him. This intensive involvement resulted in Barney becoming increasingly dependent upon Bob Barker for meeting his needs. He even began looking to meet other needs through developing parasocial relationships with other media celebrities, like William Zabka.

We Need an Intervention: Common Theoretical Critiques

Since its original publication, uses and gratifications theory has benefited from over forty years of research and revision. Ruggiero (2000) outlined five common criticisms of uses and gratifications theory:

1. *Narrow focus upon the individual:* Uses and gratifications theory often ignores organizational and societal factors that may influence media use.
2. *Lack of synthesis in typologies of media use:* A good amount of uses and gratifications research has focused upon the needs people seek to fulfill through different types of technology. This type of research has resulted in numerous typologies of media use, many of which are never fused into larger, comprehensive views of media use.
3. *Unclear concepts and terminology:* Ruggiero (2000) argues that many of the theory's central terms—such as needs, consequences, motives, and behavior—need to be more clearly defined.
4. *Inconsistent application of concepts and terminology:* Perhaps because many of the theory's concepts are not clearly defined, their application in uses and gratifications research tends to be inconsistent. For instance, the terms "needs" and "motives" are often used interchangeably, and inconsistently applied.

5. *Simplistic understandings of key assumptions:* Several of the theory's key assumptions are also criticized, especially when researchers thoughtlessly accept them across very different circumstances. In particular, the theory's argument that media audiences are typically active (Assumption #1) may be misleading and make it difficult for researchers to be aware of instances when media is used more ritualistically (i.e., habitually). In addition, the theory's argument that people are aware of their motives for media use and can report these motives to researchers (related to Assumption #2) has received extensive criticism.

The Awesome Theory That Is Uses and Gratifications

Although by no means perfect, uses and gratifications theory continues to be a prominent theoretical framework in the communication field. This chapter reviewed its historical development, five key assumptions, and five common criticisms. Taken holistically, the chapter also illustrated the relevance of communication theories (like uses and gratifications theory) in general, in understanding how people meet real needs in their lives, through their communication and media usage.

Keywords from This Chapter

Audience activity
Functional alternatives
Hypodermic needle theory
Instrumental
Limited effects theory
Media dependency theory
Parasocial relationships
Ritualized
Uses and gratifications theory

References

Bineham, J. L. (1988). A historical account of the hypodermic model in mass communication. *Communication Monographs, 55*(3), 230–46.

Derrick, J. L., Gabriel, S., & Tippin, B. (2008). Parasocial relationships and self-discrepancies: Faux relationships have benefits for low self-esteem individuals. *Personal Relationships, 15*(2): 261–80.

Horton, D., & Wohl, R. R. (1956). Mass communication and para-social interaction. *Psychiatry, 19,* 215–29.

Katz, E., Blumler, J. G., & Gurevitch, M. (1973). Uses and gratifications research. *Public Opinion Quarterly, 37*(4), 509-23.

Kremar, M., & Strizhakova, T. (2009). Uses and gratifications as media choice. *Media choice: A theoretical and empirical overview* (pp. 53–69). New York, NY: Routledge.

Kellet, G. C. (Writer), & Fryman, P. (Director). (2007). Showdown [Television series episode]. In C. Bays (Producer), *How I Met Your Mother*. Los Angeles, CA: 20th Century Fox.

Pearce, K. (2009). Uses, gratifications, and dependency. In S. Littlejohn & K. Foss (Eds.), *Encyclopedia of communication theory* (pp. 979–81). Thousand Oaks, CA: Sage Publications.

Rubin, A. M. (2009). Uses-and-gratifications perspective on media effects. In J. Bryant & M. B. Oliver (Eds.), *Media effects: Advances in theory and research* (3rd ed., pp. 165–84). New York, NY: Routledge.

Ruggiero, T. E. (2000). Uses and gratifications theory in the 21st century. *Mass Communication & Society, 3*(1), 3–37.

The application of uses and gratification theory to Barney Stinson's fabricated paternal relationship with *The Price Is Right* host Bob Barker questions the legitimacy of parasocial relationships in the context of fulfilling interpersonal needs. When juxtaposing parasocial relationships like Barney's and Bob Barker's against the psychological development model of Maslow's hierarchy of needs, it becomes clear that parasocial relationships can significantly impact the process of achieving self-actualization. As demonstrated by Barney Stinson in *How I Met Your Mother*, the use of parasocial relationships in situations where face-to-face interpersonal interactions are impossible may provide a temporary solution to the need for love and belonging, thereby expediting the fulfillment of self-actualization.

The first assumption of uses and gratification theory highlighted by author Linnea Sudduth Ward suggests that "people select and use traditional and new media for goal-directed, purposeful reasons." As such, parasocial relationships may be a fortuitous catalyst to realizing the third stage of Maslow's pyramid: the need for love and belonging. Barney, for example, fabricates his relationship with Bob Barker to fill a void that circumstance prevents him from achieving in a traditional interpersonal setting—face-to-face interaction with his father, no television medium required.

However, these parasocial relationships ultimately may not satisfy the need for love and belonging on their own, thereby prompting the experiencer to seek an interpersonal relationship that does fulfill these needs in a lasting and gratifying manner. In Barney's case, the parasocial relationship with Bob Barker temporarily satisfied his needs, allowing him to grow into adulthood with a present, though arguably limited, self-esteem. Eventually, this relationship no longer fulfills the need for paternal love and belonging on its own, and Barney rejects the parasocial to pursue the interpersonal. The parasocial relationship is then advantageous in two regards: in childhood, it prompted him to satisfy the need for paternal love, and in adulthood, it prompts him to seek a genuine interpersonal relationship that has the potential truly to fulfill his needs in a way the parasocial relationship does not.

As demonstrated by Barney's character, parasocial relationships play an important role in the development and fulfillment of human needs, particularly in the context of Maslow's hierarchy. Though they may provide

only a temporary solution to any stage of psychological development, the transient nature of certain parasocial relationships provides important transitional experiences that can prompt lasting and genuine satisfaction.
—Katie Bennett

Part IV

Interpersonal Communication

"Don't Open, Dead Inside"—External and Internal Noise in *The Walking Dead*

Andrew Cole & Bob DuBois

Shortly after Sheriff's Deputy Rick Grimes wakes from a coma, he comes across a bold message spray painted on the hospital cafeteria doors. It reads: "DONT OPEN, DEAD INSIDE." Until he encounters this blunt message, Rick staggers through the abandoned hospital and discovers that it is dark, soiled with blood, and littered with bullet holes. There is other evidence of chaos and disarray too, including a rotting corpse on a hallway floor. Eventually, as Rick contemplates the stark message on the boarded-up, padlocked cafeteria doors, pale fingers creep out between the doors. Rick panics, then turns, runs, and finds a fire exit, from where he ventures out into the world. The message "don't open, dead inside" could have a variety of meanings in different contexts. But once out in the world, Rick quickly learns the full and gloomy meaning of the message: the dead have risen, and now walk again, attacking the living.

Basic models of the communication process typically include *noise* as a core component. Noise is a concept that is more complex than it sounds. In particular, recognizing and differentiating the two major forms of noise, external and internal, can be tricky. When talking about noise in the context of communication studies, we do not mean simply environmental factors that disrupt sound. Instead, noise represents anything that complicates the composition, delivery, and understanding of intended messages. To that end, **external noise** reflects environmental factors that interfere with the delivery of a message, as it travels from a sender to receiver. Conversely, **internal noise** is a term used to describe psychological factors of the sender and receiver that interfere with accurate composition and perception of messages.

This chapter highlights some provocative examples from the first season of the AMC television show *The Walking Dead* to better explain noise and provide some examples to help you distinguish between its external and internal forms. Paying more attention to noise in our daily lives can help us to develop into more mindful and effective communicators.

In this chapter, we first introduce you to the concept of noise in communication, and how it differs from what we usually think of when we consider noise. Then, using examples, we explain the difference between external and internal noise. Once you have a better understanding of what noise is, and

how external and internal noise differ, we provide some examples from *The Walking Dead* to illustrate these concepts more fully. Finally, we conclude with some suggestions as to why we should all think more about noise in our daily communication with others.

Noise in Communication

If you are in an introductory communication course, for instance, on interpersonal communication or public speaking, you have probably learned about some variation of Shannon and Weaver's (1949) basic communication model. This model is often referred to as the Sender/Receiver Model, or the Linear Model of Communication. Interestingly, the model was first developed to describe how information travels through the telephone; but, over time, communication researchers refined the model in an attempt to explain how human communication works more generally (Barnlund, 1970; Berlo, 1960; Schramm, 1954). Though communication models like the Sender/Receiver model may simplify the communication process a bit, they can be useful especially when we first start learning about communication concepts. In particular, they provide us with a useful vocabulary for talking about the communication process in a variety of settings.

Though the look of basic communication models may differ slightly from textbook to textbook and class to class, generally these models depict the communication process as involving five core components: 1) a sender; 2) a receiver; 3) a message; 4) a channel; and 5) noise. At first glance, the communication process, and these components, can seem pretty obvious. First, a sender composes and sends a message. The message contains the information the sender wants the receiver to have. A receiver receives, and then tries to make sense of, the sender's message. The channel is the medium through which the message travels from sender to receiver. Sender, receiver, message, and channel are all pretty straightforward. Noise, however, is a bit trickier to understand, at least at first. Noise includes all sorts of things that could interfere with accurate and effective communication, including features of the sender, receiver, channel, and message.

When we think of noise, we usually would think of sounds; but noise in communication represents far more than just environmental factors disrupting the quality of speech sounds (e.g., the presence of other distracting sounds). Anytime we engage in interpersonal communication, we simultaneously act as both senders and receivers. Additionally, we all vary widely in

our thoughts, emotions, motivations, assumptions, vocabulary, sensory and cognitive capacities, and personal histories. These individual differences we all bring to the table complicate our communication with each other, often in subtle and clever ways. We can encode and decode messages in a limitless number of ways, and environmental factors in the channel can often confuse the message as well. In short, noise is everywhere in human communication.

In its journey from conception, to composition, to transmission, to sensation and perception, a message encounters both internal and external noise. A sender first conceives of the need for communication. Once the sender knows the purpose of the communication, she or he encodes initial ideas and goals into the specific contents of the message, including words and other characteristics. The information in the message is influenced by the intentions, emotions, and other characteristics of the sender, and the channel used to send the message. Face-to-face (verbal and nonverbal) communication is one channel we use to transmit messages. Telephone (verbal) communication represents another kind of channel. We communicate using a number of other channels as well, including technology-driven channels that rely on sharing messages in writing (e.g., social media like Facebook and Twitter, email, and text messaging), or through audio/visual means (e.g., SnapChat, Instagram, and others). Regardless of the particular channel we use to transmit a message, the message invariably encounters noise along the way.

When a message reaches a receiver, the receiver decodes the message to discern its informational contents. The receiver's interpretation of the message is influenced by her or his own communication goals, emotions, and individual differences. The way noise impacts sender, receiver, and channel characteristics is illustrated by the game of telephone you may have played in school as a child. In telephone, a child starts with a message (usually a short sentence), and the message is passed from one child to another, until it reaches the final child, who then relays the message (now often strikingly different from the original) back to the class. Each sender and each receiver selectively encodes and decodes the message, as it moves along the channel (in this case, serial, face-to-face communication). Passing the message from child to child ultimately restructures the intended message in astonishing ways, for many reasons, including psychological reasons inherent to each sender and each receiver, and external factors inherent in children passing on information to each other and in the classroom environment.

Differentiating between External and Internal Noise

As we previously noted, external noise is the interference a message experiences as it travels through a channel. In its most traditional form, and the form we are most familiar with, external noise is a loud sound. However, external noise more generally is any characteristic of the communication environment that degrades or blocks the message, as it moves along through the channel. Loud sounds, such as an airplane crossing overhead or police sirens, can definitely disrupt a message in verbal communication. You probably will not hear what I am saying if a plane crosses right over our heads while we talk. Increasingly, however, external noise results from the technology used to support communication. For example, when text messaging was rather new, the authors of this chapter experienced connectivity problems between cellular phones and towers that sometimes prevented messages from reaching the receiver. In one such case, a message did not arrive until several days after it was sent! Imagine now, if such connectivity issues occurred while two people were in the middle of an argument. Such external noise taking place in the middle of an argument could substantially, and negatively, impact that communication (and potentially the relationship).

While external noise is an environmental characteristic that impedes the smooth flow of a message in a channel, internal noise represents interference within senders, as they compose messages, and receivers, as they make sense of messages. Whereas external noise represents a more tangible form of noise, where physical and environmental factors like loud sounds and technology problems disrupt the delivery of a message, internal noise represents a psychological and more abstract form of noise, rooted in individual difference, including sensory capacities, perceptions, and previous experience. Psychological dynamics such as assumptions, attitudes, stereotypes, heuristics, prior learning, physiological states, drives, motives, emotions, and mood significantly influence us as we compose messages (encode), and as we interpret messages (decode). In the text-message example we gave earlier, in the middle of an argument the person who failed to receive a text-message response might, incorrectly, assume that the lack of response was intentional and mean-spirited. Another person, who had experienced a similar miscommunication before, might think nothing of a lag time between messages. Since internal noise is rooted in an individual's own previous experience, it varies widely from person-to-person, relationship-to-relationship, and context-to-context. For that reason, as communicators, we really need to think

about how internal noise affects us and those with whom we communicate. Internal noise is always present, so it is worth taking the time to appreciate and understand how it applies in any given communication situation. In this chapter, *The Walking Dead* supplies us with a number of helpful examples of both kinds of noise.

The Walking Dead

AMC's *The Walking Dead* is a television show based on Robert Kirkman's graphic novel. Young adults (18–49), in particular, often tune in to *The Walking Dead,* now in its sixth season (Kissell, 2014). In the show, the dead, referred to by the living as "walkers" and "biters," roam around looking for living people to eat. Receiving a bite from a walker leads the living to develop an intense fever, die, and then resurrect as walkers. The show offers so many examples of external and internal noise throughout its six seasons, and this chapter explores examples chosen from the first three episodes of season one (Kirkman, Adlard, Moore, Luse, Darabont, MacLaren, & McCreary, 2010). These are not the only possibilities, however; and we invite you to explore further seasons and episodes, and come up with your own examples!

External Noise in The Walking Dead

At the beginning of this chapter, we introduced you to Rick, who had just woken up from a coma. As Rick first encounters the world of the walking dead, his first thoughts are of finding his wife, Lori, and son, Carl. After meeting survivor Morgan and his son Duane, Rick learns that the government initially attempted to move people into Atlanta, when the dead began attacking. Hearing this, Rick decides to travel into Atlanta, with the hope of finding his family. On the way, Rick uses the emergency channel on his police car radio, in hopes of contacting other survivors. However, as a result of poor signal and static, Rick does not receive the repeated responses from a group of survivors, warning him that Atlanta is overrun with walkers. As a result, Rick continues on into the city. In this example, the static and poor signal Rick encounter while using the police radio—the channel—represent types of external noise. Though the message from Rick was received by the group of survivors outside Atlanta, their repeated messages in reply encountered so much interference that Rick did not even realize they responded.

Once in Atlanta, Rick experiences a series of life-challenging struggles and mishaps, as he finds himself in a city overrun by walkers. Ultimately

Rick ends up encountering other survivors; but after a series of near-death encounters with large groups of walkers, he and the other survivors end up trapped in a downtown building, surrounded by hundreds of hungry walkers, eager to devour them. Unfortunately, again due to poor reception and static, the trapped survivors in Atlanta are unable to communicate with their fellow survivors outside the city.

As the trapped survivors brainstorm possible ways to escape, they recognize that the walkers appear to identify the living by smell. The scent of the living is essentially a message from the living to the walkers, saying, "I am food." Rick intuits that the trapped survivors can create a type of external noise that will mask that message, by covering themselves from head to toe in the blood and guts of the dead. Once covered with the noise-generating blood and guts, Rick and another survivor, Glenn, walk among the walkers undetected, in search of transportation to use to rescue the remaining survivors. This example demonstrates how environmental factors other than sound can serve as external noise and disrupt a message as it travels through a channel. In this case, the "walker scent" disrupts the "I am food" message, in the olfactory channel. Unfortunately, as it begins to rain, the external noise generated by the smell of the blood and guts slowly dissipates, and the walkers gradually receive the message that food is, indeed, walking among them. Rick and Glenn are then besieged by walkers, and have to run to escape.

Internal Noise in The Walking Dead

Internal noise becomes more of a problem for Rick, when he escapes Atlanta and makes his way with the other survivors to their campsite outside the city. Rick is elated to discover that Lori, Carl, and his former co-worker and best friend, Shane, are among the survivors. However, a number of psychological factors almost immediately introduce internal noise into the communications between Rick, Lori, and Shane. Unbeknownst to Rick, Lori and Shane are now lovers. Lori and Shane's affair is fueled, in part, by Lori's belief that Rick was dead, which Shane had told her. As viewers watching the show, we know Lori and Shane's relationship exists. We can recognize some of the subtle nonverbal and verbal information contained in messages exchanged between Lori and Shane, even when Rick does not. For example, both Lori and Shane share expressions of shock, and perhaps guilt, when they first see Rick alive. Lori even initially hesitates to embrace Rick. As Rick has been in a coma, his recognition and understanding of the full informational content

contained in messages sent by Lori and Shane are colored by his previous, now out-of-date, experiences with them. Oblivious to what transpired while he was in the hospital, Rick simply loves Lori, and trusts Shane as his best friend, without having any idea of the infidelity and betrayal. In turn, Lori and Shane are impacted by the experiences they have shared together without Rick. The interactions between Rick, Lori, and Shane thus demonstrate the complex nature of communication, when there are secrets, hidden assumptions, and other complications that create internal noise.

Once Rick settles into life in the camp, the internal noise resulting when senders attempt to encode a message is made clear, in an exchange between Rick, a survivor named Dale, and the other survivors outside Atlanta. Rick thoughtfully tries to describe how he felt after waking up from a coma to discover quickly that the dead had risen. He ponders many possible feelings, but eventually settles on his feeling "disoriented." Dale, recognizing the struggle we all can have at times while choosing how to describe feelings, says, "Words can be meager things; sometimes they fall short." Dale describes a problem of encoding in internal noise. In attempting to describe his experience, Rick is challenged by the multitude of feeling words he has in his vocabulary, and struggles to reconcile his pre-coma life with the world he now experiences. Similar to the text message example we shared earlier in this chapter, every one of us experiences communication breakdowns and problems expressing ourselves, because of the ambiguities involved in choosing the words (verbal), facial expressions (nonverbal), and other behaviors that ultimately comprise our message. Like Rick, we often struggle in finding the right words to express what we want to say.

As Rick describes his experiences to the group, Carl informs Rick that Lori told him Rick had died. Rick replies that he understands how that assumption could be reasonable. However, he does not realize that Lori had thought he was dead not because of the risk in the world overrun with walkers, but because Shane had intentionally misinformed her. As Rick is unaware of Lori and Shane's love affair, his perceptions of the people that Lori and Shane were before his coma prevents him from being able to understand accurately who they are now. Driven by his memories and assumptions, Rick interprets events that could make him suspicious differently from how we, as outside viewers, do. For example, Rick believes Shane watched over Lori and Carl strictly as a favor to him, and tells Shane he can never repay such a debt. As Rick and Lori talk later that night, Lori tells Rick, "I'm so sorry for everything," and "I would take it all back." Though Rick receives and under-

stands the messages on one level, internal noise stops him from being suspicious, and prevents him from appreciating the full meaning behind the message. When Lori then asks Rick if he still wants his wedding ring that she kept, a confused Rick responds "of course." Rick simply does not realize Lori's messages have further meaning, about their relationship and her relationship with Shane. Instead, based solely on his own perceptions and previous experience, Rick interprets Lori's messages as her apologizing for leaving him in the hospital, when he was still alive. He therefore forgives her, without having any idea of the relationship between Lori and Shane, and the true meaning behind Lori's messages.

Conclusion

In all of our lives, as in television, communicating effectively is challenging. No matter how clearly and effectively we think we communicate a message, there are always psychological factors within the people we talk to, and environmental factors in the channels we use, that serve as noise to disrupt, or even completely block, our messages. As we have repeated throughout this chapter, external noise describes interference with a message as it travels through a channel, and internal noise describes psychological interference occurring within senders and receivers. From the beginning of *The Walking Dead,* the series offers countless examples of both types of noise. The "don't open, dead inside" sign on the hospital cafeteria doors; Rick's failure to receive a warning response from the survivors outside Atlanta; Rick and Glenn's insight to cover themselves in walker blood and guts; Rick's failure to describe his feelings accurately; and his incorrect perceptions of Lori and Shane, all highlight the impact of noise in communication. Ultimately, noise makes the goal of communication, which begins with the accurate understanding of the sender's message, difficult, if not impossible. Therefore, the more we can understand, and look for, external and internal noise, as it impacts our communication with others in our daily lives, the more effective we can become as communicators.

Keywords from This Chapter

External noise
Internal noise

References

Barnlund, D. (1970). A transactional model of communication. In K. K. Sereno & C. D. Mortensen (Eds.), *Foundations of communication theory* (pp. 83–102). New York, NY: Harper and Row.

Berlo, D. K. (1960). *The process of communication.* New York, NY: Holt, Rinehart & Winston.

Kirkman, R., Adlard, C., Moore, T., Luse, T., Darabont, F., MacLaren, M., McCreary, B. (Producers) (2010). *The walking dead: The complete first season* [Television program]. Beverly Hills, CA: Anchor Bay Entertainment.

Kissell, R. (2014, December 1). AMC's 'Walking Dead' scores best-ever finale ratings, beats football in demo. *Variety.* Retrieved from: http://variety.com/2014/tv/news/amcs-walking-dead-scores-best-ever-finale-ratings-beats-football-in-demo-1201367788/

Schramm, W. (1954). How communication works. In W. Schramm (Ed.), *The process and effects of communication* (pp. 3–26). Urbana, IL: University of Illinois Press.

Shannon, C. E., & Weaver, W. (1949). *The mathematical theory of communication.* Champaign, IL: University of Illinois Press.

As an undergraduate of Communications Studies, I can confidently say that noise is a concept very important to the study of communication. As a huge fan of AMC's *The Walking Dead*, I can also say that I wish this chapter had been around when I was learning about this concept. The way I originally learned about this subject was similar to the introduction of this chapter that references Shannon and Weaver's 1949 model of communication, which was originally designed to describe telephone transactions, and later used as a general model for how all communication works. Noise, especially internal noise, can be an abstract concept, even more so if the examples given to describe it are vague. Using such a popular artifact is a great way to ensure increased understanding of this concept. Even if you are unfamiliar with the show, this chapter provides a detailed recollection of events, so you can understand the references. Also, it only references the first three episodes of the first season, which are easily accessible online or through Netflix, so you can watch the show for yourself to better understand the concepts.

Utilizing a widespread TV series that is even popular amongst the age group of those who are likely learning about this concept is a great idea. People are more likely to understand and retain information about things they are already familiar with, and laying out the definitions and providing recognizable examples for how these messages can be affected, misinterpreted, or even blocked is a useful learning tool. As the authors of this chapter and I have said before, learning about noise, and especially internal noise, can be a complicated subject. This is most likely because most people think the way they interpret their messages is the way others will interpret them, too; but that is most often not the case. As discussed in this chapter, a number of factors can influence the way a message is sent, received, and deco-ded. Those factors can range from a disruption in the technology used to send a message, to a person's previous assumptions about a message.

I think the notion of understanding and anticipating noise in the messages we send and receive is a hugely important aspect of the way we communicate, and is a concept that should be better recognized. People interpret messages in vastly different ways, because people themselves are immensely different. Acknowledging those differences, while producing and interpreting messages with others, would largely improve the way we communicate.

By eliminating surface assumptions of messages and bypassing external influences that affect messages, we can learn to better understand the intended meaning of messages and communicate more successfully with others. *The Walking Dead* series is a great example of the effects noise has on messages. The identification of noise in the show helps us better understand and identify the factors noise has on communication in our everyday lives, which then leads to a generally more effective way of communicating with others.

—Nicole Formato

Hook, Line, and Sinker—Theories of Interpersonal Deception and Manipulation in *Catfish*

Holly Holladay & Sara Trask

Jarrod was a young, single father who was recently divorced from his high school sweetheart. Although he was pessimistic about finding love again, he did so in Abby, a beautiful woman whom he met on Facebook. There was only one catch: despite multiple attempts to arrange a meeting, he had never met Abby in person. Because of these repeated failed attempts, Jarrod became suspicious that Abby was not disclosing the entire truth about herself. Was it possible that Abby was not, in fact, who she said she was? Could she be lying about her identity?

Lying is a fact of daily life. In fact, college students admit they intentionally try to mislead someone in one of every three social interactions (DePaulo, Kashy, Kirkendol, Wyer, & Epstein, 1996). Individuals routinely engage in acts of deception in order to benefit themselves in some way, often trying to present themselves more favorably to others (Burgoon & Buller, 2008; DePaulo & Kashy, 1998). Two theories that help us understand deception in relationships are **Interpersonal Manipulation Theory** (IMT) and **Interpersonal Deception Theory** (IDT).

Interpersonal Manipulation Theory

Interpersonal manipulation theory helps us understand how deceptive messages are crafted. In every day interactions, individuals divulge somewhat honest and somewhat deceptive messages (McCornack, 1992). In other words, manipulation occurs in all of our everyday interactions. Using the Cooperative Principle (CP) from Grice's (1989) theory of conversational implicature as a framework, IMT categorizes how individuals can deceive in their relationships, through violations of quantity, quality, manner, and relation. **Quantity** violations refer to the amount of information someone provides. Individuals may manipulate their messages by limiting the amount of information they share with the other person. If individuals deceive by presenting untruthful information, which we consider "bald-faced" lying, they have committed a **quality** violation. Another type of violation is **manner**. Those who create this type of violation provide information that is vague or

ambiguous. For example, if your mom asks you what you are doing this evening, rather than telling her that you are going out with friends (instead of studying for that big exam), you say you have "a lot of stuff to do." Finally, individuals who enact a **relational** violation provide information that is irrelevant to the conversation. These individuals attempt to change the subject to avoid telling the other person the truth. An individual who discloses all of the necessary information that is relevant, informative, truthful, and clear has provided a cooperative message. However, not many (if any) messages are cooperative, as individuals constantly control the information they choose to share with others. In fact, Turner, Edgley, and Olmstead (1975) found that 61.5% of messages involve some sort of manipulation.

The ability to deceive also falls on those who listen to the deceptive message. Individuals can use the above message violations, because listeners believe they are receiving a cooperative message, instead of a manipulated one. Additionally, listeners often perceive additional information that is simply not true. The interpersonal deception theory brings in the interaction between the deceiver and the deceived, which allows us to understand better how deception works.

Interpersonal Deception Theory

Interpersonal deception theory incorporates not only the deceiver's message, but also the recipient of the deceptive message (Buller & Burgoon, 1996). Though deceivers elect to communicate a deceptive message by hiding, distorting, misinterpreting, or avoiding communication (Burgoon, Buller, Guerrero, Affifi, & Feldman, 1996), the receiver is also an integral part in the deception process. Deceivers use both verbal and nonverbal messages during their communication, yet it is the receiver's feedback that determines acceptance or skepticism of that message. Three underlying assumptions surround deception.

First, *deceptive communication is goal driven*. Individuals attempt to deceive others to achieve either a personal or relational goal. These goals may include trying to protect themselves from embarrassment or as a way to maintain relational harmony (Burgoon & Buller, 2008; DePaulo & Kashy, 1998). Because individuals want to achieve their goals, they will often engage in acts of deception, making deception an intentional act. Second, *deception is both verbal and nonverbal*. Deceivers often intentionally elect how to communicate their verbal message. They choose messages they feel will

distract the receiver from truth. However, at times, nonverbal communication can be unintentional, which makes deception easier to detect. Third, *receivers are active participants in deception.* When receivers hear a deceptive message, they can accept the message as the truth, or they may experience suspicion or disbelief, and then provide feedback to the sender of the message.

IDT explains how senders and receivers engage in the process of deceiving and detecting deception, while engaging in interactions; but to understand deception further, the propositions for IDT must be examined. (For a more detailed understanding of each proposition, please review Buller & Burgoon, 1996).

Deception Involves Interactivity and Task Demands

First, deceptive communication can be communicated and detected differently based on interactivity. Interactivity refers to whether the message is in direct response to another message, occurs in real time, or allows for a delayed response, and whether the message allows for multiple verbal and nonverbal channels (i.e., face to face), or whether the channels are mediated (e.g., email, text messages, etc.) (Burgoon & Buller, 2008). Secondly, deception involves task demands. If the relationship between the sender and receiver is considered significant, it will impact the participants' ability to deceive, and detect deception.

Deception Is Influenced by the Closeness of the Relationship

To build on task demands, individuals who have high expectations of their relationship will expect the sender to be truthful. When a deceiver believes that the receiver expects truthfulness and is familiar with his or her deception, he or she is less likely to fear detection. The ability to deceive is intertwined with behavioral displays. Burgoon and Buller (2008) acknowledge that deceivers are intentional in managing their content, nonverbal behaviors, and overall image. However, individuals cannot control all of their communication, including their arousal or impaired speech (e.g., stuttering).

Receivers Have the Ability to Detect Deception and Signal Suspicion

Though some individuals believe it is easier to deceive in mediated contexts because it takes away nonverbal communication (Zuckerman, DePaulo, & Rosenthal, 1981), IDT predicts that receivers have a better ability to detect

deception if the communication occurs through non-interactive channels, such as text or email (Dunbar & Jensen, 2011). Additionally, written messages can be recalled and used to expose the deception (Wise & Rodriguez, 2013). When suspicions then arise, receivers will often alter their communication patterns by asking more questions or trying to obtain more information on a particular subject about which they are skeptical. When receivers do this, they often alert the deceiver, causing the deceiver to modify their message to be more believable. This leads to reciprocity of communication, or the back and forth between sender and receiver. Deceivers and receivers of the message often play off each other's verbal and nonverbal behaviors during a deceptive communicative interaction, which usually causes individuals to adapt their messages based on their perception of the other. So, how do we know when deception has been detected? The ability to deceive relies on both deceiver and receiver; for deception to be successful, deceivers must perceive that they have successfully communicated their deceptive message. Additionally, receivers must judge the message as believable.

Using MTV's *Catfish* to Examine Deception

Jarrod and Abby's relationship in the opening example is illustrative of the deception that grounds the relationships depicted on MTV's *Catfish: The TV Show*. One of the most popular series in MTV's current programming lineup, the show is an extension of a 2010 documentary of the same name. Prompted by his own experience with an online romantic partner, *Catfish* follows filmmaker Nev Schulman's quest to help young people determine if their online romantic partners are being truthful or deceitful about their identities. Each episode of the documentary reality series focuses on a single couple, one of whom has written to Nev for his assistance with background checks and research to determine if his or her partner's online presentation is authentic. Under Nev's guidance, these couples meet for the first time, and often discover that some element of what they believed to be true about their romantic partners is, in fact, deceptive. In some cases, the person's identity is completely fabricated by a friend, family member, or former lover. In Jarrod and Abby's case, Jarrod's suspicions were warranted; late in the episode, Abby is revealed to be the alter ego of Melissa, a woman who claims to be someone else, in order to improve her self-esteem. Since *Catfish*'s premise revolves around the ways in which individuals in personal relationships de-

ceive one another, it provides an example for understanding the principles and strategies of IMT and IDT, particularly in the age of computer-mediated communication.

"That's the Crazy Thing about the Internet: You Can Be Whoever You Want to Be"

As previously discussed, interpersonal manipulation theory considers how messages are deceptive, based on both the type and amount of information shared between relational partners. Indeed, Melissa's communication consists of quantity, quality, manner, and relational violations, all of which serve to deceive Jarrod in some capacity. In *Catfish*, **quantity** violations often exist, when one relational partner refuses to let the other hear his voice or see his face, thereby limiting the amount of information he gives to his partner about this particular aspect of himself. For example, when Melissa tells Jarrod that her computer lacks video-chat capabilities, it is because she does not want him to be able to see her so that she can limit the amount of information he has regarding her appearance. In Melissa's case, this quantity violation is used to support her **quality** violations; to build her Facebook profile, she uses photos of someone else that she has downloaded from the Internet. Therefore, Melissa must limit the amount of information she shares with Jarrod, because otherwise she might be caught in her "bald-faced" lie.

Melissa's **manner** violations structure many of her interactions with Jarrod, both in the development of their relationship off-camera, and during the episode. As the couple discusses their future together, Melissa tells Jarrod that she'll move to his rural town in Georgia so they can be a "real couple," but she is noncommittal when Jarrod tries to make firm plans. In fact, Jarrod struggles to convince Melissa to visit him at all. Shortly before she was scheduled to meet him for the first time, Melissa calls Jarrod to say "something had come up" with her family, and she would be unable to come to Georgia. Jarrod tells Nev that these ambiguous exchanges are relatively common from Melissa, sharing that when it comes to picking a time to meet, "it seems like there's always something." When Nev offers to drive to Mississippi to meet Melissa, she evasively tells him, "I don't know what I have going on tomorrow...," before finally committing to the visit.

After Jarrod and Melissa meet face to face, the deception cannot continue. Melissa acknowledges that she has a lot of explaining to do, and stumbles through some explanations, saying all of her emotions were true, but she just

"had a different face" from what he expected. When Jarrod and Melissa meet the following day to discuss their situation, instead of talking about why she chose to deceive him, Melissa turns the conversation to his emotions. She states, "I overplayed things in my mind. So much to take in for both of us really, but especially for you. ... I know how you act when you are sad and I was worried about you." Instead of addressing her reasons behind the deception, she focuses the conversation on how Jarrod must be feeling. This is an example of a *relational* violation. Though each of these categories can be mutually exclusive, it is common for individuals to combine the types of violations in their conversations. Our deceptions are not always easy to categorize along these lines, but violations consistently occur in deception, in some form or another.

Those who seek Nev's guidance often do so because something about their romantic partner's behavior or communication has made them suspicious. This emphasizes that in order for deception to occur, there must be someone on the receiving end of the deceptive message. Therefore, interpersonal deception theory gives us a way to explore both sides of the deceptive process. When combined with the specific propositions of IDT, the underlying assumptions of the theory allow us to consider how the goals and intentionality of the deceiver, as well as the relational context of the partners, drive deception.

IDT argues that deceptive communication is driven by the relational or personal goals of the deceiver, and that the achievement of these goals makes deceptive communication intentional. Melissa's goals underpin her choice to be deceptive in her relationship with Jarrod, as well as in her communication with Nev. First, when Nev calls to speak with her at the beginning of the episode, she responds when he addresses her as "Abby," even though her name is Melissa. Melissa's goal, in this case, is to uphold the consistency of her story; because she has used another identity in her previous communication with Jarrod, she must also craft an intentionally deceptive message to Nev in order to prevent being discovered as Melissa. Secondly, she articulates personal goals to help justify her deceptive messages when she is uncovered as fraudulent at the end of the episode. Nev questions Melissa's choice to deceive Jarrod, and she replies that she had "so many self-esteem issues. ... I couldn't handle the depression anymore, so I had to find something to make myself happy. I got so much out of it."

Intentionality also impacts the verbal and nonverbal messages crafted by the deceiver. Many of the verbal messages Melissa constructs are intended to

aid in the success of her deception, such as the vague excuses she provides to avoid meeting Jarrod face-to-face. Moreover, Melissa's choice to communicate with Jarrod under an alias acts as a verbal message with the intent to deceive. When Nev and his partner, Max, Google her identity at the beginning of the episode, they comment that "Abby Johnson" is a "relatively generic" name. Although they do not overtly question her decision to choose this name, it is possible that Melissa's choice of such a common name worked to make her deception more difficult to detect.

IDT suggests that nonverbal elements are often out of the deceiver's control, but in Melissa's case, one particular element of her nonverbal presentation—her voice—aids in her deception. After speaking with Melissa on the phone for the first time, Nev and Max observe that her voice "sounds like that girl in the picture, ... like [her voice] is coming out of that body." Jarrod also comments about her "sweet voice," and Jarrod's friend Angela, who has spoken with Melissa on the phone, says that her voice is "petite." In other words, the things that Melissa cannot control, such as the perceived femininity of her voice, are even consistent with the online image she has manufactured.

The final underlying assumption of IDT is the notion that receivers are active participants in the deception process, given that they must either accept a message as truth, or express suspicion that the message is deceptive. As the recipient of a deceptive message, for over a year and a half Jarrod accepted Abby's story, but something changed which caused him to express that suspicion and contact Nev to assist him in meeting Melissa face-to-face. During the show, Jarrod negotiates feelings of acceptance and suspicion with Melissa. Jarrod believes that there are parts of Melissa that are authentic, even if other parts of her are deceptive. He shares, "If I meet her and she's not who she says she is, that's gonna be a downer. But if her humor, her personality is the exact same as who I've been talking to on the phone? Then awesome. I've just got a good feeling. I'm feeling great about everything."

Expanding on the three underlying assumptions to IDT, *Catfish* also provides examples of the propositions that occur during deception.

Deception Involves Interactivity and Task Demands.

Melissa is able to be deceptive as Abby, because of the mediated nature of their communication; but as soon as they meet face-to-face, she must come

clean. She shares that "all of [their communication] was me, just not me. All of the emotions, just a different face, I suppose."

Deception Is Influenced by the Closeness of the Relationship

Jarrod and Abby have developed a deep intimacy; their Facebook chats reveal that they refer to each other by pet names such as "baby," and tell each other "I love you" frequently. Perhaps because of this intimacy, Jarrod does not want to believe Abby is being untruthful with him.

Receivers Have the Ability to Detect Deception and Signal Suspicion

Jarrod suggests that he wants to believe everything that Abby tells him is true, but he "has no idea," signaling his suspicions. He says that has a lot to do with growing up as an "outcast" and being looked at by girls as "just our friend," so he finds it difficult to believe a beautiful girl like Abby would be interested in him. Once Jarrod meets Melissa, he shares that he has "thousands and thousands of questions," as he tries to make sense of her deception. He also acknowledges that now a lot of the stories, particularly Melissa's inability to visit, make sense, showing how he is able to see the deception retrospectively.

"I Realize Now I Should Have Just Told You"

Interpersonal manipulation theory and interpersonal deception theory offer ways to think about the role deception plays in the relational communication process. By examining *Catfish*, a popular cultural artifact that makes deception central to its premise, we can understand that deception is an intentional communicative act that relies on both the deceiver's construction of messages, and the recipient's interpretation of those messages.

Although IMT and IDT offer insight into the dyad's communication process, it fails to account for the ways in which third parties influence the construction and interpretation of deceptive messages. For example, *Catfish* regularly features individuals who express suspicion to friends and family that their romantic partner may be deceptive. For example, Jarrod's friends Angela and Sara describe his relationship with "Abby" as "a little sketchy," because of her inability or unwillingness to make firm plans to meet in person. Thus, we can think about the ways that IMT and IDT can be extended to include the extra-dyadic communication surrounding the relational partner's deceptive communication.

Keywords from This Chapter

Interpersonal Deception Theory
Interpersonal Manipulation Theory
Manner
Quality
Quantity
Quality violation
Quantity violation

References

Buller, D. B., & Burgoon, J. K. (1996). Interpersonal deception theory. *Communication Theory*, 6, 203–42.

Burgoon, J. K., & Buller, D. B. (2008). Interpersonal deception theory. In L. A. Baxter & D. O. Braithwaite (Eds.), *Engaging theory in interpersonal communication multiple perspectives* (pp. 227–39). Thousand Oaks, CA: Sage Publications.

Burgoon, J. K., Buller, D. B., Guerrero, L. K., Affifi, W., & Feldman, C. (1996). Interpersonal deception: XII. Information management dimensions underlying deceptive and truthful messages. *Communication Monographs, 63*, 50–69.

DePaulo, B. M. & Kashy, D. A. (1998). Everyday lies in close and casual relationships. *Journal of Personality and Social Psychology, 74*, 63–79, DOI: 10.10370022-3514.74.1.62

DePaulo, B. M., Kashy, D. A., Kirkendol, S. E., Wyer, M. M., & Epstein, J. A. (1996). Lying in everyday life. *Journal of Personality and Social Psychology, 70*, 979–95.

Dunbar, N. E., & Jensen, M. L. (2011). Digital deception in personal relationships. In K. B. Wright & L. M. Webb (Eds.), Computer-mediated communication in personal relationships (pp. 324–43). New York, NY: Lang.

Grice, H.P. (1989). Studies in the Way of Words. Cambridge, Mass: Harvard University Press.

McCornack, S. A. (1992). Information manipulation theory. *Communication Monographs, 59*, 1–16.

Turner, R.E., Edgley, C., & Olmstead, G. (1975). Information control in conversations: Honesty is not always the best policy. *Kansas Journal of Sociology, 11*, 69–85.

Wise, M., & Rodriguez, D. (2013). Detecting deceptive communication through computer-mediated technology: Applying interpersonal deception theory to texting behavior. *Communication Research Reports, 30*, 342–46, DOI: 10.1080/08824096.2013.823861

Zuckerman, M., DePaulo, B. M., & Rosenthal, R. (1981). Verbal and nonverbal communication of deception. In L. Berkowitz (Ed.), *Advances in experimental social psychology* (Vol. 14, pp. 1–57). New York, NY: Academic.

We live in a time where face-to-face communication is a thing of the past. It is much easier to send an email or text message, than to make a phone call or arrange to meet in person. Though these new modes of communication save time, they completely eliminate any ounce of real verbal interaction with others. Instead of going out to meet people, I can now sit on my couch and swipe through hundreds of profiles in minutes. As technology gets more and more efficient, more doors are open for deception and manipulation. This idea is the central motivation for MTV's *Catfish: The TV Show*. Being an avid watcher of the show, I have seen how easy it is for one person completely to manipulate another. In the case of Jarrod and "Abby," Melissa was too insecure to share her true identity. Though the conversations and feelings were all real, Melissa's motivation behind the lies was her unhappiness with her physical appearance. Here, Melissa showed the goal that was driving her deceptive communication. This is one of the most common situations to take place on the show; all it takes is the creation of a fake Facebook profile and a commitment to the new identity. Because Melissa did not send pictures or engage in video chats with Jarrod, this Facebook profile was Jarrod's only source of knowledge for Abby's physical appearance. Therefore, it was easy for Melissa to manipulate, using both quality and quantity violations. Because of the simplicity provided by technological advancements, deception and manipulation get easier as time goes on. Though this ensures that Nev and Max will not be out of a job any time soon, it means that those looking to find love online will need to be careful of whom they decide to trust.
—Caitlyn Andrews

"Got a Secret. Can You Keep It?"—*Pretty Little Liars*, Friendship, and Privacy Management

Alysa Ann Lucas

The TV show *Pretty Little Liars* highlights both a valued function and troublesome aspect of friendship. Friends, our trusted confidants, are expected to conceal our secrets. However, a betrayal of confidences is always a risk. The friends on *Pretty Little Liars*, Aria, Emily, Hanna, and Spencer, know this risk well, after sharing their secrets with "frenemy" Alison. Specifically, after an accident called "The Jenna Thing" binds all five friends together, the girls are uncertain if Alison will use their private information against them, if they do not keep the "Jenna" situation a secret.

When Alison goes missing, it appears the constant threat of her sharing their secrets has also disappeared. But, when Alison's body is discovered one year later, and the girls receive texts from a stalker named "A," the threat returns. Did Alison share their secrets? Who is "A"? Does "A" know about "The Jenna Thing"? Most importantly, will "A" reveal their secrets to others? These questions about owning and controlling private information reflect the theory of Communication Privacy Management (CPM). The purpose of this chapter is to apply CPM to the interactions in *Pretty Little Liars*, where concealing and revealing private information can be deadly.

Pretty Little Liars, Friendship, and Secrets

Revealing information is risky (Petronio, 2002; Rosenfeld, 2000), but with our friends, sharing secrets seems less scary. Friendship is conducive to revealing private information, as the connection entails such commitments as being trustworthy, supportive, and protective of confidences (Reohr, 1991). Essentially, we seek out friends because of these qualities, and we expect our friends will want and need the same. The nature of friendship, then, produces an environment that welcomes conversations secrets may be revealed (Petronio, 2002).

However, the voluntary nature of friendship, and the potentially stressful nature of providing social support (Adelman, Parks, & Albrecht, 1987), may implicate friends who are not always prepared to cope with the information being revealed (McBride & Mason Bergen, 2008; Petronio, 2002).

Pretty Little Liars

Pretty Little Liars is a popular TV series centering on five friends. The girls believe that Alison is their friend, because she has the ability to make them feel special. However, after they share information with her, she often uses it to control and manipulate them. For example, when "The Jenna Thing" happens, Alison uses their secrets against them, as a way to have them do and say what she wants. Alison knows that Hanna binge eats, Emily likes girls, Spencer kissed her sister's boyfriend, and Aria's father cheated on her mom with one of his students. If they do not want these secrets to be revealed, they cannot tell anyone about the accident.

"The Jenna Thing" begins with the girls trying on clothes in Alison's bedroom. Alison claims that her neighbor, Toby, is spying on them. Thus, he needs to be taught a lesson. Alison suggests they throw a stink bomb in his garage, his frequent hangout spot. Although the girls are originally opposed to the idea, Alison is able to convince them it is an innocent way to get their revenge. The stink bomb causes an explosion that sets fire to the garage and blinds Toby's step-sister, Jenna. Hanna thinks they should immediately confess, but Alison threatens the girls into keeping quiet. Furthermore, because Alison knows that Jenna has coerced Toby into a physical relationship, she is able to blackmail Toby into taking the blame for the accident. The girls are bound together, knowing they caused the loss of Jenna's sight; but to protect themselves, they promise not reveal the secret.

Alison disappears, and the friendship group disbands, until one year later, when Alison's body is discovered, and the girls are brought back together during the police investigation. The girls must determine what information, if any, about "The Jenna Thing" they will reveal to the authorities. When questioned by the police, the girls stick together and say they have no idea what happened, reinforcing the idea that they are the sole, collective owners of this information. They continue to promise not to share the truth, even knowing that "The Jenna Thing" may have somehow contributed to Alison's death. An exploration of CPM, and an application of its components to the secrets of the *Pretty Little Liars*, will help us understand the process of concealing and revealing private information.

Communication Privacy Management Theory

The purpose of CPM is to examine the process one takes to determine if he or she should reveal to or conceal information from someone else (Petronio,

1991). CPM is built upon five suppositions that serve as groundwork for the three processes of the theory. The next section will outline the suppositions and detail the processes, using examples from *Pretty Little Liars*, to illustrate this complex process.

Five Suppositions of Privacy Management

Five suppositions provide the foundation for the rule-management system of CPM (Greene, Derlega, Yep, & Petronio, 2003; Petronio, 2002). The *first supposition* focuses on the **conceptualization of private information**. CPM moves past self-disclosure, to explore the fact that when we disclose, we are revealing private information about the self and others (Petronio, 2002). Unlike **Social Penetration Theory**, which focuses on building intimacy through self-disclosure, CPM focuses on the idea that "disclosure is not the same as intimacy, and not all of private information (even at its most risky) leads to intimacy" (Petronio, 2002, p. 5). CPM reasons that many of the disclosures in friendships could lead to conflict, or other negative judgments. *Pretty Little Liars* offers a good example of this theory. Although revealing some private information to Alison may have been about becoming closer friends, her knowledge of the others' information is dangerous and threatening, because she can use it against them.

To reveal or conceal is a complex process (Greene et al., 2003; Rosenfeld, 2000) that entails the assessment of potential risk to the self (Petronio, 1991). This is because exposing oneself to another can be embarrassing and uncomfortable (Petronio, 2002), and can lead to compensatory decisions to protect oneself, such as using secrecy and deception (Rosenfeld, 2000). CPM specifically discusses individuals creating and building boundaries, as a means to protect the self (Petronio, 1991), because the risk of disclosure may mean losing control over the information, or having someone use that information against us (Rosenfeld, 2000). Alison knows everyone's secrets, including the physical relationship between step-siblings Jenna and Toby. This knowledge allows her to manipulate them and their information in ways that benefit only her. After "The Jenna Thing," it becomes clear that knowing this secret is problematic for the siblings and beneficial for Alison Because she knows the secret, she is able to avoid the consequences of having permanently injured Jenna.

The *second supposition* of CPM details the privacy boundaries that we create around our private information. To understand the concealing and re-

vealing of private information, CPM uses a **boundary metaphor** (Petronio, 1991; 2000; 2002). The metaphor provides a way to demonstrate the regulation of private information (Petronio, 2010; Petronio & Durham, 2014), because boundaries "identify the border around private information" (Petronio, 2000, p. 38). Additionally, the delineating boundaries may help us protect ourselves (Petronio, 1991), because we can make decisions about who has access to our private information (Petronio, Ellemers, Giles, & Gallois, 1998). Therefore, with boundaries marked, the metaphor suggests we believe our information belongs to us (Petronio et al., 1998), and this control over what is public and private can be clearly understood (Greene et al., 2003; Petronio, 2002). Throughout their friendships, Alison makes it clear through bullying that she is the one that marks the boundaries. She tells the girls not to tell anyone about "The Jenna Thing" (i.e., private), as well as threatens to share their private information, once she becomes a co-owner (i.e., public). Moreover, to protect herself and her friends, Alison uses Jenna and Toby's secret as a way to shift blame. Thus, through Alison identifying the boundaries of their secrets, the girls and step-siblings find themselves going along, as a way to protect their information.

Once boundaries are marked and the information is controlled, the *third supposition* expands the idea of **control** and ownership. By marking boundaries, we are able to control who has access to private information (Rosenfeld, 2000), because we believe we have right to regulate what we reveal and conceal (Petronio, 2000; 2002). But, when we decide to reveal information to someone, we are essentially inviting them to be co-owners in the private information (Greene et al., 2003; Petronio, 2000). Now they share in the responsibility of the private information, including access to and protection of it. Thus, information may begin as personally private, but it becomes co-owned, where all those who are privy to the information may decide together who else can gain access, and to which parts of the information (Petronio, 2002). In the end, those co-owners jointly determine who is within the boundary of private information. Jenna and Toby's physical relationship is their private information, but Alison finds out, because she lives across the street and can see into their home. Thus, Alison becomes a co-owner of the information, whether or not they invite her in.

The *fourth supposition* focuses on the **privacy rules** used in the decision to grant someone access to private information. Petronio (2002) indicates that people depend on such rules, when they are regulating control over their private information. When others become co-owners, rules are then negotiat-

ed as a way to clarify how, when, and with whom the information will be revealed (Greene et al., 2003). For example, the girls have a number of established rules about the access to private information about "The Jenna Thing" and other secrets surrounding Alison's death. For example, Alison dictates the group's privacy rules, directly after Jenna is injured, because she does not want to be held responsible. To ensure that her friends are on board, she threatens them with sharing their individual secrets. Additionally, the group of friends determines together that they will maintain Alison's privacy rules, even after she is found dead. They begin receiving creepy messages from the stalker, "A," and, since they are not sure who it is or what information he or she might have, the girls believe maintaining a code of silence is best way to keep their secrets quiet.

After Alison is found dead, they continue to establish new rules, as they are confronted with concealing or revealing their collectively held information. Aria suggests they should get together, share the messages from "A," and determine what they should do next. When Spencer sees Jenna texting with a device for blind individuals, she tells the group, and they wonder, "Is Jenna 'A'? Is she finally getting us back for the accident?" Thus, the information flow, to and from others, was based on the rules they created (Petronio, 2000). It is through these established rules that individuals can feel as if they have some control over their private information (Greene et al., 2003).

The *fifth supposition* highlights the **dialectical nature** of private information (Petronio, 2010). An individual may wish to be open with someone, but feel afraid of being embarrassed, after revealing private information (e.g., Rosenfeld, 2000). Simultaneously wanting to disclose and maintain privacy results in conflict over one's individual autonomy (Petronio et al., 1998; Rosenfeld, 2000). For instance, Alison knows all the girls' secrets, but they do not know much about her, and this becomes clearer after she is found dead. The girls come together to discuss "The Jenna Thing," why Alison was murdered, and their privacy rules used to maintain their secrets. During one of these conversations, Spencer reveals that Alison had been dating an older boy the summer she disappeared, and the other girls wonder why Alison never told them. It appears that Alison struggled with balancing her own openness and privacy with her friends, because she understood the risk of sharing and the risk of being private. Or, perhaps, manipulative Alison was well aware of this contradiction and it allowed her strategically to manipulate her friends. CPM centers on the idea that privacy and disclosure are contra-

dictions that one needs to balance (Petronio, 2002), and Alison is able to play her friends against each other, long after her death because of it.

Rule Management Processes of Privacy Management

With the five suppositions in place as the underpinnings of CPM, the three rule management processes can now be discussed. In the following section, each process will be described, using research and examples from *Pretty Little Liars* as support.

Privacy rule foundations. According to CPM, we use privacy rules as criteria to make choices that help us remain in control of our own information (Petronio, 2000). Therefore, boundaries are either viewed as tight or loose, based on the rules we use as criteria for granting or denying access (Petronio et al., 1998). The privacy rule foundation can be divided into two features, including rule development and rule attributes (Greene et al., 2003; Petronio, 2002). First, *rule development* focuses on the ways privacy rules are established (Petronio, 2002). For example, rules may be established based on culture (e.g., the role of privacy in culture), gender (e.g., men and women may differ in how they share), motivations (e.g., how motivated someone is for disclosure or privacy), context (e.g., the situation helps determine if information is shared), and risk-benefit ratio (e.g., weighing the advantages of revealing vs. concealing) (Greene et al., 2003; Petronio, 2002). It is clear that the girls have established their own culture, valuing privacy of the in-group's secrets, because that is what leader Alison dictated and threatened. Additionally, considering some of nastiness Alison directed toward them when she knew their secrets (e.g., threatening to share if they didn't keep "The Jenna Thing" quiet), it is no wonder that each individual girl struggles, or feels less motivated, to tell their friends about their own troubles. However, as private information is revealed, contextually they are forced to share by their blackmailing stalker, but revealing their individual secrets to their friends may offer them some safety and protection from "A."

Second, *rule attributes* focus on the way people obtain their privacy rules, and the properties of these rules (Petronio, 2002). For example, rules may be acquired from a preexisting set, or new rules may be established among co-owners (Petronio, 2002). Additionally, rules may become routine over time, as the repeated use of privacy rules proves to be successful for the private information owner (Petronio, 2002). The girls are questioned by the police about Alison's murder, but, as these meetings continue, they stick

with the same rules of concealment, regarding "The Jenna Thing." After each meeting, the girls determine that their private information is intact, and that there are no negative consequences experienced, so why share the information with anyone else? Sharing the information could result in the girls being seen as persons of interest in the death of their friend, or suffering the full consequences of Alison's "stink bomb" prank. No matter how the rules are obtained or how habitual they become, owners of information are able to exert their control by using the rules to grant and deny access (Petronio et al., 1998).

Boundary coordination. The rule management process of boundary coordination can help answer this question about sharing secrets. In particular, when people grant access to their private information they must negotiate boundary linkages, permeability, and ownership (Petronio, 2000). Unfortunately, differing perceptions about how and with whom they co-own information may result in conflict over coordination (Petronio, 2000). Thus, part of the process of negotiation may be accepting that there are both individual and collective boundaries (Petronio, 2002). The girls do not always agree on the rules of coordination, as they continue to conceal individual secrets about "The Jenna Thing," all of which could shed light on Alison's death. For example, on the night of the prank and Jenna's injury, some of the girls are against the prank, and Hanna thinks they should go directly to the police. However, the girls' speaking out against Alison results in a conflict among them all, and Alison threatens to share their secrets with others. But, the conflicts do not always end with victory for Alison. She tells Spencer she is going to reveal the secret about Spencer kissing her sister's boyfriend, Ian; but Spencer sees this as opportunity to negotiate boundaries, by threatening Alison with sharing "The Jenna Thing" with everyone. Nonetheless, to balance the tension of privacy and disclosure among the co-owners, the rules need to be agreed upon (Petronio, 2002).

Boundary linkages. A boundary linkage refers to the connection one has to private information (Petronio, 2002), and the "alliance between discloser and recipient" (Petronio & Durham, 2014, p. 340). These connections can happen in a number of ways (Greene et al., 2003). First of all, revealing information to a friend can be a way to link someone to private information. Through privacy rules, people may determine which individuals to link to their particular boundary. Additionally, an individual may find that another person is linked to their private information, because they overheard it or were linked by another co-owner (Greene et al., 2003). Indeed, a boundary

linkage creates an allegiance between two or more people (Petronio, 2002), whether they are invited in or enter accidentally.

Linkages to private information are made frequently among the girls and others, in *Pretty Little Liars*. First, the friends become linked to "The Jenna Thing," because they are all together when it happens, and because Alison forces them to be part of it. Next, after Alison and Spencer fight over revealing Spencer's kiss with Ian and "The Jenna Thing," Alison decides to reveal the information to her older brother, Jason. He becomes connected to the prank. However, Alison uses this link as a way to protect herself continuously from responsibility for the event, since she lies and tells Jason it was all Spencer's idea. Although Jason has false information about "The Jenna Thing," he is seen as helpful in understanding why his sister was murdered. This linkage proves to be problematic for Spencer.

Boundary ownership. Once someone becomes a "co-owner" of information, boundary ownership outlines the rights they have regarding the private information. These rights are typically dictated by the "original owner" (Petronio, 2002). Because someone believes they own information and has control over it, a "co-owner" may receive full or partial rights to the private information. In particular, these rights are based on their perceptions and what rights are provided to them (Petronio, 2002). During this negotiation, co-owners may determine if anyone else can know the private information, and, if they can, when the information can be revealed to those individuals (Greene et al., 2003). When Aria learns that Hanna has been taken to the police station, she wonders if Hanna will reveal "The Jenna Thing," despite the group pact to keep quiet. In this case, Aria is explicit about ownership; but in a lot of cases this protection of secrets may be implied instead. This process indicates that boundaries are fluid, because some people can be granted access while others are denied (Petronio, 2002). But, co-owners should agree upon boundary lines, because it can be challenging to jointly manage boundaries around private information (Greene et al., 2003; Petronio, 2002).

Boundary permeability. When considering a co-owned privacy boundary, how much information does each person receive? This question is answered through the negotiation of boundary permeability, where the amount of access to a privacy boundary is determined (Petronio & Durham, 2014). Co-ownership does not mean that all individuals linked to the private information know everything (Greene et al., 2003), or that boundary-access is kept in place (Petronio et al., 1998). After "The Jenna Thing," Alison threatens the girls to keep the secret; but Alison does not reveal everything about

that night to them. For example, she blackmails Toby into taking the fall. Spencer has partial information about this, because she sees her friend yelling at Toby, but she does not know why until later. After Alison is murdered, Spencer shares what she saw, because it becomes relevant to figuring out how their friend was killed. Thus, Spencer adjusts her friends' access to this private information. When boundaries are closed (**thick boundaries**), there is very little information flow (e.g., Greene et al., 2003). However, if the boundaries are open (**thin boundaries**), there may be too much information flow. Some people may decide to tighten or loosen the boundaries (Petronio et al., 1998), through rules of permeability (Petronio, 2010). However, once someone becomes privy to information, it cannot be reversed. They become co-owners and mutually responsible for the information (Greene et al., 2003).

Boundary turbulence. The synchrony of boundary coordination is critical, because challenges, conflicts, and invasions lead to boundary turbulence (Petronio, 2000). Given the many boundaries we have to manage across relationships and the complexity of coordination, it is not surprising that we experience turbulence (e.g., Petronio, 2000). For example, a disturbance experienced in the management process may occur, due to rule violations and unclear boundary lines (Petronio, 2004), unmet expectations (Petronio, 2010), misuse of private information (Greene et al., 2003), or accidentally revealing too much or withholding information (Petronio & Durham, 2014). The girls in *Pretty Little Liars* frequently experience boundary turbulence, as "A" tries to reveal their private information to other people. When they first receive contact, they wonder how "A" found out the information. For example, how does "A" know about "The Jenna Thing"? Is Jenna the person stalking them? Trying to determine what the girls know, what "A" knows, and what they can do about "A's" threats, produces tension among the friends. Because so much depends on the information, the girls participate in conflict. Conflict happens when they learn that Alison has shared information with Spencer about her older boyfriend. Why would she only tell Spencer? Why did Spencer wait to tell them, especially since the information might help with the murder investigation? Finally, because the girls are bound together in "The Jenna Thing" and are the friends of the murdered girl, they typically find a way to reconcile and come together, with new privacy rules, to cope with their private information.

Overall, such experiences of turbulence may benefit relationships, because people can improve how they define their privacy with other people

(Greene et al., 2003; Petronio, 2010); but it can also lead to conflict, and other uncomfortable situations, with co-owners and others (Greene et al., 2003; Petronio, 2013). To avoid turbulence, co-owners must act in coordinated ways (Petronio & Durham, 2014); but the turbulence often occurs anyway, and provides individuals with an opportunity to make adjustments to their coordinated rules (Petronio, 2000).

Conclusion

Emily tells the police, "Alison said that telling secrets kept us close." One might expect friendship to be a relationship conducive to revealing private information, but as CPM and *Pretty Little Liars* demonstrate, the process is complex (Rosenfeld, 2000), and can be challenging as people try to coordinate mutual responsibility for shared secrets (Petronio, 2000). Certainly, *Pretty Little Liars* is a compelling example of CPM, allowing us to explore how we reveal and conceal private information. In particular, in the aftermath of "The Jenna Thing," Alison is able to link herself to her friends' risky, personal information (e.g., Petronio, 2002), identify it as private, and manipulate it into threats against her friends, and control the flow of their information herself. All the while, Alison never truly reveals any of her secrets, in return. But, even from the grave, she influences the privacy rules and boundary coordination among her friends, as well as the turbulence they experience each time they receive a message from "A."

Keywords from This Chapter

Boundary coordination
Boundary metaphor
Conceptualization of private information
Control
Dialectical nature
Privacy rules
Privacy rule foundations
Rule attributes
Rule development
Social Penetration Theory
Thick boundaries
Thin boundaries

References

Adelman, M. B., Parks, M. R., & Albrecht, T. L. (1987). Supporting friends in need. In T. L. Albrecht & M. B. Adelman (Eds.), *Communicating social support* (pp. 105–25). Newbury Park, CA: Sage Publications.

Greene, K., Derlega, V. J., Yep, G. A., & Petronio, S. (2003). Communication privacy management and HIV disclosure. *Privacy of HIV in interpersonal relationships* (pp. 17–35). Mahwah, NJ: Lawrence Erlbaum Associates Publishers.

McBride, M. C., & Mason Bergen, K. (2008). Communication research: Becoming a reluctant confidant: Communication privacy management in close friendships. *Texas Speech Communication Journal, 33*(1), 50–61.

Petronio, S. (1991). Communication boundary management: A theoretical model of managing disclosure of private information between marital couples. *Communication Theory, 1*(4), 311–35

———. (2000). The boundaries of privacy: Praxis of everyday life. In S. Petronio (Ed.), *Balancing the secrets of private disclosures* (pp. 37–49). Mahwah, NJ: Lawrence Erlbaum Associates Publishers.

———. (2002). Overview of communication privacy management. *Boundaries of privacy: Dialectics of disclosure* (pp. 1–35). Albany, NY: SUNY Press.

———. (2004). Road to developing communication privacy management theory: Narrative in progress, please stand by. *The Journal of Family Communication, 4*(3&4), 193–207.

———. (2010). Communication privacy management theory: What do we know about family privacy regulation? *Journal of Family Theory & Review, 2,* 175–96.

———. (2013). Brief status report on communication privacy management. *Journal of Family Communication, 13,* 6–14.

Petronio, S., & Durham, W. T. (2014). Communication privacy management theory: Significance for interpersonal communication. In D. O. Braithwaite and P. Schrodt's (Eds.), *Engaging theories in interpersonal communication: Multiple perspectives* (2nd ed.) (pp. 335–49). Thousand Oaks, CA: Sage Publications.

Petronio, S., Ellemers, N., Giles, H., & Gallois, C. (1998). (Mis)communicating across boundaries: Interpersonal and intergroup considerations. *Communication Research, 25*(6), 571–95.

Reohr, J. R. (1991). *Friendship: An exploration of structure and process.* New York: Garland.

Rosenfeld, L. B. (2000). Overview of the ways privacy, secrecy, and disclosure are balanced in today's society. In S. Petronio's (Ed.), *Balancing the secrets of private disclosures* (pp. 3–17). Mahwah, NJ: Lawrence Erlbaum Associates Publishers.

Telling secrets is anything but pretty for these little liars. The TV show *Pretty Little Liars* is a perfect example for illustrating communication Privacy Management Theory. The show is very easy for our generation to relate to, and you do not have to see it to understand how it relates to the concept. Students especially can connect their everyday life with CPM. We all have friends with whom we trade secrets and gossip, and eventually, it gets us into a black hole. That is the simple storyline of this show. I can apply CPM to every episode I have watched of *Pretty Little Liars*. There is not one episode in which one of the four main characters is not keeping a secret. Throughout the seasons, multiple secrets are revealed, affecting stories, the girls' thoughts, and even their safety. The main characters in the show have to make a decision whenever a secret is revealed. Using the five suppositions of privacy management, we can better understand why the girls make the decisions they make. Not only does the chapter help explain their decisions; it also helps clarify our own. Speaking for myself, I go through this with my friends all the time, although it does not involve such serious situations as in *Pretty Little Liars*. One of us tells another something that the other cannot know, and BOOM—it erupts into a major conflict. Throughout the story line of this series, I can clearly see the different suppositions. I can't express enough how important it is, to show something that relates to communication, as well as to the students! It makes it much more interesting and enjoyable for us. Taking a TV series like this, and connecting it with CPM, helps the concept stick, and helps me actually understand the material. Although *Pretty Little Liars* is not the show for everyone, it is the show for this chapter!
—Alissa Poster

CHAPTER 20

Social Penetration Theory and Relationship Formation in *Harry Potter*

Kelli Jean K. Smith & Sharmila Pixy Ferris

In this chapter, we discuss **Social Penetration Theory** (SPT), a theory about self-disclosure and relational development. Relationships are important to every one of us, from our first relationships in our families, to the friendships, romances, and work relationships we develop throughout our lives. SPT helps us better understand how these relationships grow and progress.

Social Penetration Theory has become part of the academic curriculum in Communication Studies in general, and the study of **Interpersonal Communication** in particular. Most undergraduate communication theory textbooks explain the theory in much the same way we do here. Although SPT was conceptualized before social media became common, the theory is still relevant today. The changes in self-disclosure, and the relational benefits that come with it, can be seen in online relationships, as well as offline (face-to-face) relationships.

Because we feel that a shared viewpoint can help us better understand Social Penetration Theory, we use the well-known example of Harry Potter. Most of you have grown up with the Harry Potter books and films, which are said to be the most far-reaching cultural phenomenon of the 21st century (*Time* Staff, 2013), and are definitely an integral part of millennial culture (Whited, 2002). Because of its overwhelming popularity, we feel that Harry Potter provides an understandable way to illustrate the precepts of Social Penetration Theory. We think this will work well, as many other teachers have used Harry Potter in their classrooms (Belcher & Herr-Stephenson, 2011; Frank & McBee, 2003; Harrell & Morton, 2002; Kern, 2003; Vezzali, Stathi, Giovannini, Capozza, & Trifiletti, 2015). For the sake of focus, we will use excerpts and examples from the first book: *Harry Potter and the Sorcerer's Stone* (Rowling, 1997). In this first book of the series, Harry discovers his magical heritage. He goes to Hogwarts School of Witchcraft and Wizardry, where he develops a number of friendships, the strongest of which are with Ronald Weasley and Hermione Granger.

As you read this chapter, you will note the use of in-text citations throughout. We hope you will not find these citations intrusive, but they are necessary. As a university student, you too will be expected to support your

assertions with relevant and appropriate scholarly research, including books and articles from academic journals.

Social Penetration Theory

Irwin Altman and Dalmas Taylor, in their 1973 book *Social Penetration*, conceptualized Social Penetration Theory, as a way to understand how relationship closeness develops between people. **Social penetration** refers to verbal behaviors such as exchanging information, nonverbal behaviors such as facial expressions and physical contact, and environmental behaviors such as positioning chairs to facilitate conversation. It also includes forming impressions of others, developing positive or negative feelings toward them, and predicting how they might behave in a variety of situations. Our communicative behaviors, and our perceptions of our interactions and interaction partners, vary at different levels of intimacy. To put it another way, SPT describes the process of moving from a superficial relationship, into a more intimate relationship.

When Altman and Taylor (1973) talk about **relationships**, they are referring to all kinds of connections between people, not just romantic relationships. SPT applies to friendship, work relationships, teacher-student relationships, and doctor-patient relationships (to name just a few), as well as romantic partnerships. Our relationships vary, in their level of social penetration. For instance, your relationship with your romantic partner is more intimate than your relationship with a casual acquaintance, and your relationship with a friend you have known since grade school is more intimate than your friendship with your new college roommate. Whatever the type of relationship, Altman and Taylor feel that the main way our relationships develop is through **self-disclosure**, the voluntary sharing of information about ourselves with others. Personal information we disclose can include our personal history, attitudes and opinions, hopes and fears, successes and failures, etc. Sharing such information allows us to get to know each other and develop more intimate relationships.

The Social Penetration Process

Altman and Taylor (1973) believe that relationships progress from non-intimate to intimate, in some predictable ways. They believe people are like onions. We have layers that represent different aspects of our personality. The outermost layers represent our public self and include basic, non-

threatening information, while the deeper layers represent our private self and include more intimate, personal information. As our relationships become more intimate, our self-disclosure increases in breadth and depth. **Breadth** refers to the number of topics that we feel we can discuss. **Depth** refers to the personal significance and level of intimacy of the disclosures we make.

In the early stages of a relationship, self-disclosure is narrow in breadth and shallow in depth. Early on in a relationship, we limit ourselves to a few topics, such as our major and where we're from, and we only provide superficial information. As the relationship develops, we feel free to discuss a wider range of topics (greater breadth), and are comfortable with sharing more personal information (greater depth). For example, talking about your favorite TV show is not very personal; but if you talked about how the last episode was difficult to watch because it reminded you of how you lost your brother to leukemia, that would be far more personal.

Altman and Taylor (1973) tell us that Social Penetration Theory is a theory of relationship development over time, or a **stage model**. Partners go through four stages of the social penetration process, as they become closer to each other. The first stage is **orientation**. At this stage we make superficial disclosures and follow norms of appropriateness. Nonverbally, we tend to display positive reactions, such as smiles and nods, while avoiding negative reactions, such as frowns.

The first stage of Social Penetration can be seen on the train to Hogwarts, where Harry, Ron, and Hermione share superficial information and follow norms of appropriateness and reciprocity in self-disclosure. In the early stages of a relationship, self-disclosure is narrow in breadth and shallow in depth. When Harry meets Ron, first at King's Cross when Mrs. Weasley helps Harry find the way to on Platform 9 & ¾, and later on the train where they share the same compartment, they exchange initial getting-to-know-you information, demonstrating some breadth but little depth. After the Weasleys recognize Harry by his lightning-shaped scar, Harry discloses "public" information—that he does live with Muggles, and his Dursley relatives are "horrible." Harry's disclosure gets a little deeper, when he tells Ron that he "doesn't remember Voldemort's attack " (Rowling, 1997, p. 99).

The next stage, **exploratory affective exchange**, is where we start to reveal a little bit more of our personality. In *Harry Potter*, for instance, the trio of Harry, Ron, and Hermione reach this stage in their first term at Hogwarts. The Sorting Hat chooses all three of them for Gryffindor House. Like Harry,

Ron, and Hermione, in this stage we feel less guarded about giving some personal information, but are still cautious about sharing too much of who we are (e.g., "too tired to talk much, they pulled on their pajamas and fell into bed," Rowling, 1997, p, 130). We also begin to learn the meaning of some of the nonverbal messages our partners send. In the **affective exchange** stage, we are very comfortable with our partners, and feel that we can share both positive and negative information about ourselves. There are still some things that we choose not to reveal, but we do share very personal information on some topics. Our ability to understand our partners' verbal and nonverbal behaviors continues to increase in this stage. We discuss Harry, Ron, and Hermione in this stage in more detail, later in the chapter.

The final stage is **stable exchange** where we feel free to disclose our deepest thoughts and feelings to our partners. We also feel that we can predict, with a great deal of accuracy, how our partners would feel or act in a variety of situations. This is clearly evident in the way Harry, Ron, and Hermione trust each other in the second half of *The Sorcerer's Stone*, as they work together to save Hagrid's baby dragon, through their adventures in the Forbidden Forest and their recovery of the actual Sorcerer's Stone. The stable exchange stage is evident more in event, than in dialogue, in *The Sorcerer's Stone*, because there is little overt self-disclosure between Harry, Ron, and Hermione. Perhaps this is because the characters are under eleven years old in *The Sorcerer's Stone*, and pre-adolescents aren't normally presented as engaged in meaningful dialogue about shared feelings. Or it could be an authorial focus on action, rather than relational development.

Research suggests that we tend to like people who disclose to us, and we disclose more to people whom we like (Collins & Miller, 1994). Patterns of self-disclosure and relationship development are similar in online and offline relationships. The breadth and depth of our self-disclosure increase over time, in both online and offline relationships (Chan & Cheng, 2004). In online relationships, increases in breadth and depth of self-disclosure are also associated with higher levels of trust, liking, love, and commitment in online relationships, mirroring what is seen in offline relationships (Yum & Hara, 2005). This suggests that online self-disclosure has the same relational benefits, as disclosures made face-to-face.

Factors Influencing the Social Penetration Process

Self-disclosure is affected by several factors, including reciprocity, cost-reward dynamics, and proximity. For relationships to grow in intimacy there must be **reciprocity** in self-disclosure. That is, both parties must self-disclose, for relationships to develop. Intimacy will not develop if only one partner discloses intimate personal information, and the other continues to reveal only superficial information. For instance, on the train to Hogwarts, Ron **reciprocates** and discloses "public" information about his family and his four brothers; his self-disclosure gains depth when he reveals his family's poverty. The reciprocity in self-disclosure, at this early point, promotes the development of their friendship.

Self-disclosure needs to be gradual, and partners need to match the intimacy of the disclosures. Saying something too personal too soon creates an imbalance in the relationship, which can make the other person uncomfortable. This gradual process of disclosure and reciprocity varies from relationship to relationship, and can depend on the specific partner. For example, if a co-worker and your best friend were to ask you about your weekend, you'd probably give them different answers. You may tell your co-worker that you saw a movie and then went out to dinner, but you may not feel comfortable telling him or her how you had an argument with your partner during dinner. You would, however, be comfortable sharing the more personal information with your best friend. In return, your co-worker and best friend would likely tell you what they did over the weekend, maintaining a similar level of disclosure.

Circumstances and choice can interfere with self-disclosure, as Harry and Ron discover on the train to Hogwarts. They meet Hermione for the first time on the train. Hermione discloses that she is a Muggle, but has read a lot about magic and is already quite good at it. However, although Hermione discloses quite a lot about herself, she does not give Harry and Ron the opportunity to reciprocate with self-disclosure of their own: Hermione walks into their compartment on the train, starts speaking in a "bossy voice" (Rowling, 1997, p. 105), tells Harry she "know[s] all about" him—and "then ... le[aves]" (p. 106). The lack of reciprocity hinders the development of Harry and Ron's friendship with Hermione. At this point in their friendship, both Harry and Ron don't really like Hermione, and they hope Hermione won't be living in their house.

According to Social Penetration Theory, self-disclosure is also affected by **reward-cost dynamics**. There are potential rewards, costs, and risks associated with self-disclosure. For example, self-disclosure can lead to greater intimacy between partners. It shows that we trust our partners enough to share personal information with them. We can also receive advice or support from others, when we disclose problems or negative emotions. On the other hand, when we disclose to others, we run the risk of their betraying our trust, by sharing that information with other people. There is also the chance that our partners might become angry and attack us, or even use the information we disclose against us. If we reveal negative information, our partners might like us less, or reject us altogether. Self-disclosure can sometimes be a risk to the relationship itself, if it is associated with demands or expectations that a relational partner does not feel comfortable assuming. For example, if your roommate tells you that he is depressed and thinking of quitting school, you may have the responsibility of contacting your resident advisor or his parents. You might also feel that you're responsible for keeping an eye on him, until he has dealt with his depression. We make the decision to disclose, by weighing the potential rewards we would gain, against the potential risks involved in making the disclosure. If the cost of disclosure is perceived to be higher than the rewards, then less is disclosed. The larger the reward-cost ratio, the more disclosure takes place.

Reward-cost often is relevant during the affective exchange level. In the affective exchange level, partners are very comfortable with each other and feel that they can share both positive and negative information, evaluating the cost-reward ratio, when deciding what to do. This can be seen in Harry, Ron, and Hermione's relationships. In *The Sorcerer's Stone*, when Snape appears to be hexing Harry during a Quidditch game, Hermione surreptitiously sets Snape's robe on fire, to take his attention off of Harry and stop Snape's magic. Using magic to set a teacher's robe on fire could get the rule-respecting Hermione into real trouble, but she decides that the risk is worth the reward of saving Harry. Ron takes a similar risk as he sees Hermione casting the spell, and keeps her secret. Similarly, there are great potential risks for Harry, Ron, and Hermione, when they secretly work to get Hagrid's baby Norwegian Ridgeback dragon rescued by Ron's brother Charlie. The strong level of trust they have in each other during these events cements their friendship, moving them into the final stage of stable exchange, allowing them to meet the many challenges necessary in order to reach the Sorcerer's Stone.

Finally, another element that affects self-disclosure is **proximity**. People are more likely to form relationships and share intimate information with those who are in close physical proximity to them. This is demonstrated by a seminal study by Festinger, Schachter, and Back (1950), who found that students who lived closer together in the student apartments were more likely to become friends, than students who lived farther apart. Proximity gives us more opportunities to interact and become familiar with each other. This allows our relationships to grow more intimate over time. In *Harry Potter*, proximity promotes relationship development, when Harry, Ron, and Hermione are all sorted into Gryffindor. They find themselves living in the same house, taking classes together, and eating every meal together.

Proximity leads to **familiarity**, which also influences interactions. The level of familiarity between Harry and Ron can be seen when Harry and Ron trust each other enough to sneak out together, to warn Hermione about a troll who has invaded the school. Harry and Ron save Hermione from the troll, and Hermione lies to protect them, telling Professor McGonagall that she went to face the troll herself, and that Ron and Harry had been trying to save her. After this incident, they become less guarded and closer to each other. This quotation from the book sums it up: "There are some things you can't share without ending up liking each other" (Rowling, 1997, p. 179).

Conclusion

We hope that the relationships between Harry, Ron, and Hermione help you better understand Social Penetration Theory, a theory that explains how relationships develop through communication and self-disclosure. As people move from sharing superficial, to more intimate and personal, information, they get to know each other more deeply. Although it can be risky, opening up and making ourselves vulnerable allows us to form meaningful relationships with others. The friendships developed by Harry, Ron, and Hermione during their first year at Hogwarts demonstrate how taking risks can lead to rewards that can last a lifetime. Through increasing levels of self-disclosure, people allow others to penetrate their public selves and get to know their private selves. Disclosure is affected by cost-reward dynamics, or perceived rewards and perceived costs and risks, with greater disclosure occurring with larger reward-cost ratios. Disclosure occurs over time (that is, it goes through several stages), and is affected by other factors, including reciprocity and proximity. You can see how the friendships developed by Harry, Ron, and

Hermione during their first year at Hogwarts demonstrate the development of relationships through self-disclosure. In our own lives, understanding the social penetration process can help us become more skillful at managing our relationships.

Keywords from This Chapter

Affective exchange
Breadth
Depth
Exploratory affective exchange
Familiarity
Interpersonal Communication
Orientation
Reciprocates
Reciprocity
Relationships
Reward-cost dynamics
Proximity
Self-disclosure
Social penetration
Social Penetration Theory
Stable exchange
Stage model

References

Altman, I., & Taylor, D. (1973). *Social penetration: The development of interpersonal relationships*. New York, NY: Holt.

Belcher, C. L., & Herr-Stephenson, B. (2011). *Teaching Harry Potter: The power of imagination in multicultural classrooms*. New York, NY: Palgrave Macmillan.

Chan, D. K. S., & Cheng, G. H. L. (2004). A comparison of offline and online friendship qualities at different stages of relationship development. *Journal of Social and Personal Relationships, 21*, 305–20.

Collins, N. L., & Miller, L .C. (1994). Self-disclosure and liking: A meta-analytic review. *Psychological Bulletin, 116*, 457–75.

Festinger , L., Schachter, S., & Back, K. (1950). *Social pressures in informal groups: a study of human factors in Housing*. Redwood City, CA: Stanford University Press.

Frank, A. J., & McBee, M. T. (2003). The use of *Harry Potter and the Sorcerer's Stone* to discuss identity development with gifted adolescents. *Journal of Advanced Academics, 15*(1). doi: 10.4219/jsge-2003-438

Harrell, P. E., & Morton, A. (2002). Muggles, wizards, and witches: Using Harry Potter char-
acters to teach human pedigrees. *Science Activities*, *39*(2), 24–9.
doi:10.1080/00368120209601081

Kern, E. M. (2003). *The wisdom of Harry Potter: What our favorite hero teaches us about moral choices*. Amherst, NY: Prometheus Books.

Rowling, J. K. (1997). *Harry Potter and the Sorcerer's Stone*. (Special Anniversary Edition, 2008). USA: Arthur Levine Books, Scholastic Press

Time Staff. (2013, July 31). Because it's his birthday: Harry Potter by the numbers. Retrieved from: http://web.archive.org/web/20130801013055/http://entertainment.time.com/2013/07/31/because-its-his-birthday-harry-potter-by-the-numbers/

Vezzali, L., Stathi, S., Giovannini, D., & Capozza, D., & Trifiletti, E. (2015). The greatest magic of Harry Potter: Reducing prejudice. *Journal of Applied Social Psychology, 2*, 105–21.

Whited, L. A. (2002). Harry Potter: From craze to classic? In L. A. Whited (Ed.), *The ivory tower and Harry Potter: Perspectives on a literary phenomenon* (pp. 1–12). Columbia, MO: University of Missouri Press.

Yum, Y., & Hara, K. (2005). Computer-mediated relationship development: A cross-cultural comparison. *Journal of Computer-Mediated Communication, 11*, 133–52.

In this chapter, there are a few things I would reassess. First of all, let's remember that Hermione isn't a Muggle—even though her parents are! But more to the point of the chapter, I would also reexamine the idea that intimate relationships can only form if both sides are willing to share information. I think that it is important to consider, especially in a college environment, that some people share more information about their past than others share in return. However, these people can still become close friends, because of the proximity effect, despite not reciprocating the sharing of deep intimate details. Also, to capture the full effect of the comparison to the *Harry Potter* novels, it is important to evaluate all of the novels and see how the friendships grow. In the beginning of the article, the author mentions that Harry, Ron, and Hermione's friendship grows more through actions than through words, in the first novel. This to me is a demonstration of the superficial and underdeveloped friendship between the three. This can be compared to those friends in college with whom you only go to parties. Say you go to a party with someone you have been sharing surface information and personality traits with, and the party gets busted. You have this connection through the actions and occurrences of that night, but that does not immediately cause the friendship to grow. You need to exchange words, talk about how you each felt about the event, and exchange other information. This is more how I envision the friendship of Harry, Ron, and Hermione at this point in the book series.

I also think that the chapter needs to consider, or could evaluate, the romantic relationship that develops between Ron and Hermione later on in the novels, and use the theories to explore how that friendship changes, comparing the events that make a romantic relationship grow between Ron and Hermione, as opposed to Harry and Hermione. This would not only strengthen the theory, but also strengthen the use of this story as an example. Another aspect in which I disagree with the views of this chapter is the distinction between college friends and high school friends. I think that it is unfair to compare the two, for a couple of reasons. While length of time known helps to strengthen the friendships in high school, there is also a type of immaturity that comes with childhood friends that takes away from the strength of the friendship. In my experience, high school friends work more on the aspect of proximity than college friends. In college, you can choose to change your seat, or you can choose who to

go to the library with, you can choose your roommate, and you can even choose to stay in your room alone. It takes more effort to make and keep friends from college, because everyone is at a different point in their lives and has different goals. My college friends are built on a completely different set of circumstances than my high school friends. I found myself in college, and the types of people I befriended reflect that.

—Allison Williams

About the Contributors

Janelle Applequist is an Assistant Professor in Integrated Advertising, Public Relations, and Health Communication at the University of South Florida, in the Zimmerman School of Advertising and Mass Communications. Upon presenting a TED talk in 2014 at TEDxPSU, she felt more passionate than ever about combining her research trajectories with her academic instruction at the undergraduate and graduate levels. As a health communication researcher, focusing on both quantitative and critical/qualitative approaches, she is invested in how patients are represented, and the ways in which health care is presented to patients alongside consumerist discourses. Janelle received her bachelor's degree in Broadcast Journalism and Psychology (2009) and her master's degree in Media Studies (2011), from the Pennsylvania State University. She completed her Ph.D. at the Pennsylvania State University in 2015, with a dissertation featuring mixed-methods approaches to the content of prime-time television pharmaceutical advertisements. While researching and teaching at Penn State, Janelle received two individual research grants, and was the recipient of the 2014 University-Wide Harold F. Martin Teaching Award. Janelle has taught large, general education areas, and also advanced theoretical topics, featuring the following courses: Media and Democracy, World Media Systems, and International Communications; and Qualitative Research Methods at the graduate level.

Nancy Bressler is an Assistant Professor at Wheeling Jesuit University, and teaches communication courses, such as Research Methods, Presentational Speaking, and Introduction to Communication. She earned her master's degree in Communication at the University of Hartford, and her Ph.D. in Media & Communication from Bowling Green State University. Over the past five years, she has made more than twelve pedagogical presentations at International, National, and Regional Communication Association conferences, about the incorporation of media into course content, to encourage active learning in the classroom. Her research interests focus on the role of media in American culture, and how media representations influence and contribute to American identity. Dr. Bressler's research integrates media studies, critical/cultural studies, and interpersonal communication approaches. For example, she investigates familial relationships in mediated contexts, including the relationships between family members, family structure, gender roles, and class status, as portrayed in popular culture texts. Most recently, her research

questions to what extent humor can be a preeminent genre, where innovative interpretations of society can be analyzed, explored, discussed, and scrutinized. Because humor demonstrates a relationship between the media text and its audience, Dr. Bressler examines these particular texts to understand the underlying social and cultural ideologies in media representation.

Claudia Bucciferro is an Assistant Professor of Communication Studies at Gonzaga University, where she teaches international/intercultural communication, communication theory, research methods, and popular culture. She has a Ph.D. in Communication from the University of Colorado at Boulder and a Master's degree in Linguistics from the University of Concepción, Chile, where she also completed her undergraduate studies in Communication and Journalism. Her research focuses on media representations and intercultural/international issues. Her work has appeared in several journals and edited collections. She is the author of the book FOR-GET: Identity, Media, and Democracy in Chile and editor of The Twilight Saga: Exploring the Global Phenomenon. Her new book project presents a cultural analysis of the X-Men films.

Garret Castleberry (M.A., University of North Texas) is a Ph.D. candidate, and the Director of Forensics for the Department of Communication at the University of Oklahoma. His ongoing research investigates polyvalent critical/cultural themes, as well as socioeconomic and mythic narratives embedded within contemporary transmedia texts and popular culture. With strategic emphasis in television studies and the post-network televisual mediascape, Garret previously published in special issues of *Cultural Studies ⇔Critical Methodologies* and the *International Journal of Qualitative Research*, with upcoming contributions in *The ESPN Effect* (Peter Lang, 2015) and *Television, Social Media, and Fan Culture* (Lexington Books/Roman & Littlefield, 2015). Recent publications combine genre studies, autoethnography, and ideological criticism, to explore the rhetorical work performed by televisual artifacts.

Andrew Cole is an Instructor of Communication Skills at Waukesha County Technical College in Pewaukee, Wisconsin. Dr. Cole received his master's and Ph.D. in Communication from the University of Wisconsin-Milwaukee, and a bachelor's degree in Speech Communication from the University of Wisconsin-Whitewater. His research interests center on communication

technology, media studies, social influence, and health communication. He has teaching experience in university and technical college settings, where he has taught courses in public speaking, interpersonal communication, conflict resolution and peace studies, and business/professional communication. Dr. Cole also has professional experience in instructional design, and the use of educational technology in online and blended courses. He worked on the development of the UW Flexible Option competency-based certificate program, in Business and Technical Communications.

Jake Dionne graduated with a B.A. in Communication Studies from the University of North Texas in 2014. He is currently a master's candidate and teaching assistant, in the Department of Communication & Rhetorical Studies at Syracuse University, where he researches rhetoric and internatural communication at the intersections of critical animal studies, critical environmental studies, queer theory, and trauma studies. While in Texas, he developed an affinity for Kenneth Burke, whose books shaped his research goals. Broadly speaking, he is interested in understanding how rhetoric results in violence against more-than-human bodies, which, among other "things," include spaces, places, ecosystems, and animals. His publications include an essay about rhetoric, pornography, and homonormativity, and a journal article about queer ecofeminism and film's dimensions of ecological liberation.

Bob DuBois is an Instructor of Social Sciences at Waukesha County Technical College, in Pewaukee, Wisconsin. He is also an adjunct instructor at Milwaukee Area Technical College, and Marquette University. Dr. DuBois earned his Ph.D. in Educational Psychology from Marquette University, a master's degree in Counseling Psychology from the University of Texas at Tyler, a master's degree in Industrial/Organizational Psychology from Western Kentucky University, and bachelor's degrees in Psychology and Philosophy from Western Kentucky University. His research interests center on student learning, prosocial behavior, suicide prevention, psychological assessment, and simulation. He has more than 15 years of teaching experience in university, community college, technical college, and government and industry settings, and has taught online, hybrid, and in-class courses in introductory, developmental, abnormal, industrial, and social psychology; psychological testing; thinking critically; research and statistics; and ethics. Dr. DuBois also has professional experience as a psychological consultant to

government and industry, and is a frequent invited speaker on diverse issues relevant to instructional design and technology, student learning, lifelong learning, and suicide prevention. He is also a Licensed Professional Counselor (LPC).

Chrys Egan (Ph.D. in Communication, Florida State University) is an Associate Professor at Salisbury University, in the Communication Arts Department and in the Gender and Sexuality Program, examining intersections of relationships with popular culture and media. She has had book chapters published in: *Family Communication: Theory and Research* (Pearson), *Advancing Theories of Women and Leadership* (ILA), and *Communication and Global Engagement across Cultural Boundaries* (Kendall Hunt). Textbook ancillaries: *Communication Research Instructor's Manual* (Pearson), and *The St. Martin's Guide to Public Speaking: Student Workbook, Textbank, and Instructor's Manual*. Academic journal articles published in: *The Free Speech Yearbook, Studies in Popular Culture, Journal of Popular Culture, Iowa Journal of Communication,* and *Gender in Management: International Journal*. She serves a co-chair to the Popular Culture in the South conference and to the Women and Leadership Affinity Group conference. She received the 2014 SU President's Diversity Award.

Sharmila Pixy Ferris (Ph.D., Pennsylvania State University) is Professor in the Department of Communication at William Paterson University, in Wayne, NJ. She teaches group and organizational communication. Her research brings an interdisciplinary focus to computer-mediated communication, in which she has published widely. Her most recent books are *The Plugged in Professor: Tips and Techniques for Teaching with Social Media* (2013, with Hilary Wilder), and *Teaching, Learning, and the Net Generation: Concepts and Tools for Reaching Digital Learners* (2011). More information available at http://www.wpunj.edu/coac/communication/S_Ferris. htm/.

Hunter H. Fine grew up in Venice, California, a coastal enclave of intercultural, social, and creative confluence, where the physical practices of surfing and skateboarding merge. He received his doctorate from Southern Illinois University, Carbondale, and conducts critical communication scholarship that skates along intersecting themes of critical pedagogy, performance, rhetoric, and poststructuralist theory. Currently he teaches at Humboldt State

University in the Department of Communication, where he teaches and designs classes in "Communication Theory," "Social Advocacy Theory and Practice," "Intercultural Communication," and "American Public Discourse." Some of his work in this regard can be seen in *Liminalities: A Journal of Performance Studies*, and *Nerve Lantern: An Axon of Performance Literature*. Often combining site-specific performance work with new media projects, he explores the social constructions of place and space, as well as the tactical negotiations of power therein. As a critical, cultural, and rhetorical scholar, he also works to explore social implications behind popular cultural texts, such as those associated with hip-hop culture and American cinema.

Bruce W. Finklea is an Assistant Professor of Mass Communication at the University of Montevallo. He has previously published in the area of communication theory, when he co-authored the second edition of *Fundamentals of Media Effects*, with Drs. Jennings Bryant and Susan Thompson. Dr. Finklea's primary research area is gender representation in children's media. His dissertation examined masculinities in Pixar's feature films. His other research interests include media ethics and morality, social media, and popular culture. He has presented his award-winning research at numerous conferences and conventions, including the Broadcast Education Association, the Association for Education in Journalism and Mass Communication, and the National Broadcasting Society. He is an active member of BEA and NBS. After earning his bachelor's degree from the University of Montevallo in 2007, he worked as a news producer at the NBC affiliate in Birmingham, Alabama. He later earned his Ph.D. in Mass Communication, with a cognate in American Studies, in 2014 from the University of Alabama. Dr. Finklea currently resides in Calera, Alabama, with his wife, Jackie, and his daughter, Harper. He is a die-hard Trekkie and Whovian.

Krystal Fogle (M.A., Communication, Abilene Christian University) enjoys both watching and analyzing television. She has presented scholarship on *Sherlock* and *Doctor Who,* and researched and written about various pop culture artifacts, including YouTube and Pinterest. She will be pursuing a Ph.D. in Rhetoric and Media at Abilene Christian University.

Brian Gilchrist (Ph.D., Department of Communication and Rhetorical Studies at Duquesne University) joined the Department of Communication at Mount St. Mary's University as an Assistant Professor of Catholic Media in

2015. He taught communication classes at Eastern University from 2013–2015. The *trivium* (grammar, dialectics, and rhetoric) influence his research of media ecology, philosophy of communication, and rhetorical theory. His scholarly publications include peer-reviewed articles that provide a semiotic analysis of deconstruction as intercultural communication and interpret Facebook as a mobile panopticon through the lens of Michel Foucault; a Public Speaking Course Reader; teaching activities for Aristotle's rhetorical proofs and rhetorical analysis; and a review for *Explorations in Media Ecology* (*EME*) about the interdisciplinary implications of Walter F. Ong's scholarship. He is editing his dissertation, "The *Metalogicon* of John of Salisbury: Medieval Rhetoric as Educational Praxis," into a book project that articulates John of Salisbury's contribution to medieval rhetorical theory. He has presented papers in academic conferences at the international, national, regional, and state levels. His classes include "Analysis of Argument and Discourse," "Communication and Technology," "Introduction to Communication Theory," "Introduction to the Art of Film," "Mass Media and Cultural Studies," "Public Speaking," and "Rhetorical Theory."

Sally Bennett Hardig, Associate Professor at University of Montevallo, earned her Ph.D. in Communication (with a focus on rhetoric and gender studies) from the University of Memphis in 2006. She currently serves as the Chair of the Department of Communication at the University of Montevallo. She also teaches courses in persuasion, argumentation and debate, gender communication, health communication, and environmental communication, all from the rhetorical perspective.

Joe Hatfield graduated with a B.A. in English, with a concentration in the Writing and Rhetoric subfield, from the University of North Texas in 2014. He is a graduate student in the Department of Communication and Rhetorical Studies at Syracuse University. His research interests include rhetorical theory and criticism, cultural studies, and critical theory, with emphases in queer theory, affect, and archival methods and practices. He has previously published on film, queer theory, and ecofeminism. He is currently researching the socio-cultural politics of queer archives in New York City. His chapter in this book is a culmination of his love of pop music, rhetoric, and, of course, Lady Gaga.

Gerald J. Hickly III is undoubtedly the black sheep of the contributors associated with this volume. Pedigree-wise, Gerald holds a B.A. in Communication Studies from Grove City College (2013), and an M.A. in Communication Studies, with an emphasis in rhetoric and philosophy of communication, from Duquesne University (2015). While not the traditional scholarly type, Gerald has a great natural passion for critical analysis of media artifacts, and is glad that the serendipitous partnership with Dr. Roberts, established as a term of his Research Assistantship for the 2014–2015 school year, has lent him the opportunity to assist and contribute to this volume.

Holly Holladay is a doctoral candidate in the Department of Communication at the University of Missouri. Her work on television audiences, fans, and popular culture has been published in *Television & New Media* and *Popular Music & Society*.

Alysa Ann Lucas (Ph.D., Pennsylvania State University) is an Assistant Professor in the Department of Communication and Dramatic Arts at Central Michigan University (CMU). Her research interests include interpersonal and dark side of interpersonal communication, with a special focus on friendship and peer communication. Specifically, she studies the influence of friendship qualities and communication on the sexual decision-making process of emerging adults. She recently received an Early Career grant through CMU, to conduct the two-study longitudinal research project entitled, *Emerging Adults in College: The Role of Friends in Sexual Decision-Making*. Her most recent work appears in *The Handbook of Lifespan Communication*.

Paul A. Lucas is an Assistant Professor at the University of Pittsburgh at Johnstown. He has a Ph.D. in Rhetoric from Duquesne University. His research focuses primarily on pop culture and marketing, and he has presented at conferences such as the National Communication Association Conference, Eastern Communication Association Conference, Southern States Communication Association Conference, and Pop Culture/American Culture Association Conference. He has a chapter published in the book *The Twilight Saga: Exploring the Global Phenomenon,* and he has published work in the *Communication Annual Journal of the Pennsylvania Communication Association*.

Kathleen Glenister Roberts (Ph.D., Indiana University-Bloomington, 2001) is Director of the Honors College at Duquesne University. She has taught at

Duquesne University, primarily in Communication and Rhetorical Studies, since 2001, and was Director of the Communication Ethics Institute from 2004–2006, and Director of the University Core Curriculum from 2008–2011. Roberts is the author of *Alterity & Narrative* (SUNY Press, 2007), which won the International/Intercultural Communication Book of the Year Award from the National Communication Association. Her most recent book is *The Limits of Cosmopolis: Ethics and Provinciality in the Dialogue of Cultures* (Peter Lang, 2014). She has also published numerous essays in refereed journals. The most recent of these appear in *Critical Studies in Media Communication* and *Solidarity: The Journal of Catholic Social Thought and Secular Ethics*. She has been an International Folklore Fellow, a PFF Teaching Fellow, and the recipient of numerous awards for scholarship and teaching, including Duquesne's Presidential Scholarship Award.

Andrew Sharma is a Full Professor of Audio, Video, and Digital Film Production in the Communication Arts Department at Salisbury University. He has a Ph.D. in Mass Communication from Syracuse University, a graduate diploma in Advertising from Xavier Institute of Communications, and an undergraduate degree from University of Mumbai, India. He has extensive academic, and national and international industry, experience, having worked in the advertising and television industry in the United States and India. His research interests are in the areas of persuasion/media effects, and media and culture. His writings on media effects appear in various peer-reviewed journals, such as *The Journal of Visual Literacy, The Journal of General Psychology, Journal of the International Society of Teacher Education, The Journal of Radio and Audio Media*, and as book chapters in *Global Media Economics: Commercialization, Concentration and Integration of World Media Markets* (Iowa State University Press). His recent accomplishments include earning a prestigious Fulbright Scholar position in India, where he taught media as a visiting professor.

Brent C. Sleasman (Ph.D., Duquesne University) is Associate Professor in the School of Communication and the Arts at Gannon University, where he also serves as Director of the M.A. in Health Communication. He is the author of Albert Camus's *Philosophy of Communication: Making Sense in an Age of Absurdity*, and is a contributor to *The Electronic Church in the Digital Age: Cultural Impacts of Evangelical Mass Media*. He serves on the editorial board of *The Journal of Communication and Religion*.

Kelli Jean K. Smith (Ph.D., Michigan State University) is Assistant Professor in the Department of Communication at William Paterson University in Wayne, NJ. She has taught communication theory, research methods, interpersonal communication, relational communication, persuasion, and nonverbal communication. Her research interests include complaining, friends-with-benefits relationships, and obsessive relational intrusion.

Elena C. Strauman (B.A., LaSalle University; M.A & Ph.D., University of South Florida) is an Associate Professor in the Department of Communication at the College of Charleston. Her research interests lie primarily in the areas of rhetoric and health communication, particularly how people and subjects are represented in popular texts, and the impact that those representations have on public perception. Her work has appeared in *Communication Quarterly, Journal of Social and Personal Relationships,* and *Journal of Medical Humanities.*

Sara Trask (Ph.D., University of Missouri) is an Assistant Professor at Randolph-Macon College. Her scholarship centers on interpersonal communication, emotions, and intimate relationships, particularly the role of affection and deceptive affection in close relationships.

Linnea Sudduth Ward is a doctoral candidate in the Department of Journalism and Technical Communication at Colorado State University. Currently, her research interests focus upon computer-mediated instructional communication and media choice.